LOST
HANOVER
NEW HAMPSHIRE

LOST
HANOVER
NEW HAMPSHIRE

FRANK J. BARRETT JR.

THE
History
PRESS

Published by The History Press
Charleston, SC
www.historypress.com

Copyright © 2021 by Frank J. Barrett Jr.
All rights reserved

First published 2021

Manufactured in the United States

ISBN 9781467148993

Library of Congress Control Number: 2021937210

CONTENTS

ACKNOWLEDGEMENTS

This book has been many years in the making within the pages of my imagination; however, it was my editor, Michael G. Kinsella at The History Press, who took an active interest and found a way for it to, at long last, come to fruition. But that was only the first—and very necessary—step. Once again, the staff at Dartmouth College's Rauner Library have been very professional and helpful, and to the college, I give it great credit for many of the exceptional historic images that can be found on the following pages of this book. But this is a book of stories and images from the past, and therefore, the many authors and others who, over the years, took note of and compiled the many threads of history about the "College on the Hill" and the "Village at the College" deserve special credit. Their work from years ago made this work possible many years later. And lastly, because I am, by nature, a very visual person, and because this book is both a very visual and scholarly work, a lot of credit must go to the many photographers who cared and took delight in crafting images of the ongoing evolutionary nature of this very special community. Henry Osgood Bly, Howard Harrison Langill, Adrian Bouchard and David Peirce are known to us, and all had a good eye for creating a good picture. And then there are the countless others whose names are now, unfortunately, lost to history. Thank you all for jobs well done. And a final thanks to my parents, Dorothy H. and Frank J. Barrett, who always encouraged and supported a young boy's interest in history, architecture, landscape and so much more.

INTRODUCTION

Tuesday, July 4, 1961, dawned overcast, with a strong chance of rain; however, that did not in the least dampen the spirits of Hanover's citizens as they gathered for a third day to celebrate the town's bicentennial. It had been two hundred years to the day since New Hampshire's royal governor Benning Wentworth, from his office in Portsmouth and on behalf of King George III of Great Britain, had issued a charter that officially created this new town within the dense wilderness of the Upper Connecticut River Valley. And two centuries later, it was time to pay tribute to the community it had become. The parade started at 10:00 a.m. that morning, down at the school complex on Lebanon Street, and it jubilantly worked its way up to South Main Street. Rounding the corner, the celebrants headed north "up street," where they noisily circled the Dartmouth Green before proudly arriving at the reviewing stand that had been temporarily set up on the west side of the Green. I was an eight-year-old boy watching this amazing procession with great fascination, standing at the Hanover Inn Corner in front of the inn's coffee shop that looked out onto Main Street.

By this time, I was developing an interest in the history of my hometown of Hanover, as well as old buildings, early automobiles and carriages and other diverse objects and subjects—all history related. I was, therefore, elated when Dartmouth College dean Thaddeus Seymour passed by in his magnificent 1930 Packard Phaeton with the top down, carrying the college president John Sloan Dickey and several other local dignitaries. Behind them

came Jack Manchester with his 1924 Model T Ford Gulf Oil truck and other antique automobiles. I was proud to be able to point out to my mother—somewhat authoritatively, I am sure—that I knew everything about these old vehicles and more. The day concluded with additional celebratory festivities commemorating Hanover's history, all outlined in a nicely compiled sixteen-page booklet that was illustrated with a smattering of historic images of the town from years before, titled *Hanover Today & Yesterday: A Program and Keepsake*. To this day, I still have my now well-worn copy from sixty years ago.

I was very fortunate to have grown up in postwar downtown Hanover, the son of an architect. Around the time of that celebratory parade, I decided that I, too, wanted to be part of that ancient profession, where I could hopefully exercise my combined love of history, buildings and landscape. From that time on, I have witnessed the changes that have come to Hanover and Dartmouth, and I have chronicled them accordingly. As a boy, from the seat of my bicycle, I often observed old buildings being torn down and new ones take their place. On occasion, my father left his mark on the built landscape as an architect; and then, starting in 1973, on my return from engineering school, I commenced working full time in his office. Together, he and I made our mark on the ever-changing built environment of Hanover. Concurrently, from that early age forward, it was always the old images of the built and natural landscape that would fascinate and captivate my attention and imagination. With each old image discovered and beheld, new knowledge of the past was gained, but equally so, new questions would surface concerning that which had become lost and was gone forever.

History is, among other things, the telling of stories about a shared and sometimes lost past. Stories about buildings and landscape, the causes and effects of the course of history, events—tragic and triumphant—changing tastes and changing needs, hopes and aspirations. Being a very visual person, and inseparably coupling these stories and historic patterns with historic images of past buildings and landscapes, has provided me with a lifetime of fascination, fulfilment and delight. Now, sixty years after that parade that so captivated my adolescent attention, I look at many of these old images of Hanover and Dartmouth, buildings and landscape long gone, much of which had vanished before my time, and it is akin to looking at old friends from the past and having the pleasure of knowing and cherishing their stories. Buildings lost to time, like the Dartmouth Hotel, the Tontine Block and the Heanage House, are old lost friends, indeed. And for many of these old images, with the buildings and scenery that they depict that long ago became lost to time, it is a joyful reminder of how many of my life's long

and deep interests started and were nourished in the village of downtown Hanover and Dartmouth College many years ago. Perhaps it can be said that what is shared within the pages of this book has been in the making since that parade turned onto Main Street and headed "up street," toward the Hanover Inn Corner and the Dartmouth College Green.

This book is, in part, about the continuously unfolding story of the Hanover village and Dartmouth College and its built environment; however, it is not intended, in any way, to be a history of the town or the college. That work has been very nobly done by others preceding me. Instead, this is a collection of historical narratives—stories, if you will—about the buildings and landscape that, in years past, were integral parts the of the growth and development of the "Village at the College" in Hanover, and of the "College on the Hill," a shared history that was, from the start, deeply and inseparably interwoven. Although the town and college remain like old friends from long ago, these landscape vistas and individual buildings no longer remain. One could say that they have been "lost" to the unrelenting and swiftly moving passage of time. However, thanks to photographers from years past—many with a good eye for a picture—and the compilation of many of historic narratives and records, their images and stories remain to be shared within the pages of this book. Unfortunately, space considerations dictated that hard choices had to be made concerning the amount of story line and images that could be included. Nonetheless, it is my sincere hope that the reader will enjoy learning about this lost past as much as I have over my lifetime and as much as I have, of late, enjoyed compiling it and sharing it with those who might have a similar interest.

Frank J. Barrett Jr.
Greensboro, Vermont

1

COLONIAL PRELUDE

HANOVER

The chartering of the town of Hanover and its subsequent settlement was part of a larger pattern of settlement that occurred within the region of northwest New England, beginning around 1760, following the defeat of France in Canada by Great Britain that marked the end of the so-called French and Indian Wars. For about one hundred years prior, it was not clear which of these two European superpowers of the day was going to dominate the North American continent. Therefore, the desire by Great Britain to settle the lands of what is today northwestern New England was halted by the threat of French raiding parties aided by their Native allies. However, the fall of Canada to the British soon eliminated that threat, and by 1760, it was considered safe to push settlement into areas of New Hampshire above the Merrimack River Valley at Salisbury, north into the Upper Connecticut River Valley above Fort Number Four at Charlestown and west to Lake Champlain. At that time, there was no settlement north of Fort Number Four, nor was there any within the Green Mountains of present-day Vermont, except for very minimal settlements near the Massachusetts border. However, within a span of only about six years, the royal governor of New Hampshire Benning Wentworth came to play an outsized role that left a lasting imprint on the region well beyond the present-day borders of the Granite State.

From the start, in the early 1620s, the area that became known as New Hampshire had a rough go of it. Not only was the territorial region only vaguely described by grants received from King James I of England, but with the start in 1630 of the Great Puritan Migration into the Massachusetts Bay Colony, New Hampshire was finding itself overshadowed by its far larger and more populated neighbor to the south. This was to remain a festering problem, manifesting itself in numerous and vexing ways for the next one hundred years. Finally, in 1741, King George II of Great Britain (1683–1760) took several important steps that set New Hampshire on a new course.

The boundary lines separating New Hampshire from Massachusetts to the south and the territory of Maine (which Massachusetts then controlled) to the east were firmly established by the king's government in London. And just as important, the king decreed that, henceforth, New Hampshire was a royal colony, independent of any jurisdictional role and oversight provided by Massachusetts and was, therefore, to have its own royal governor. The capital of the royal colony was to be Portsmouth. Toward that end, in June 1741, Benning Wentworth (1696–1770) of Portsmouth was appointed by the king as the royal governor of New Hampshire. On December 13, 1741, Wentworth assumed the office. Furthermore, he was also appointed the King's Surveyor General. This gave Wentworth oversight, on behalf of the King, of the vast virgin forest lands of all New England and beyond.

Benning Wentworth was the eldest child of Lieutenant Governor John Wentworth (1671–1730) and the great-grandson of "Elder" William Wentworth (1615–1697). Under the leadership of Benning's father, John, the Wentworths had become one of the most prominent political and mercantile families in Portsmouth. Benning had graduated from Harvard in 1715 and had gone on to become increasingly successful as a merchant while also representing Portsmouth in the provincial assembly. In 1734, he was also appointed a King's Councilor.

On becoming Royal Governor, Wentworth did not take long to reason that, although King George II had not established the colony's westernmost boundary with the colony of New York, it was, in fact, a line located approximately twenty miles east of the Hudson River, no different than the western boundaries of the lower colonies of Connecticut and Massachusetts. Therefore, he reasoned, as Royal Governor, he was authorized by the British Crown to grant patents and establish new towns within this unoccupied land that was part of New Hampshire. As such, in 1749, he issued the charter that created the Town of Bennington, located about twenty miles east of

the Hudson River and a short distance north of the boundary line with Massachusetts. New York authorities complained loudly, stating that the border between their colony and New Hampshire was the Connecticut River. Wentworth, however, paid little attention to this and continued to grant towns across the lower spine of the Green Mountains, next to Massachusetts, as well as up the Connecticut River Valley, a short distance from Fort Number Four. Protests from New York authorities to King George II went unanswered; and by 1756, a new wave of open warfare with the French and their Native allies broke out, and the matter was pushed aside for the time being. For the next three years, North America was consumed by war, and the area of northwestern New England remained too dangerous for any further settlement.

By 1760, with the surrender of French North America assured, Benning Wentworth turned his attentions back to settling these virgin land—on both sides of the Upper Connecticut River—that he considered to be New Hampshire. During the four years of war, American troops from southern New England had crossed through this wilderness region going to and returning from service in Canada, and they had greatly admired its beauty and settlement potential. The population of southern New England, especially in Connecticut, was prospering and increasing in numbers, and many desired to settle these new lands.

In December 1760, two men traveled from Mansfield in Windham County Connecticut to Portsmouth to put a petition before the royal governor, representing not only themselves but about 240 other area residents. The petitioners were seeking a grant of land in the Upper Connecticut River Valley in the area of the "Lower Coos," also known as the "Upper End of the Great Meadows"—in the vicinity of present-day Haverhill, New Hampshire, and Newbury, Vermont. The two gentlemen, Joseph Storrs and Edmund Freeman Jr., were graciously received by the governor and were told that he would take the matter under consideration. They then returned to Connecticut to await Benning Wentworth's decision.

Soon thereafter, Wentworth acted, and in March 1761, a land surveyor, Joseph Blanchard of Dunstable, New Hampshire, working with Colonel Josiah Woodward, set out from Fort Number 4 and traveled north up the river on the ice of late winter. At six-mile intervals, until they reached the junctions of the Wells and Ammonoosuc Rivers on the upper end of the Lower Coos, the men marked and numbered trees on the banks of the Connecticut River—the corners of future townships. Later that spring, teams of surveyors journeyed through the area and laid out a tier of new townships

several blocks deep along both sides of the River, from Charlestown north to the northern boundaries of Haverhill, New Hampshire, and Newbury, Vermont. Back in Portsmouth, the surveyors' notes were used to map out and create the charters for what would become the first of many new towns carved out of the virgin wilderness.

On July 4, 1761, from his provincial office in Portsmouth, Wentworth issued the first charters he referred to as the "Middle Grants," due to their location around the mid-point in the upper river valley. Created were the towns of Hanover, Lebanon, Enfield, Hartford and Norwich. Four of these new towns were clearly named for towns that had already been established in the lower colony of Connecticut, and it is believed that the fifth, originally spelled "Hannover" in its charter, was named for a parish located within the town of Norwich, Connecticut. It is possible that Wentworth intended to name the new town in honor of King George III (1738–1820), who was the third British monarch descended from the German noble house known as the House of Hanover. The king, then only twenty-two years of age and born George William Frederick, had only recently succeeded to the British throne after the sudden death of his grandfather King George II on October 25, 1760. The historical record does not at all make clear Wentworth's choice of the name; however, as it was first written in the charter that was issued that July, the name "Hannover" was soon thereafter simply spelled with the second "n" dropped. In very rapid succession, more towns followed on both sides of the Connecticut River, as did the protests from New York officials to authorities in London who were close to the British Crown.

When the elderly King George II died and his young twenty-two-year-old grandson King George III ascended to the throne of Great Britain, the new king was determined to be more engaged with his North American colonies and to deal with some long-festering matters that had been left unresolved by his beloved grandfather. One of those matters concerned the ongoing territorial dispute between New York and New Hampshire regarding the lands west of the Connecticut River—of which, New Hampshire's claim was dubious, at best. In 1764, the Lords of Trade in London ruled that New Hampshire's western border was the Connecticut River, thereby upholding New York's claim to that land that would, thirteen years later, become the Republic of Vermont. By July 1764, when George III made the Lords' decision official by decree, the best of that land west of the Connecticut River, extending into the Lake Champlain Basin, had already been chartered by Governor Wentworth into new townships and was in the hands of eager

settlers, most from southern New England. Within an astonishingly short amount of time, Wentworth had issued as many as 138 charters for new towns west of the River. And between 1761 and 1766, he had also chartered 41 new towns east of the River, as far north as Lancaster. As a result, by 1766, the total number of towns in New Hampshire alone surpassed 150.

The purpose of this narrative is not to highlight the life of Benning Wentworth, although he did, indeed, leave an oversized imprint on the region of northwestern New England, nor is it to present a defense of his time in office as the Royal Governor of New Hampshire. But it is important that the reader understand his legacy as it relates to the town of Hanover and to the region at large. There were many people then—as there are to this day—who accused Benning Wentworth of overreaching self-interests. This was especially true when the Lords of Trade finally took up the New York matter of the "New Hampshire Grants" in 1764. There is no denying the fact that, with every charter that established a new town, Wentworth and a small circle of associates around him, many of whom were family members, benefited greatly by selling shares in the newly incorporated towns to proprietors, most of whom were from outside of New Hampshire. And it was true that with each new town that was chartered, Benning Wentworth kept two shares (the equivalent of five hundred acres) in his own name, as he did in Hanover. This came to further frustrate the matter and added to Benning Wentworth's eventual woes.

Similar to the Puritan colonies of Massachusetts and Connecticut, Wentworth clearly intended to establish self-supporting towns based on local democratic government and fee simple ownership of land. By 1760, through some amount of trial and error, Wentworth had learned that the ideal size of a township was about six miles square, containing about twenty-four thousand acres. This size allowed all inhabitants within the town to be able to attend the all-important annual town meeting without undue inconvenience. Furthermore, each township that Wentworth created had between sixty-five and seventy shares and a similar number of proprietors—including Wentworth with his two shares. These shares also included set-asides to support the establishment of a public school, the first settled minister, the Glebe and the "Society for the Propagation of the Gospel in Foreign Parts" that was an effort to counter the work of French Jesuits among the Native communities in Canada. By taking five hundred acres of land in his own name within each new township and through collecting one-time fees from the proprietors of these newly created towns, by 1764, Benning Wentworth had become a very wealthy man.

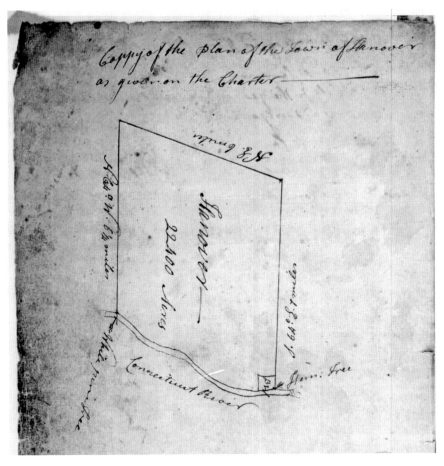

An early copy of the sketch that was included in the July 4, 1761 Hanover Charter. The town of Lyme is to the left (north); Canaan is above (east) and Lebanon is to the right (south). Note that the corners on the river are marked "White Pine Tree" and "Hem. [Hemlock] Tree," and the governor's five-hundred-acre lot is marked "BW." *Courtesy of Dartmouth College.*

By 1766, in the wake of the very messy controversy with New York two years earlier (which was continuing to be a very serious problem for the British Crown because of the heavy-handedness of New York authorities), King George III concluded that Benning Wentworth, the longest-serving English royal governor in all of British North America, was increasingly becoming an embarrassment to the young king. And standards and norms of the day were changing within New England and within the king's government in London. The New York controversy initiated an

investigation of the royal government in New Hampshire. In London, the Board of Trade accused Wentworth of "negligence, misconduct and disobedience" and recommended his dismissal. In an effort to shore up crumbling political support for the Wentworth family, Benning's nephew John Wentworth II (1737–1820) was dispatched to London, where he spent more than a year carefully guiding the family's fortunes—political and otherwise—and preserving the family's good name.

John Wentworth of Portsmouth, the son of Mark Wentworth who was a younger brother of Royal Governor Benning Wentworth, was, like his uncle, a graduate of Harvard, where he received a bachelor's degree in 1755 and a master's degree in 1758. Although he was born to wealth and privilege, John Wentworth was a very capable individual in his own right. While in London, the king's government, working with John, decided that Benning Wentworth should be allowed to graciously resign from his government offices. They also decided that John Wentworth would be appointed as a replacement. In August 1766, John was commissioned as Royal Governor and Vice Admiral of New Hampshire and Surveyor General of the King's Woods in North America. Before he returned to North America, John was awarded a doctorate of common law from Oxford University. After a difficult crossing, he arrived in Charleston, South Carolina, in March 1767, where he proceeded to make his first major survey of the forests of Georgia and the Carolinas on behalf of the Crown. He then made his way north overland and was received in Portsmouth with much ceremony on June 13, 1767.

DARTMOUTH COLLEGE

Within nine years of the chartering of Hanover, Eleazar Wheelock and Dartmouth College became integral parts of each other. It is a fascinating story, the full breadth of which has been well documented by others and need not be retold within these pages; however, a brief overview is important, as it will provide the reader with a better understanding of the context of this book.

Eleazar Wheelock (1711–1779) was born in Windham, Connecticut, the only son of Deacon Ralph and Ruth Huntington Wheelock. By the time Eleazar was born, Ralph Wheelock had a prosperous farm in excess of three hundred acres and was a deacon in the local Congregational church.

Both of Eleazar's parents were from distinguished New England Puritan families originally from the Massachusetts Bay Colony. Coincidentally, given Eleazar's later achievements, he was the great-grandson of Reverend Ralph Wheelock (1600–1683), the first teacher in the first free public school in America, established in Dedham, Massachusetts, in 1644. At the age of twenty-two, in 1733, Eleazar graduated from Yale College, having won the first award of the Dean Berkeley Donation for his distinction in classics. Eleazar continued his theological studies at Yale until he was licensed to preach by the New Haven Association in May 1734. The following year, Wheelock was installed as the pastor of the Second Congregational Church of Lebanon, Connecticut, in an area of the town that was referred to at that time as "Lebanon Crank." Today, this area is incorporated into the separate town of Columbia. Eleazar served there as minister for thirty-four years while also serving as an itinerant preacher.

At the time of Wheelock's graduation from Yale, a religious revival known as the Great Awakening was sweeping through the Lower Connecticut River Valley. The movement was characterized by itinerant evangelists, dramatic religious conversions and religious zeal. One of the most popular preachers in the colonies was George Whitefield (1714–1770), an English Anglican and, later, one of the founders of the Methodist Church. He toured lower New England, preaching salvation to crowded churches and hillside throngs. Up the Connecticut River, at Northampton, Massachusetts, was Reverend Jonathan Edwards, also a powerful and compelling preacher, who delivered the famous sermon in Enfield, Connecticut, titled "Sinners in the Hands of an Angry God." Wheelock became acquainted with both of these men, and they were to have a tremendous influence on him.

In 1743, the Connecticut Assembly, in an attempt to regulate revivalist activity, passed "An Act for Regulating Abuses and Correcting Disorders in Ecclesiastical Affairs." This act stated that ministers who preached outside of their own congregation could not collect a salary, and as a result, Wheelock lost much of his means of support. Though he owned a great deal of farmland, much of it inherited from his father, it was necessary for him to find an alternative source of income. Turning his attentions back to his church in Lebanon, he began taking male students into his home and preparing them for college at either Harvard or Yale. At first, these young men were the sons of established White families within the region; however, in 1743, he took in Samson Occum (1723–1792), a Mohegan Native who spoke English and had been converted to Christianity during

his childhood. Occum lived in the Wheelock household for the next four years, and Wheelock had great success in preparing him for the ministry. After leaving Wheelock in 1748, Occum, a handsome man with a commanding presence, went on to become a Presbyterian minister and a powerful and charismatic preacher in his own right among the Montauk Tribe on eastern Long Island.

Reverend Wheelock's success with Samson Occom encouraged him to pursue creating a school for Native youth, with the purpose of instilling in the boys elements of a secular and religious education so that they could return to their Native culture as missionaries. The girls were to be taught "housewifery" and writing. The school was to be supported by charitable contributions. Toward this end, in 1754, six years after Occum had left his home, Reverend Wheelock accepted two Delaware Natives from New Jersey. The school was located next to Wheelock's home and church, situated on the Green in Lebanon and consisted of two small buildings and a small parcel of land. The funding for the land and buildings was a gift from Colonel Joshua More, a wealthy farmer and landowner from nearby Mansfield. Other Native youth from New England tribes and the Six Nations were soon enrolled. By 1762, Wheelock had more than twenty young Natives in his charge.

What Wheelock chose to call More's Indian Charity School was soon a success and brought Wheelock a lot of notoriety for his work, although funds for its operation were always in short supply. In spite of continued financial difficulties, Wheelock, buoyed by his success working with Native students, began to think about constructing a new, larger school, perhaps located in a region of the Northeast other than Lebanon, Connecticut, closer to larger populations of Natives. In 1765, at the suggestion of Reverend George Whitefield, Wheelock sent Samson Occum and Reverend Nathaniel Whitaker of Norwich, a Presbyterian minister and close confidant of Wheelock's, to the United Kingdom to raise funds for a new school. This two-year effort, aided, in part, by Reverend Whitefield, was a tremendous success, and while traveling through England, Scotland and Ireland, they raised more than £11,000, most of which was placed in the charge of an English board of trustees, headed by William Legge, the Second Earl of Dartmouth. Legge was very influential within high circles of English society and government, and he was very supportive of the combined efforts of Occum and Whitaker on Wheelock's behalf. Occum, an immensely talented, powerful and impressive orator, preached to assembled crowds as Whitaker passed the hat, collecting money. And not

only did Legge himself make a sizable gift, but he arranged an audience for Occum to preach before King George III, who then proceeded to make a sizable gift to Wheelock's cause in the name of the Crown of England.

By June 1768, Occum and Whitaker were safely back in North America, and a fabulous sum of money was on deposit in London, under the careful watch of a board of English trustees. During the time that Occum and Whitaker were overseas raising money, Wheelock continued to think about how to obtain a charter for the new school that he was envisioning and where to permanently locate it. As Wheelock contemplated his new school, he received numerous offers and advice from interested parties both far and near Lebanon, Connecticut, as to the best location for the school.

Wheelock's own preference had always been in the direction of the Susquehanna River in either New York or Pennsylvania. Regardless, propositions were received from Georgetown, Maine and locations on the Kennebec River, all the way to the Mississippi River, and as far south as Virginia and the Carolinas. For a brief time, a location on the Ohio River, below Pittsburg, was in the running, as was a location on the St. John's River, which was suggested as late as 1768. The area of Albany, New York, for an extended period of time, offered great appeal and promise. Meanwhile, in Lebanon, Connecticut, citizens of that community were urging Reverend Wheelock to consider growing his Native charity school at its present location. As early as 1763, only several years after Governor Benning Wentworth, the Royal Governor of the Province of New Hampshire, had begun opening the upper regions of the Connecticut River Valley for settlement, Wentworth told Wheelock that he would gift him five hundred acres to entice the school to settle there. By 1765, the first offer from a town within the River Valley came to Wheelock from Thetford, which offered him two thousand acres if he and his school would consider settling within that town.

What motivated Benning Wentworth's overtures to Wheelock is not entirely clear; however, by 1767, he had been replaced as Royal Governor by his nephew John Wentworth II, and it is clear that this new governor had a deep commitment toward the betterment of his colony. Later that year, Wheelock was in correspondence with John Wentworth, exploring the possibility of locating his proposed new school within the Upper Connecticut River Valley of New Hampshire; and by the following year, Wheelock had been contacted by persons representing the towns of Lyme and Thetford, Orford, Bradford, Newbury and Haverhill. All of these

towns were making compelling arguments as to their individual virtues, and some were going so far as making substantial offers of property. Soon, towns closer to Fort Number Four and over in the Pemigewasset Valley were also showing an interest in the school.

By the late summer of 1768, Wheelock was in a deep quandary as to what to do, as he was completely undecided as to where he should locate his school. In his heart, he still wanted to be in the Susquehanna River Valley, where he would be close to the Native tribes and a potential body of students. Others, however, were advising him that the Albany and Western Massachusetts areas should still be carefully considered and not dismissed. Meanwhile, from Portsmouth, New Hampshire, the persuasive Governor John Wentworth was continuing to exert his influence, and he had close ties to the King, from whom a school charter could be obtained.

Thus, Wheelock looked to Lord Dartmouth and the English Board of Trustees for direction. In April 1769, Dartmouth and the Trustees wrote to Wheelock, unanimously supporting locating the new school within the "District of Cowas, in the Government of New Hampshire." And although they believed that both the towns of Orford and Haverhill were excellent potential locations, they left the final decision of a location on the eastern side of the Connecticut River up to Wheelock.

With that amount of direction from the English Trustees as to the proposed school's location and with the realization that only in New Hampshire, from Governor John Wentworth II as an agent of King George III, would he be able to receive the necessary charter to establish a new school, Wheelock—with, no doubt, some reluctance—by the end of April, turned his attention toward working with the governor in preparation for establishing his new school in New Hampshire. Throughout the remainder of 1769, Reverend Wheelock and Governor John Wentworth fashioned a royal charter that was issued in the name of King George III for the school that Wheelock was envisioning. During most of this time, Wheelock remained in Lebanon, Connecticut, overseeing the daily operations of Moor's Indian Charity School, but in his place in Portsmouth, in close correspondence with Wheelock and acting on his behalf, was his son-in-law Colonel Alexander Phelps. After many months of exceedingly close cooperative efforts between the various men, on December 13, 1769, Governor John Wentworth II, in the name of King George III, signed the charter that established Wheelock's new school, which was to be located in New Hampshire. Reverend Eleazar Wheelock had proposed that the new school be named after Governor John Wentworth; however, Wentworth

was far too modest and refined, and the name "Dartmouth" was taken for purposes of conciliating the English Trustees and increasing their support for the new school—including the important and well-connected Lord Dartmouth's.

As 1770 dawned, Wheelock had a substantial sum of money on deposit in London with the English Trustees, plus a charter from the king allowing him to establish a new school; however, the exact location was still undecided, and it was increasingly becoming a point of frustration and anxiety for Wheelock. Furthermore, Governor Wentworth renewed his prior suggestions to Wheelock that a suitable location for the school would be the town of Landaff, situated in the Ammonoosuc River Valley, two towns north of the Haverhill/Newbury area. To Wentworth's way of thinking, not only would locating Dartmouth College this far north greatly help the development of the northern region of the colony, but more importantly, having the college control an entire town, including its local government, as in English college towns, would provide for a healthier and safer environment for the growth and development of its students. And then, somewhat unexpectedly, the name Hanover came up as a potential suiter.

The first settlers of Hanover were from the area near Lebanon, Connecticut, and knew Wheelock and his work as an educator. On September 4, 1769, Deacon Edmund Freeman from nearby Mansfield, wrote to his son Jonathan, an early proprietor and settler in Hanover:

> *I hear and believe that it is determined that Mr. Wheelock's school is to be settled in the Province of New Hampshire. I have heard transiently that Dr. Wheelock thinks likely in Hanover, or in Orford, or in another town, I know not the name. The doctor, as I hear, says Hanover is settled with the most serious, steady inhabitants. Rejoice if you are, and continue worthy of a good character.*

That October 17, Hanover's proprietors voted to encourage subscriptions (offers of land), since "there appears a prospect of Dr. Wheelock's school being settled in this town." It is not known if this interest in and from Hanover was, at the time, known by those in Orford and Haverhill who were promoting their town's interests, but any interest in locations on the river below Hanover was no longer mentioned. Interest in the towns of Plymouth, Rumney and Compton, within the Pemigewasset River Valley, was strong, with significant offers of land, cash and labor. In March, the

proprietors of Haverhill voted to add additional land and a potential mill site to their standing offer to Wheelock. And the town of Bath, situated between Haverhill and Landaff, was supporting Haverhill's bid with additional offers of adjacent lands.

Wheelock, by then aged fifty-nine, had yet to travel north into the Upper Connecticut River Valley to personally review matters and inspect the various sites and offers being put forth by the competing towns; however, during the months of February and March, Colonel Phelps was busily traveling throughout the region on his father-in-law's behalf, assessing the various offers and discussing matters with interested parties.

James Murch was one of Hanover's earlier settlers who, after a failed attempt by others before him, had successfully overseen the construction and placed into operation Hanover's first saw and gristmills. As such, he was a capable man of local prominence, and being originally from the Lebanon, Connecticut area, he was an old acquaintance of Wheelock. Early in 1770, as Hanover continued to build interest in having the new college located there, the town entrusted the matter to Murch, who apparently had conversations with Colonel Phelps that winter. The first step Murch undertook on Hanover's behalf was to write to Wheelock on February 10, 1770, in an effort to gain more time to put an offer together for locating the college in Hanover, where upon he wrote:

> *There is great engagedness and large subscriptions making by the proprietors and others of the towns of Plainfield, Hartford, Harford [Hartland], Lebanon, Norwich, Hanover and some other towns for the said school if it would be in Hanover in the Province of New Hampshire, now, sir, I suppose that Colonel Phelps never heard of this subscription, and I apprehend he has not laid this donation with circumstances of the place, before the board at Portsmouth.*

Clearly, Murch was working with the towns surrounding Hanover to raise money in support of Hanover's effort to place an offer before Wheelock of land and cash, but he needed time. In the same letter to Wheelock, Murch went on to write:

> *Trusting in your wisdom and willingness to hear everything of consequence to said school, I would therefore pray that the place for said college may not be fixed on till the donations may be gathered and the circumstances of place be properly laid before their honors.*

P.S.—I suppose there can be as much or more said in favor of its going to the said town of Hanover than any town on the river—which will be laid before their honors in writing, if desired.

With Murch having gained some time and after organizing the surrounding towns to work in support of the Hanover location, he traveled to Connecticut and met with Wheelock to discuss the situation further. Murch pointed out to Wheelock that there was considerable renewed interest in the college and its eventual location by the river towns. He also pointed out to Wheelock that at the upcoming annual March town meeting, each community would have the opportunity to "renew and enlarge their subscriptions," thereby making even more lucrative offers possible. After Murch's visit and return to Hanover, Wheelock, in a lengthy letter to the English trustees, reported as to where matters stood as of mid-March, and he admitted the following:

I hoped the colonel and the trustees in that province would have been able to furnish such materials as might enable us to determine upon the very spot without any further difficulty, and that I might set all wheels in motion for building and making preparation for my removal with my family and school immediately; but I find the case much otherwise.

Understanding James Murch's point about waiting and letting the various towns have their town meetings to see what additional "subscriptions" might yet be raised, Wheelock went on to write:

Nothing can be done by me consistently in this affair till their subscriptions are all brought in, and then it is not likely it can be determined with safety on honor to the cause and satisfaction to the inhabitants without viewing the several places fixed upon and hearing the reasons and arguments of the several parties upon the spot. I expect that Colonel Pitkin, one of the trustees [from Portsmouth], will accompany me in that affair as soon as the roads are settled.

The result of the March town meetings within the area surrounding Hanover on both sides of the river was strong local support in favor of seeing the college located in Hanover. Lebanon went so far as to vote "to give 1,441 acres adjoining to Hanover line, and to Mr. Tilden's land, to be laid one mile and a half square, for the support of Dr. Wheelock's school, upon condition

that it be erected in Hanover." On the same day as the successful town meeting votes, Murch wrote a lengthy letter to his friend Wheelock. First, Murch made it very clear to Wheelock that the land being offered by Lebanon in support of the college was mostly good land, contrary to what Wheelock's son-in-law Colonel Phelps was saying. Furthermore, Murch questioned if Phelps could be impartial and fair in his assessments concerning the proposed Hanover location due to his (Phelps's) ownership of lands in Orford and his associations with persons of similar interests. Murch further stated that if Phelps was not being bribed by persons in Orford, as was the rumor, there was nonetheless the local appearance that he was solely trying to advance his own interests.

In that same letter to Wheelock, dated March 13, 1770, after calling into question Colonel Phelps, Murch went on to lay out for Wheelock, carefully and clearly, the reasons for considering the proposed Hanover location. He wrote:

> *Now, sir, I shall endeavor to set before you some of the benefits of this place for the college: First, here is a large tract of land of near three thousand acres or more, all lying together, and the greater part of some of the best land. I shall only add that there may be a good road to Portsmouth; and it is in line to Crown Point from Portsmouth, and a very narrow place in the great river for a bridge; and it is by a pair of falls, and where salt and other articles, brought up the river, will be cheaper than they will be further up.*

Other than some very crude trails, there were not yet any east–west roads cut through the region other than a few well south of Hanover at Charlestown and Fort Number Four. At that location, there existed some amount of roadway west, through Keene to Number Four, and the Crown Point Military Road, which extended from Number Four, across the Green Mountains, to Crown Point at Lake Champlain. It was well understood that there was dire need for a road into the central area of the Connecticut River Valley from the Merrimack River Valley and Portsmouth. When that road might be cut through the dense wilderness area that separated the two watersheds was unknown, as this interior area was only starting to be settled. In 1770, there were no bridges on the entire river, and given the engineering technology available at the time—or the almost complete lack thereof—suitable locations that could accommodate such a structure without fear of washout were few and far between. The falls on the Connecticut River that Murch referred to were the White River Falls,

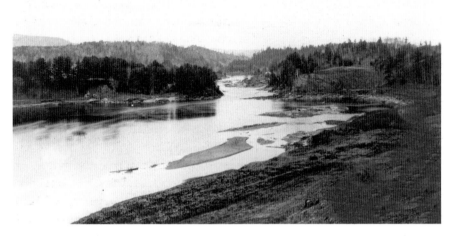

The White River Falls on the Connecticut River, looking upstream from New Hampshire, circa 1860. Over a distance of about a mile, the river dropped thirty-seven feet. Today, these falls are submerged under the backwater of Wilder Dam, which was completed in November 1950 and located to the left of where this photograph was taken. *Author's collection.*

where, over the course of about three-quarters of a mile, the Connecticut River dropped thirty-seven feet. These falls were a significant impediment to river travel for both persons and freight. And the Connecticut River was the primary means of travel into and out of the entire region.

Toward the end of March, Wheelock became increasingly interested in locating the college farther south in the valley. Apparently, he was understanding the points that James Murch was advocating. On the other hand, Governor Wentworth still strongly wanted the college to settle in the Landaff-Haverhill region of the valley. By this time, Wheelock asked a close friend of his, Reverend Jonathan Parsons of Newburyport to discuss the matter with the governor, attempt to sound him out and report back to him. As Parsons wrote Wheelock on March 24, 1770, "he [Wentworth] would yield it should be at Haverhill or Bath...but he greatly preferred Landaff to any other place." Additionally, as Parson went on to report, Wentworth said, "And further yet, it will soon be a good coach road from Landaff to Portsmouth."

By spring, matters had come to such an impasse that nothing short of Wheelock making a trip to the region, hopefully in the company of the governor, could settle the matter. To this end, as the southern New England countryside became dry after the previous winter's snow, Wheelock planned to head north, up the Connecticut River Valley, by sometime in April. Unfortunately, not only was the governor unavailable, but other delays caused a much later start. Finally, in May, Wheelock, in the company of his brother-in-law Reverend Benjamin Pomeroy of Hebron; Colonel Samuel Gilbert, a close personal friend, also from Hebron who had proprietary rights in Lyme, New Hampshire; Wheelock's son Ralph; and Wheelock's physician, Dr. John Crane, set out, heading north up the Connecticut River, presumably on horseback. They arrived in New Hampshire around June 1, and by June 8, they were in Hanover. We do not know if they conducted any business south of Hanover as they worked their way up the river.

By the time Wheelock and his traveling companions reached Hanover, the proprietors of Hanover and others had assembled a package of land holdings, all adjacent to each other, that consisted of the 1,441-acre parcel in Lebanon that was previously mentioned, a 1,200-acre parcel in Hanover along Mink Brook for Dartmouth College, a 300-acre parcel for Reverend Wheelock and his family and a 500-acre parcel for the college that belonged to former governor Benning Wentworth.

As previously noted, during the years that Benning Wentworth was governor, when a new town was chartered, he always reserved a five-hundred-acre parcel for himself known as the "governor's right." These parcels were always located within the corner of a new township, next to a similar parcel within the adjoining township—as was the case in Hanover and Lebanon. By the time that King George III had removed Benning Wentworth from the governor's office and, in his place, installed his young nephew, these five-hundred-acre parcels that belonged to the governor numbered in the hundreds and had become a political liability for the Wentworth family. In many cases, the parcels were given to the proprietors of the specific towns in which they were located—as had happened in Lebanon, where they were then deeded to individual settlers. In Hanover, this had not yet happened, so the former governor indicated that he would be willing to give the five-hundred-acre lot to the college, should it choose to settle there.

The party was met in Hanover by Colonel Phelps and spent three days carefully looking at the land being offered. Because there was not yet any established village in Hanover and the nearest house of the twenty-five or so settlers in the town was several miles or more away, the party was put up

at the inn of Captain Burton, which was situated on the Norwich Plain. In addition to reviewing the proposed land offerings, time was also spent reviewing all of the various subscriptions from surrounding towns in support of the Hanover location.

From Hanover, the party continued north to Coos to review what was being offered by the town of Haverhill and the surrounding towns in support of the proposed Haverhill location. Orford had withdrawn its offer and thrown its support behind Haverhill. And by this time, although it was being threatened by the late-coming offer from Hanover and those surrounding towns, Haverhill still thought it was secure and that it had the deal all but signed up. We no longer know how that visit from Wheelock and his party of advisors went, but by June 22, the party was over in Compton on the Pemigewasset River, reviewing that community's offer. While there, Wheelock received a letter from the trustees in Portsmouth who unanimously and earnestly recommended that the college be located in Landaff or within either Haverhill or Bath, as long as it was no more than one mile from Landaff. This authoritative letter from Portsmouth, strongly recommending the northern location, must have made Colonel Jacob Bayley of Newbury, who was, by then, traveling with the Wheelock party and representing the interests of those towns within the Coos region, feel quite secure. Wheelock, though, as evidenced by a letter he wrote to his wife on June 25 from Plymouth, remained very unconvinced. In the letter, he stated:

> *We came to this town last Thursday, and have with our wonted industry viewed the several places proposed in this and the neighboring towns. The offers made in this and other places are very generous, and I find one place in this town and in Campton and Rumney where a pretty parish may be made out of the three towns, which is very inviting—a very beautiful plain, with Baker's River running through it, with large meadows on both sides. But whether this will be the place, or whether the preference will not be given to other offers made, I can't yet tell.*

Wheelock then went on to write the following in the same letter to his wife, referring to the letter from the trustees in Portsmouth:

> *I am setting out to-morrow to wait upon the gentlemen, and hope to convince them that what they propose is impractical; and it is well it is so. I expect a very trying time. My hope ins in God, who has been my helper hitherto.*

We are all along received with great expressions of kindness and respect. I shall accomplish the business as soon as possible, and return to my family, which I long more than ever to see.

Wheelock and his fellow travelers arrived at Portsmouth by the end of June and remained there for about a week. Colonel Bayley had become somewhat concerned about the fate of Haverhill's offer and went about further sweetening the deal with additional large quantities of land and the promise of more buildings that they would erect just for Wheelock and the college. All the while, Wheelock was spending his time in deep consultation with the governor and the Portsmouth trustees.

On July 5, it was unanimously decided by those present in the room with Wheelock and the governor to support the final choice of locating Dartmouth College in Hanover. A letter from the governor's office dated that day stated, among other things:

Lands, moneys, and other aids subscribed for the use of said Dartmouth College, if placed in Hanover aforesaid, be firmly and securely conveyed to the trustees of and for the use of said college….And also that said towns of Hanover ad Lebanon previously consent, and petition to the legislature that a contiguous parish of at least three miles square in and adjoining to these aforesaid towns of Hanover and Lebanon, be set off and incorporated into a separate and distinct parish under the immediate jurisdiction of the aforesaid Dartmouth College.

Later that same day, former governor Benning Wentworth, in fulfillment of his promise he made five years before, conveyed his five-hundred-acre parcel, situated in the very southwest corner of the town of Hanover, to the trustees. He died later that year. Soon, the other parcels in Hanover and Lebanon followed. John Wentworth's desire of establishing a separate parish under the jurisdiction of the college never materialized due to a lack of effort on behalf of the two towns of Hanover and Lebanon, as well as political difficulties in Portsmouth. In the years between the establishment of Dartmouth College and the outbreak of the American Revolution in the spring of 1775, the relationship between Governor Wentworth and the colonial legislature became increasingly strained until it collapsed that spring, after armed conflict broke out in neighboring Massachusetts.

Clearly, based on correspondence, accusations and actions in the aftermath of Wheelock's decision, people of the Haverhill and Newbury

area were, in many cases, shocked and deeply disappointed. Had they not offered to Wheelock vast tracts of virgin land that included magnificent forests of many species of timber, rushing streams that would readily provide powerful mill sites and some of the richest, most easily cultivated land within the entire river valley? But Wheelock understood that he only needed enough land for cultivation to provide for his college and timber lands and mill sites sized accordingly. He was not planning to commence agricultural and timber pursuits on a large scale. And of those lands being offered to him, they were not contiguous; instead, they were broken up and even separated by the Connecticut River. Wheelock's mission was to be an educator. And he clearly understood the broader arguments put forth relative to location and transportation. In a narrative prepared by Wheelock shortly after the Hanover decision was made, he wrote that the reasons for placing the college in the southwest corner of Hanover, next to Lebanon, were many, including:

> *It is most central on the river, and most convenient for transportation up and down the river; as near as any to the Indians; convenient communication with Crown Point on Lake Champlain, and with Canada; being less than sixty miles to the former, and one hundred and forty miles to the latter; and water carriage to each, excepting about thirty miles (as they say); and will be on the road which must soon be opened from Portsmouth to Crown Point; and within a mile of the only convenient place for a bridge across said river. The situation is on a beautiful plain, the soil fertile and easy for cultivation. The tract on which the college is fixed, lying mostly in one body and convenient for improvement in the towns of Hanover and Lebanon, contains upwards of three thousand acres.*

On August 23, 1770, Wheelock placed a public notice in the Portsmouth newspapers announcing the establishment of the college. They described the site using similar language:

> *A choice tract of lands of more than 3,300 acres, which butts upon the falls in the river called White River Falls, and is the only place convenient for a bridge across Connecticut River, it being but eight rods wide, with well-elevated rocks for abutments on each side, and on a straight line from Portsmouth to Crown Point, to which is a good road; and is a place which the Indian tribes far and near have frequented and used as a hunting-ground 'till the late wars, with many other inviting circumstances.*

No sooner had the announcement been made declaring the location of Dartmouth College then Wheelock departed Portsmouth and returned home to Connecticut to conclude his affairs and prepare for the move to Hanover. Before leaving, he planned for a party of workmen to go to Hanover and open up a clearing and put up temporary buildings; however, as he was to discover later, that work never happened.

On August 8, 1770, Reverend Dr. Eleazar Wheelock, aged fifty-nine; his son-in-law Sylvanus Ripley; his physician, Dr. John Crane; and a small gang of laborers with teams of oxen and horses left Lebanon, Connecticut, and headed north up the Connecticut River to Hanover, 175 miles distant. After passing through Fort Number Four at Charlestown, they continued traveling on the "Great Road," a crudely cleared former Native American trail that paralleled the eastern bank of the river as far north as Haverhill. Finally, around August 20, they arrived at the site of Dartmouth College in Hanover. To Wheelock's dismay, not a tree had been cut nor a temporary building erected. The only thing that greeted this weary party was a dense virgin wilderness. Of the twenty-five or so families who were, by then, living in the town, the nearest was about two miles distant. The closest clearing—and only road opened as of yet—was the southern end of the so-called Half-Mile Road, which was about a mile away.

2

FOUNDING THE COLLEGE
AND CREATING A VILLAGE

1770–1780

THE COLLEGE

Reverend Dr. Eleazar Wheelock and his entourage immediately set to work, constructing temporary accommodations and clearing an opening within the dense forested growth that covered the entire landscape. Wheelock controlled more than 1,000 acres of land that would become the college and village area, which included the former 500-acre governor's lot, located at the far southwestern corner of the township, and several additional contiguous large parcels that were situated immediately to the east. On the central portion of these lands was a large plain elevated well above the Connecticut River. It was covered with a dense growth of white pines, some as tall as 270 feet. Within this plain was a rocky knob of land, today's College Park, that was densely covered with hardwood trees. The southeastern portion of this plain was a hemlock swamp, the present-day area of South Park and Lebanon Streets.

As per the terms of the charter that established the College, there was a board of trustees that was made up of five individuals from New Hampshire, including the Governor; seven individuals from Connecticut, including Wheelock; and the remaining from England. A bare quorum of seven members was necessary to transact any business. It was intended that the actual development of the college was to be located on the former governor's lot that was owned by the college, not Wheelock. Therefore, the overall layout of streets and college buildings, including the subdivision of

land for the development of a village to support the college, needed the approval of the Board of Trustees. This also included any modification of the division line between the five-hundred-acre college tract and the abutting Wheelock-owned lands.

The first order of urgent business was to create an open clearing within the dense forested landscape and to erect some amount of temporary shelter. A spot for a cabin was selected on a more level and drier part of the plain, about sixty rods from the river, near the northern line of the five-hundred-acre college tract. With a force of laborers, varying from thirty to fifty in number, many of whom were volunteers from Hanover and the surrounding area, a crude log cabin, about eighteen feet square, was erected using the fallen trees on hand. At the same time, near the cabin, an attempt was made to dig a well, but it proved to be unsuccessful. It was soon determined that the cabin was located just beyond the college limits. Therefore, that fall, the log building was dismantled and rebuilt on a slight rise in the land on the eastern side of what would become the College Green (in front of present-day Thornton Hall). And at this location, the first successful well was dug.

That fall, Mrs. Wheelock and additional family members, laborers and students arrived in Hanover, and additional crude temporary shelters were erected for their use. By the onset of winter, about six acres of land had been opened up (approximately the area of the present-day Green). For the time being, the giant white pines were simply felled and left where they landed. This made for a landscape of haphazard fallen timber—difficult to move around in during what proved to be a very snowy winter.

The winter passed largely without incident, and by summer, about forty acres of land, radiating out from the initial clearing, had been opened up. Other than what could be harvested from the surrounding forest, all provisions were brought up the River from areas that were one hundred to two hundred miles away. On horseback, a rider could make the trip in five to six days; however, with teams of oxen, it could take as much as several weeks.

In early 1771, Wheelock engaged Jonathan Freeman, a very capable land surveyor who had settled in Hanover, to layout the college and village area largely as it exists to this day. The Freeman family was from Mansfield, Connecticut, and Edmund Freeman Jr. (1711–1800) was a leading man among the original proprietors. Although he never settled in Hanover, his five sons—Edmund III, Jonathan, Otis, Russell and Moody—all did, and with the exception of Moody, they were prominent in Hanover affairs for many years. And Wheelock and those within the Freeman family had known of one another before moving to Hanover.

The plan of the village that Jonathan Freeman laid out bears evidence to his skill, sound judgment and foresight. The central feature was a rectangular-shaped parcel of about seven and a half acres with its sides squared to the cardinal points of the compass. This was to be the College Green. Around and near this space were lots of varying size (from half an acre to one acre). A one-acre burial yard was established behind the lots on the western side of the Green. College, Main and Lebanon Streets were laid out, including the beginning point of a road next to the river. The Trustees, in May 1773, formally approved putting sixteen acres at Wheelock's disposal for house lots "for the accommodation of inhabitants for the conveniency of the college."

In addition to laying out the village, in 1771, two major structures known as the Commons Building and College Hall and a twenty-eight-by-thirty-two-foot barn were erected for college use. Although hastily constructed without permanent foundations and the like, the Commons and College Hall buildings marked the beginning of Dartmouth College. Both were located in the southeastern corner of the future Green. The exact location of the first barn is no longer clear.

The Commons Building was a forty-by-twenty-three-foot single-story structure that, along with other uses, provided housing for the Wheelock family. Within the attic, there was space for Eleazar to have a room for himself. Within several years, the building was expanded with a single-story thirty-foot addition that contained a kitchen and commons area at the eastern end, and the western two-thirds made up one large room, with an aisle down the middle and a chapel for students on one side and meeting space for citizens on the other. Beside this building was College Hall, an eighty-by-thirty-two-foot all-purpose two-story building with eighteen rooms that housed as many as eighty students on the second floor and a library and classroom space on the ground floor. To furnish lumber for the construction of these and other structures, in the summer of 1771, a sawmill with a small dwelling house was constructed on Mink Brook by Israel Woodard of Lebanon, Connecticut, situated in "Sleepy Hollow." The following year, a gristmill was added.

The year 1772 once again proved to be successful. A washhouse, a bake house, a 30-by-30-foot malt house, a blacksmith shop and a 55-by-40-foot barn were all erected. The college could boast that there were between forty and fifty students enrolled. Of these students, between five and nine were Native Americans. Throughout the year, as many as thirty laborers were on hand to clear an additional 70 acres of land. By the fall of 1772, a total of

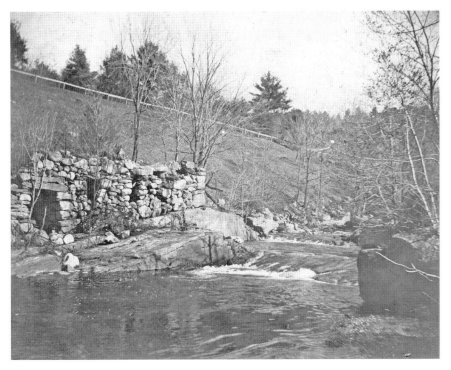

To furnish lumber for the construction of the first structures in 1771, a sawmill with a small dwelling house was constructed on Mink Brook by Israel Woodard of Lebanon, Connecticut, that summer. The secluded location, about three-quarters of a mile from the college, was called "Sleepy Hollow." The following year, a gristmill was added. Pictured are the mill ruins as seen in the early twentieth century. *Author's collection.*

110 acres had been opened up, and the fall harvest included fourteen tons of hay, 20 acres of English winter grain and 18 acres of Indian corn.

From the start, Wheelock was quick to acquire additional land abutting the north and west sides of the original five-hundred-acre college lot. In 1770, Colonel John House gave Wheelock a one-hundred-acre lot that fronted the river and bordered the college lot. This was the original lot of proprietor Peter Aspenwall and is the present-day area of Occum Ridge and Clement Road. Immediately east was a one-hundred-acre lot that belonged to William Johnson. Wheelock was able to acquire the southern half of this lot in 1771; however, the northern half came into the possession of John Payne. Payne made some further maneuvers, and in 1772, he erected a two-story house at about the site of Wheeler Hall on the eastern side of the road leading north to Lyme. Much to Wheelock's dissatisfaction—and at first unknown to him—Mr. Payne received a tavern license from authorities in Portsmouth.

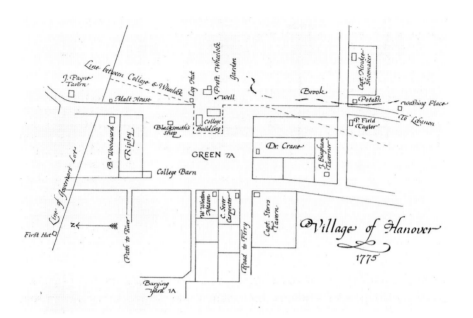

A re-created map of the campus and village area as it existed in 1775.

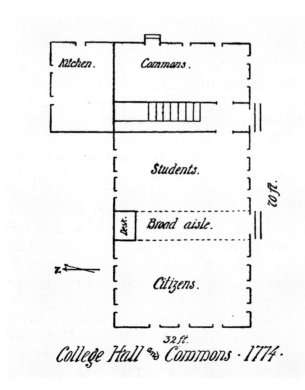

A re-created plan of the Commons Building that was erected in 1771. Within several years, the building was expanded with a kitchen and commons room addition on the north side, as seen here.

PLAN OF THE FIRST COLLEGE HALL.

A re-created plan of the first floor of the two-story College Hall building that was erected in 1771. It is believed that the second floor was a repeat of the first floor's plan.

It seems that Major Sympson, the Portsmouth sheriff, believed that his magnificence had been slighted at the first commencement exercise the year before by both the Governor, who was in attendance, and people at the College. For a number of years, Payne freely and indiscriminately dispensed liquor to Wheelock's students, both White and Native, and he even sold liquor to Wheelock's sons, despite pleas from College President Wheelock. Even Governor John Wentworth was powerless in preventing Payne's license from being renewed. Payne continued to run the establishment until he sold the premises in 1796; at which time, it ceased being a tavern. It should be noted that Payne's Inn was not the only location where students could readily acquire spirits. Much to Wheelock's alarm, but beyond his control, located immediately across the River at the ferry landing was a tavern owned by John Sergeant. Also, the tavern of Charles Hill was also located about three miles south of the village, near West Lebanon, on the New Hampshire side of the river, at the lower falls.

The college continued to expand through 1773, and the first building of real substantial presence was erected on the fledgling campus. That year, fourteen housewrights and carpenters from Connecticut constructed a wood-framed two-story home for Wheelock and his family, located on the present-day site of Reed Hall. The architecture of the building, with its gambrel roof, was of pure Connecticut Georgian design. The building was large enough that it was able to house a number of students in the third-floor garret under the gambrel roof. In 1838, the house was moved to 4 West Wheelock Street, where it remains to this day—the only remaining structure from the earliest days of the college. By the end of 1773, ninety students were on hand, about seventeen of whom were Native, and between thirty and forty laborers were working in the kitchen, washhouse, mills and fields. An additional 200 acres of land had been opened up.

Twenty acres were planted in English grain and white clover hayseed, and acreage along Mink Brook had been fenced and pastured. In all, more then 320 acres had by then been cleared, including about 15 acres in the present-day area of Webster Avenue and Occum Pond at "great expense but very good soil." The fall harvest included thirty tons of hay cut, 20 acres of grain and 20 acres of corn. The College then owned seven yoke of oxen and twenty head of cattle. In spite of this achievement, it was still necessary to purchase one hundred bushels of wheat from Colonel Bellows downriver in Walpole, New Hampshire.

The year 1774 continued with 160 acres being cleared. As a result, the cleared area around the college and the village included more then 500 acres. Another good harvest followed, with 300 bushels of wheat, 250 bushels of Indian corn and 60 tons of cut hay. For the first time, it was no longer necessary to purchase hay from farms located more than 40 miles downriver. The following year, additional land was cleared to provide pasturage for two hundred head of cattle.

As has been previously noted, no sooner had Wheelock and his family arrived in Hanover and commenced to establish the College that he acquired additional property. Wheelock and his family soon came to control almost all of the land that surrounded the college located on the former governor's five-hundred-acre lot, with the exception of John Payne's tavern. To the immediate south was land in Lebanon that had been gifted to the College by the proprietors of that town, and to the west was the Connecticut River. Wheelock was quick to work with the trustees to relocate the division lines between the college- and Wheelock-owned lands. By the time of Wheelock's death in April 1779, by gift and by purchase, the Wheelock family owned about seven hundred acres that entirely enclosed what remained of the initial college-owned former five-hundred-acre governor's lot. These lands were parceled out to his two resident daughters as farms, one hundred acres each, and his four sons, two hundred acres each. Each adjoined the others as follows: Abigail Wheelock Ripley, the land between the river and present-day Rope Ferry Road; Mary Wheelock Woodward, the land between present-day Rope Ferry Road and Lyme Road; Eleazar Wheelock Jr., the land between present-day Lyme Road and East Wheelock Street; John Wheelock, the land between present-day East Wheelock and Lebanon Streets; James Wheelock, the land between present-day South Main and Lebanon Streets; and Ralph Wheelock, the lands along Mink Brook and South Main Street. Needless to say, these six families represented, in no small part, the aggregate wealth and influence of the community.

THE VILLAGE AT THE COLLEGE

As soon as Jonathan Freeman provided Eleazar Wheelock and the Trustees with a layout of the combined College and village area, Wheelock and the Trustees set about creating a village to support the College. Two acres each were offered to a steward of the college, an "approved physician," and an inn holder, and one-acre each was offered to a "taylor" and a shoemaker. And it was agreed that Wheelock's son-in-law tutor and first college librarian Bezaleel Woodward would receive one acre "to accommodate his building place." The remaining eleven acres were for "other suitable settlers, to be disposed of at the discretion of the president."

Mr. Woodward's parcel was located on North College Street, at about the present-day eastern entrance of Baker Library. Wheelock's young bookkeeper and agent Aaron Storrs had been accepted as the innholder

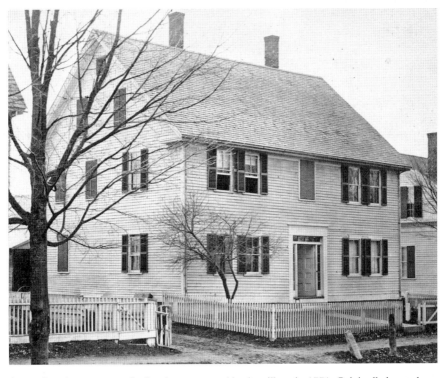

Aaron Storr's tavern was the first house erected in the village in 1771. Originally located on the southwestern corner of West Wheelock and South Main Streets, the house was moved down West Wheelock Street in 1823, and it was razed 1974 after becoming heavily altered and falling into disrepair. *Courtesy of Dartmouth College.*

and received a choice two-acre lot located at the intersection of present-day West Wheelock and South Main Streets. During 1771, each of these men constructed two-story wood-framed houses at these locations, the first such buildings in the village. On the request of Reverend Wheelock to the court of quarter sessions in Portsmouth, a tavern license was issued to Mr. Storrs that September.

The "approved physician" was Wheelock's friend and companion Dr. John Crane, who had come to Hanover with Wheelock the previous August. He was given a one-acre lot in the middle of the south side of the Green in 1773. The following year, he erected a two-story wood-framed house, similar to the Woodward and Storrs dwellings, there. Wheelock's nephew Joshua Hendee, who came from Connecticut in late 1770, was a shoemaker and tanner who, in 1772, received a lot and built a house on the south side of present-day Lebanon Street. Jabez Bingham, also a relative of Wheelock's, was an animal husbandman from Connecticut who, in 1774, received a one-acre lot at the northwestern corner of present-day South Main and Lebanon Streets.

The building trades were vitally important to the success of the new community; therefore, in 1774, a one-acre lot was given to Comfort Sever, a carpenter, and a half-acre lot was given to William Winton, a mason. Both of these lots were located beside each other on the west side of the Green—the first such lots to be developed. In 1778, Barnabas Perkins, a shop joiner, was given a one-acre lot "on the road to Lebanon"—present-day South Main Street. In 1778, Charles Sexton, a blacksmith, was given a one-acre lot beside Perkins. Other lots near the Green went to Samuel McClure, a barber, who was given a half-acre parcel on the west side "north of the road to the ferry" (present-day West Wheelock Street) in 1776; a one-acre lot on the north side of the Green went to Reverend Sylvanus Ripley, one of Wheelock's sons-in-law and a tutor at the college, in 1777. Along what is now South Main Street, Reverend John Smith, a tutor and pastor at the college church, in 1777, received a one-acre parcel on the west side of the street, at the present-day location of the municipal building. Across the street, immediately to the north of Jabez Bingham's lot, Alden Spooner, a printer, was given a half-acre lot.

As Eleazar Wheelock was nearing the end of his life and needing to unburden himself from many of the important details of college life, it was decided to bring Captain Ebenezer Brewster up from Preston, Connecticut, to be the college steward. For many years, the related concerns of the kitchen and husbandry had long been a source of considerable and never-ending

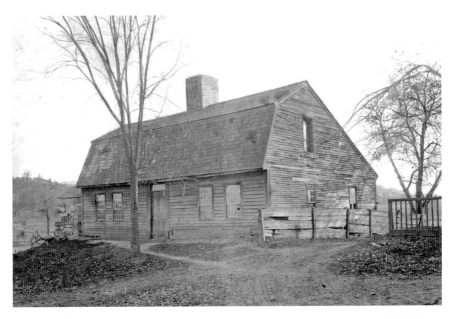

Unfortunately, little is known about this handsome early cape-style house other than it was probably erected around 1773. The architecture is purely from lower Connecticut, and the building was situated on the edge of the village on the south side of Lebanon Street, at the corner of the future Sanborn Road. The building was razed in the late nineteenth century, about the time that Sanborn Road was opened. *Courtesy of Dartmouth College.*

annoyance. Brewster was given a six-year contract and broad authority to deal with this important function of college life. In late 1778, he was granted the choice half-acre corner lot across from Aaron Storr's tavern. On this lot, he erected a two-story wood-framed house, very similar to Dr. Crane's house beside him and the Storr's tavern across the street. Today, this is the location of the Hanover Inn. Brewster also received an additional half-acre lot beyond the western side of the Green, behind the McClure lot, apparently as a garden plot. Within two or three years, Brewster, while he was still the college steward, received a license from provincial authorities to turn his home into a tavern, much to the surprise and displeasure of college officials. Brewster fulfilled the terms of his contract as college steward and continued running a tavern at this location until the house was moved away and a new brick hotel building was erected on the site in 1813.

The 1770s witnessed not only the successful founding of Dartmouth College in Hanover, but also the creation of a village to support the college. Beginning April 1775, the remaining half of the decade became wracked with violent revolution as the United States of America fought for its

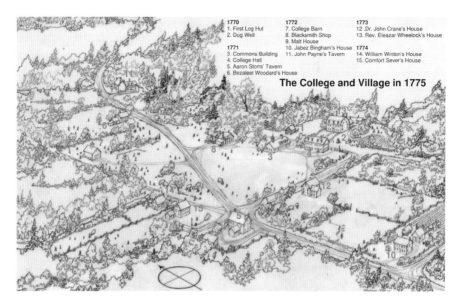

The College and Village in 1775

1770	1772	1773
1. First Log Hut	7. College Barn	12 .Dr. John Crane's House
2. Dug Well	8. Blacksmith Shop	13. Rev. Eleazar Wheelock's House
	9. Malt House	
1771	10. Jabez Bingham's House	1774
3. Commons Building	11. John Payne's Tavern	14. William Winton's House
4. College Hall		15. Comfort Sever's House
5. Aaron Storrs' Tavern		
6. Bezaleel Woodard's House		

A sketch made in the 1960s of the village and campus as it probably looked in 1775. This is believed to be an accurate depiction.

independence from Great Britain. This was a great strain on the young college that could have easily brought ruin to the fledgling institution. Miraculously, however, it did not, and both the College and village survived, although its initial period of growth was suspended. In three years, from its founding in 1770, the population of Hanover increased from 20 families to 70, comprising about 90 students and 342 souls. Of these families, about a dozen dwelt in what became referred to early on as the "College District"; the rest were scattered throughout the still very rural remainder of the town. Ten years later, at the end of a long and brutal war, the "College District" counted 25 heads of families. Of the 90 students in 1773, about 60 were independent-paying scholars, which provided necessary cash not only for the collage, but also for the small village community of which the College was an integral part. As best as we can tell, by the end of this first decade, about twenty permanent dwellings had been built in or around the rough frontier-looking campus and village area, complementing a small handful of college buildings. Beyond the village, in "Sleepy Hollow," off Lebanon Street at Sand Hill, there were several small mills powered by the flowing waters of Mink Brook, and two or three small dwellings had been erected. The new college and village had taken hold.

THE TOWN OF DRESDEN AND THE WESTERN REBELLION

At the time that the decision was made to locate the College in Hanover, in 1770, a condition was made by Royal Governor John Wentworth, with the consent of the Trustees, that the towns of Hanover and Lebanon would agree to and petition the legislature: "that a contiguous tract of at least three miles square, in and adjoining these aforesaid towns of Hanover and Lebanon, be set off and incorporated into a separate and distinct parish, under the immediate jurisdiction of the aforesaid Dartmouth College." The reasoning was that this gave "the power of the college to keep out bad inhabitants, prevent licentiousness, regulate taverns and retailers of strong liquor, prevent the corruption of students by evil-minded persons, encourage and support religious ordinances, etc." The formation of this separate "parish," as envisioned and repeatedly attempted by Governor Wentworth and Reverend Wheelock, was not to happen. In 1771, both Hanover and Lebanon approved the formation of the new district, but the Legislature in Portsmouth did not. During the next two years, approval of the college district failed to make it through the Legislature twice, and by this time, Governor John Wentworth was having great difficulties with an increasingly hostile legislature on many fronts. By 1774, things had become so strained that a revolutionary second extralegal legislative body was formed in Exeter, at first calling itself the "Provincial Congress" and, later, the "Exeter Party." With the formation or the Exeter Party, it seemed that any hope of creating a separate College District had died—but that was not to be.

Following the events at Lexington and Concord in April 1775 was the collapse of New Hampshire's government, which was loyal to King George III. By midsummer, amid political chaos, to save his life, Royal Governor John Wentworth fled Portsmouth for Nova Scotia, and the Exeter Party immediately filled the political vacuum. With nothing to go on as a model, they asked the Continental Congress, then gathered in Philadelphia, for guidance in establishing a new state constitution. The reply said that Congress was busy handling rapidly unfolding events that were pertinent to the growing rebellion with Great Britain and that New Hampshire was going to have to work things out for itself.

By November 1775, the Exeter Party had drafted a new state constitution; however, of the total of eighty-nine proposed legislative seats, only six went to towns in Grafton County, and of those, only one seat was assigned to

Hanover, Lebanon, Grafton, Orange and Enfield. In response to this perceived outrage, which the Exeter Party chose not to address, around January 1776, Bezaleel Woodward, his brother-in-law John Wheelock of Hanover and Elisha Payne of Lebanon formed what they chose to call the "College Party" and began beckoning other New Hampshire towns within the Upper Connecticut River Valley to join the cause of greater legislative representation. That July, eleven towns met in Hanover, at the College, and for all intents and purposes declared their independence from the Exeter Party. As "clerk of the United Committees" Bezaleel Woodward was clearly in charge of the new party and its growing rebellion, and at the center of it all was Dartmouth College.

Across the river, within the Green Mountains, rebellion had been slowly building following the July 1764 decision by King George III that all lands west of the Connecticut River were, in fact, part of New York, and not New Hampshire. Heavy handedness by New York officials concerning the matter of taxation and land titles with new settlers was coming to a boiling point, led by Ethan Allen and his Green Mountain Boys in Bennington. In time, they came to call themselves the "Bennington Party" and were starting to take notice of the College Party and their grievances. By September 1776, in Hanover, Lebanon, Hartford and Norwich, the first mentions of a new state to be called "New Connecticut," with is capitol located at the "College District," could be heard. By early 1777, the College Party had detached about forty towns from western New Hampshire and were headed toward forming a new state. In June, the United Committees met at Aaron Storrs's tavern and issued their final ultimation to the Exeter Party concerning state governance: at least one representative per town, locating the capital near the center of the state and immediately convening an assembly for establishing a permanent plan of government. The Exeter Party chose not to act. By this time, on July 2, 1777, in Windsor, in large part due to the ongoing actions of Ethan Allen and his brothers, the new Republic of Vermont was born. Through 1778, the Bennington and College Parties continued to flirt with each other in a somewhat nuanced and complicated dance; however, in time, Vermont came to realize that its political grievances and objectives were of very different origins from those of the western New Hampshire towns, and Vermont continued to go its own way, although a series of complicated moves and countermoves did continue for a time.

As the rebellion in the Connecticut River Valley grew, despite the uncertainty of events in Vermont, the idea of the newly formed state of New Connecticut continued to take hold. And increasingly, Dartmouth

College was eyed as the new capital, in part because of its central location in the river valley, but also because it was the most populous village in the area, and it had the educational, literary and business talent to support the proposed new enterprise. On February 19, 1778, what had informally been referred to in the past as the College District was incorporated into the Town of Dartmouth. This was, however, short-lived, as it was pointed out that there was already a town named Dartmouth in the White Mountains of northern New Hampshire (the present-day Town of Jefferson). Therefore, at a meeting of college and village citizens, the name Dresden was substituted. At the regularly scheduled annual town meeting on March 10, the Town of Hanover was served with an official announcement, signed by Aaron Storrs as moderator, of the creation of the new and independent Town of Dresden: "taking in all of that part of your town, which you gave your consent to have taken at your meeting in March, 1774." This was the proposed College District that the New Hampshire Legislature had never approved. The parting was amicable, and both municipal bodies—Hanover and Dresden—easily sorted out their related affairs. The boundary lines separating the two towns were carefully made and recorded. Lebanon fulfilled its earlier commitment of creating a College District and included adjacent land that also became part of the new town. The total land area of the new town was 5,760 acres, of which, over 4,000 acres were owned by Dartmouth College and the Wheelock family (in both Hanover and Lebanon). The amount of land in Hanover that went to create Dresden was about 3,000 acres. The remaining land from Lebanon was about 2,760 acres.

In the years that followed, both Storrs's and Payne's taverns were the center of much political action. After Captain Ebenezer Brewster opened his home as a tavern and he increasingly became more involved in regional political affairs, his tavern also became the center of political debate and action.

Political rebellions can be risky business, and so it was for New Connecticut's rebellion from New Hampshire and Vermont's rebellion from New York. The various political parties that represented these competing interests—the New York, Bennington, College and Exeter Parties—where all attempting to make their cases before the Continental Congress. Congress, in trying to manage the war with Great Britain, remained annoyed by what was being termed the "Western Rebellion" but could do little else, and for a time, chose not to. Finally, following General Washington's October 1781 victory at Yorktown and the prospect of a coming peace, Congress

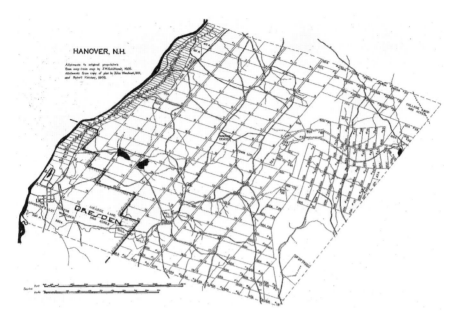

A lotting map of the entire town, showing the area that broke off and became the separate Town of Dresden, which existed from 1778 to 1784.

threatened to send Washington and some of his battle-hardened troops into western New England and settle the matter—by force if necessary. Congress made it clear that the rebellion must stop, and toward that end, it proposed splitting the newly conceived Republic of Vermont down the spine of the Green Mountains: the western half to New York and the eastern half to New Hampshire. Before that happened, Vermont settled—at least for the time being—its differences with New York, such that Vermont went its own independent way and relinquished any claim to lands east of the Connecticut River. In March 1791, Vermont joined the Union as the fourteenth state. For the College Party, New Connecticut and the Town of Dresden, it was a bitter end of new statehood. In March 1782, a meeting was held at Brewster's Tavern. There, fifteen articles as measures "relative to the settlement of animosities" was drafted, and a committee was named for applying for readmission of the seceding towns was formed. During its presentation, the Exeter Party made it clear that anything less than unconditional submission would not be accepted.

Although the College Party, New Connecticut and Dresden all came to a quiet and anticlimactic end, in the final analysis, Bezaleel Woodward, John Wheelock and their conspirators achieved their goals. In June 1784, a new

state constitution was adopted, with the provision that every town with 150 voters was entitled to one representative in the house of representatives, plus an additional representative for every 300 voters above that number. And towns with fewer than 150 voters were grouped together for representation. And it was agreed that, in time, a new, more centrally located state capital would be established. In 1808, the state's government was moved from the seacoast to Concord. Interestingly, the new constitution also contained language stating that no "president, professor, or instructor of any college… shall at the same time have a seat in the senate or house of representatives, or council." This was obviously a punishment meted out to Dartmouth College for having been in the forefront of the short-lived but intense-while-it-lasted Western Rebellion.

The idea of a separate College District did not fully die with Dresden at first. At a town meeting held on September 6, 1784, the idea resurfaced and was received favorably, but nothing more came of it. Again, on November 12, 1792, a second attempt was made; however, it, too, withered to nothing. It would not be until October 29, 1855, that the Village Precinct of Hanover, New Hampshire, was organized, as per state law, for the purposes of better fire protection, maintenance and improvement of streets, schools and tree planting. With occasional changes from time to time, the village precinct remained in place until 1963, when the town and precinct were merged back into one.

One question remains: how did the name Dresden come to be, and who was responsible for it? We will never know for sure the answer to this riddle, but there are several theories. The name Dresden, like the German city, is believed to be of ancient Sorbian or Slavic origins—Sorbian: *drezg* ("a forest"), and Slavic: *drezd'any* ("alluvial forest dwellers"). However, there were no residents of German descent in the Upper Connecticut River Valley at that time, and the name Hanover was taken from a small church parish named "Hannover," located in Norwich, Connecticut, that well predated the first Hanoverian English king crowned in 1714. The probable explanation goes to either Bezaleel Woodward or John Smith. Woodard was a brilliant Dartmouth College professor and a man of many interests with a deep interest in geography. Smith, also a Dartmouth professor and a graduate in the class of 1773, had extraordinary linguist abilities and spoke Latin, Greek, Hebrew, Arabic, Samaritan, Chaldaic and a handful of Asian languages.

Within the Upper Connecticut River Valley, the name Dresden did not entirely die as the last embers of the Western Rebellion cooled and

eventually ceased to flicker. In November 1963, the United States Congress passed legislation allowing for the formation of the first interstate school district in the country between Hanover, New Hampshire, and Norwich, Vermont. Shortly before his assignation, President John F. Kennedy signed this legislation into law. At that time, William W. Ballard, a biology professor at Dartmouth and member of the Norwich School Board, appropriately suggested the name Dresden School District. And so it remains to this day.

3

THE COLLEGE ON THE HILL

1780–1865

DARTMOUTH COLLEGE

Dartmouth College continued to function during the war for American independence from Great Britain; however, its finances, greatly dependent on English support and money held by the English Trustees in London banks, was obviously imperiled, even if the college played no direct role in the armed conflict. Eleazar Wheelock also died in Hanover in April 1779, during the middle years of the war. Nonetheless, following the signing of peace agreements between the United States and Great Britain in Paris in 1783, the college was again able to look ahead. During this time, the college and Hanover had settled their differences with the State of New Hampshire.

By this time, the only college building of any real permanence was Eleazar Wheelock's house, located on a slight hill on the east side of the Green, at the site of present-day Reed Hall. The Commons and College Hall buildings had been hastily constructed and were, by then, showing signs of age and deterioration. The overall physical layout of the college and village, as envisioned and laid out by Jonathan Freeman and Eleazar Wheelock in 1771, remained intact and in favor. As a result, in the coming years, the college increasingly became located along the eastern side of the Green, although that space remained an unsightly expanse of crudely cleared stumps that drained toward the Commons and College Hall buildings.

As early as 1775, Wheelock had envisioned a large permanent college hall building being erected alongside his house; however, that remained on hold until it was again taken up by the Trustees in March 1784. There were, by then, no longer any English Trustees. They agreed that £2,000 should be spent to construct a new building for the accommodation of students on the place envisioned by Wheelock: on the "eminence east of the College Green, of brick three or four-stories in height, and long enough for six rooms on each side, with ample hallways." John Wheelock had assumed the presidency of the college after the death of his father and was part of the committee to oversee the planning and construction of this sizable and important undertaking.

It quickly became apparent that the cost of brick construction was not going to be possible. Therefore, realizing that a considerable amount of lumber was going to be necessary to construct a building of wood-framed construction, a new sawmill was erected on college-owned land on Mink Brook, off of present-day Greensboro Road and Hollenbeck Lane. The sawmill was in operation during the summer of 1784, and the cellar for the new building had been dug and foundation stone procured. Colonel Elisha Payne was designated as the "contractor" on behalf of the Trustees. The heavy timber frame for the new 52-foot-by-175-foot three-story building, reputedly the largest of its kind in New England, was finished in 1786. It took ten days to raise and required a large body of workers who were recruited from far and near. The massive hand-hewn timbers, mostly of white pine cut from the immediate area, used pieces as large as 15 inches square, 50-foot-long roof chords and longitudinal sills and plates that were as long as 75 feet. The raising of the completed frame was an awe-inspiring feat and a sight to behold. The master carpenter was John Sprague, and the workmanship was superb. The overall design of the building was modeled after Nassau Hall at Princeton.

By commencement, September 1787, the building frame was enclosed; and by 1791, after seven years of hard labor and financial sacrifice and anxiety, the building, then known as "the College," was finished at last. Nearly forty years later, it became known as Dartmouth Hall. In spite of numerous inefficiencies, for more than one-hundred years, the drafty old building was the heart and soul of Dartmouth College. But the building burned to the ground in a fire that originated in the roof, under the cupola, during the frigid and snowy morning of February 18, 1904. A near copy of the old building, this time, in brick masonry, was erected and dedicated two years to the day after the loss of the original Dartmouth Hall.

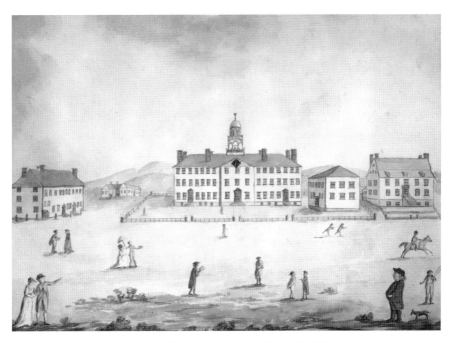

Believed to be the earliest image of the Dartmouth College, this 1803 watercolor drawing by eleven-year-old George Ticknor shows (*left to right*) Commons Hall (1791), John Wheelock's house (1786), Dartmouth Hall (1791), the college chapel (1790) and Eleazar Wheelock's house (1773). Ticknor took the liberty of showing the Green in a more presentable way than it really was at the time. *Courtesy of Dartmouth College.*

As Dartmouth Hall was nearing its completion in 1791, the Trustees took note that both of the original 1771 college buildings were in a ruinous state, in part, because means of repair had long been wanting. The Trustees voted, in August, to build a new chapel if certain arrangements could be made. However, students soon forced the issue by tearing down the old Commons Building during a "nocturnal visitation" around January 1, 1790. By March 1790, the construction of a new chapel had been contracted for at a cost of £300. The new single-story building measured fifty feet by thirty-six feet and was about twenty feet tall to the eaves, and it was completed in about five months. A hipped roof provided for a pleasing arched ceiling within. The new facility was situated at about the present-day site of Thornton Hall. It was razed to make way for that building's construction in 1828. Following the construction of the new chapel in 1791, a new Commons Hall building was constructed, located north of Dartmouth Hall, at about the site of present-day Rollins Chapel. Between these two buildings, to

the east and up on the hillside a bit, in 1786, President John Wheelock had constructed a residence for himself. Unfortunately, little is known about the Commons Hall and John Wheelock's house. Nonetheless, as the nineteenth century dawned, it can be said that the Dartmouth College campus contained four buildings: Eleazar Wheelock's "mansion" (1773), the chapel (1790), Dartmouth Hall (1791) and Commons Hall (1791). The original log hut, the first building constructed during the first summer, survived into 1780s before succumbing to rot and subsequently being torn down. And as noted previously, the two buildings that were erected in 1771 had, by then, also been razed.

MOOR'S INDIAN CHARITY SCHOOL

Moor's Indian Charity School, founded in Lebanon, Connecticut, by Wheelock in 1754 was the seed that, by 1769, had become Dartmouth College. But with the founding of the new college, and its settlement in Hanover, the former school did not dissolve or otherwise close. Instead, it also moved to Hanover, where, for a time, it was part of a complicated relationship that possibly helped assure the larger institution's survival in the early and very uncertain years on the Hanover Plain.

In 1791, as the completion of Dartmouth Hall neared and the old College Hall building was razed, a new academy building was constructed on the west side of the Green, at a site immediately north and beside the present-day site of Parkhurst Hall. The purpose of the new building was to house "Moor's School," as it had, by then, come to be referred to. The new building was probably just a simple wood-framed structure, but little else is known of the building. Regardless, for the next forty or more years, there was much controversy associated with the school and the role that it tried, or was otherwise expected, to play. This eventually led to both legal and legislative attention, and in 1834, it was directed that the school was to be reopened. Three years later, the old building was moved away, and a new "academy" building was erected in its place.

Ammi Burnham Young (1798–1874) was an American architect of considerable talent born in Lebanon, New Hampshire. He was to leave a significant imprint on the early-built environment of Dartmouth College. Ammi's father, Samuel Young, was a highly regarded builder in Lebanon, and from him, Ammi received important training in the trades before

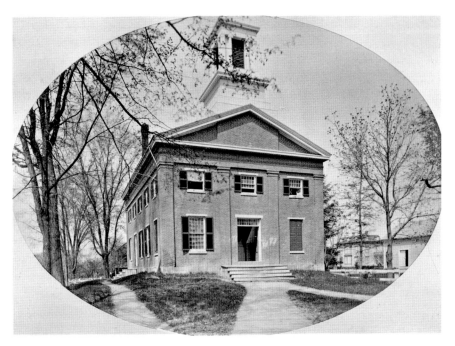

The Academy, designed by Ammi B. Young, was constructed in 1837 for Moor's Indian Charity School and was located on North Main Street. The building was a masterpiece of beautifully proportioned Greek Revival–style architecture, and it shared similarities with Reed Hall, which was designed a year later by Young and is also a masterpiece of architectural design. *Courtesy of Dartmouth College.*

working in the Boston office of a noted architect of the day, Alexander Parris. Before establishing his own office in Burlington, Vermont, in 1830, Ammi was commissioned, in 1828, to designed Wentworth and Thornton Halls. Both were designed as dormitories and were constructed the following year at an expense of $12,000. In 1837, Young was again commissioned to design the new academy building that was to house Moor's school.

The building was constructed that year for about $3,500, and in all respects, it was a masterful application of the Greek Revival style of architecture that was then very popular in much of North America. This building clearly shows Young's maturation as an architect. He was in full command of proportioning and detailing, which, a year later, he would again demonstrate on the Dartmouth campus with the design of Reed Hall, another architectural masterpiece. Ammi's brother Ira Young was, for many years, a highly regarded professor of natural philosophy at the College, and Ammi's last building at Dartmouth was

the Shattuck Observatory, constructed in 1852. This astronomy facility is a very unique piece that also speaks to Young's evolved and diverse talents as an architect.

Of the new academy building, John King Lord later wrote:

> *The cost of the building…was greater than afterward seemed expedient, as it was not sufficiently understood how nearly impossible it was that such a school could be supported without large funds under the shadow of a college, where the expense to other then [sic] boys from the vicinity must necessarily exceed what was usual in the other neighboring academies. [Dartmouth College] President Lord attempted to secure Indian pupils, visiting St. Francis and Lorette, near Quebec, for that purpose with but little success, and after twelve years of financial loss, the school was suspended in 1849.*

As will be discussed further within the pages of this book, the building continued to be used by the college, and on two occasions, it was extensively remodeled. A large addition was constructed on the rear of the building before it was finally razed in 1937. As for Ammi Burnham Young, he also designed the original Vermont State House, built between 1833 and 1838, that partially burned later. The year that he designed the Academy Building, he also designed the Boston Customs House, another architectural masterpiece of Greek Revival design. He then went on to become the supervising architect of the United States Treasury.

DARTMOUTH MEDICAL SCHOOL

The Dartmouth Medical School, today the Geisel School of Medicine, was the fourth medical college established in the United States, following the University of Pennsylvania School of Medicine, founded in 1765; the Medical School of King's College (now Columbia University) in 1767; and Harvard Medical School in 1782. Founded in 1797 by Dr. Nathan Smith (1762–1829), Dartmouth's Medical School came at a time of increasing enrollment and, at long last, some amount of prosperity. From a low of 30 total students enrolled in 1780, the student population had gradually increased to 160 by 1790. In 1791, Dartmouth had 49 students, compared to 27 each at Yale, Princeton and Harvard. The

totals for ten years gave Dartmouth 363 graduates; Yale, 295; Harvard, 394; and Princeton, 240.

Dr. Nathan Smith was from Massachusetts, a graduate of Harvard Medical School and the University of Edinburgh Medical School. He then settled in Cornish, New Hampshire, where he established a successful medical practice. Smith became concerned about the lack of medical professionals in the rural Upper Connecticut River Valley area, and as a result, he petitioned the Board of Trustees of Dartmouth College in August 1796 to fund the establishment of a medical school to train more physicians for the region. Though Dartmouth College was still financially strapped, the board approved the request, and Smith began lecturing on November 22, 1797. For much of its early life, the school consisted only of Nathan Smith and a small class of students, operating in borrowed space in the north end of Dartmouth Hall. Smith's students were educated as apprentices, and received bachelor of medicine degrees on graduation. Like Dartmouth College, the medical school had continual funding shortages. As time passed, however, the popularity of both the medical instruction and the basic sciences taught at the school drew undergraduates and training physicians alike. Smith acted as the sole administrator and instructor of the medical school until 1810, when a second faculty member was hired. Smith also revamped the curriculum, allowing the school to begin offering the doctor of medicine (MD) degree in 1812. Smith ultimately left Dartmouth in 1816, founding three additional schools of medicine at Yale University, Bowdoin College and the University of Vermont.

Based on the school's success, in 1809, Smith petitioned the New Hampshire legislature for funds to construct a standalone building for expanded medical education. The legislature obliged and appropriated $3,450 for the construction of such a facility in Hanover on the condition that Smith would convey to the State a half-acre of land near Dartmouth College and that he would donate all of his personal anatomical museum and chemical apparatus to the school.

Dr. Smith met these conditions and then some. He conveyed an acre of land on the western side of what became known as Observatory Hill next to North College Street, as well as his part of the museum and apparatus worth in excess of $1,500. For its part, the State of New Hampshire erected a substantial three-story brick building that measured thirty-two feet by seventy-five feet. When completed in 1811, the building was $1,217.14 over budget, and Dr. Smith sought to have the legislature reimburse him the money that he had personally advanced to complete the facility. After

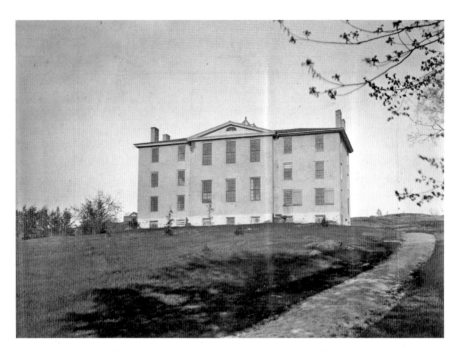

The Dartmouth Medical School, established in 1797, erected this first building in 1809 with a $3,450 appropriation from the New Hampshire state legislature. Located on the west side of the College Park, overlooking North College Street, the building's total cost when completed came to $1,217.14 over budget. *Courtesy of Dartmouth College.*

much wrangling and debate, in 1817, the legislature finally appropriated an additional $1,449.55; however, by 1813, Dr. Smith had resigned his professorship and moved to New Haven, Connecticut, where he established the medial school at Yale. He also established a medical school at Bowdoin College and helped start the University of Vermont's school of medicine. Smith's first lectures to Dartmouth students took place in 1797, and for Smith's sixteen years at the college, Oliver Wendell Holmes wrote: "[Smith] was not a chair but a whole settee of professorships."

THE CHURCH OF CHRIST AT DARTMOUTH COLLEGE

The Reverend Dr. Eleazar Wheelock's intimate affiliation with the Congregational Church, by far the most common religious denomination in New England and the basis of the region's settlement, prompted him

to organize a church soon after establishing Dartmouth College on the Hanover Plain. Thus, on January 23, 1771, he named and gathered the Church of Christ at Dartmouth College. This was not the first attempt to organize a church in Hanover. As early as 1766, the second year of the area's settlement, Hanover's proprietors imposed a tax of six shillings for the support of preaching. By 1771, the town had assumed support of the church, and by 1774, a meetinghouse in Hanover Center (no longer extant) had been erected and was in use.

From the start, and for many years thereafter, the Church of Christ at Dartmouth College was so closely connected with the college that it, in fact, became an integral part of it and remained fully separate and independent of the Congregational church in Hanover Center (three or more miles away and difficult to reach for college and village residents). For citizens within the vicinity of the college, the only available meeting place for church services was within the Commons Building, erected in 1771, which, for a time, proved satisfactory.

In March 1790, when the college decided to erect the aforementioned new chapel building, college president John Wheelock announced that half of the £300 cost of the new building was to be paid "by the inhabitants of this vicinity, who have covenanted relative thereto, conditioned that they be entitled to the use of one half of it until they be reimbursed agreeably to obligation given by the president." Indeed, within the "citizens'" southern half of the building, there were twenty-eight box pews for "inhabitants of this vicinity." This proved to be an unsatisfactory stopgap measure. The building soon proved to be too small for joint use by the college and the citizens of the rapidly growing village, especially during the college's commencement days. However, the financial condition of the collage did not allow it to erect a larger facility, although it wanted to purchase the interests in the present chapel building held by the villagers. Hence, a movement was started among the citizens to build a new meetinghouse.

College President John Wheelock urged that the new meetinghouse be made large enough that it could accommodate the college as well as the village, including the requirements of commencement days. Toward that end, he gave verbal assurances that, as soon as the college was able, the Trustees would reimburse the Proprietors a part of the expense of the building, and, in the short term, they would pay for the use of it by the College.

The first organizational meeting concerning the new facility was held in February 1794 at General Ebenezer Brewster's tavern. During the recent war for independence, Captain Brewster had become a general and was

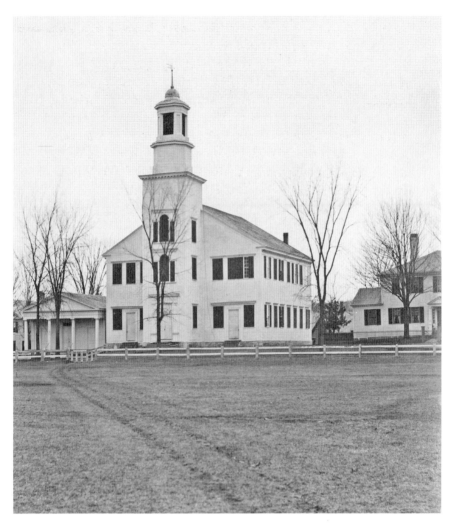

The completion in 1795 of the First Church of Christ at Dartmouth College, near the intersection of Wentworth and North Main Streets, greatly helped define the north side of the Green, just as Dartmouth Hall had done on the east side. In 1841, the vestry building was added on the left side. It was called the "calf and cow" by some of the village wags. *Courtesy of Dartmouth College.*

very active in village and regional affairs. Shortly thereafter, a committee proposed, and it was voted affirmatively that:

> *A meeting house be erected in said vicinity of sixty six by sixty feet on the ground, with thirty feet posts with a balcony at one end of about fifteen feet square, containing two staircases for passage to the galleries—the balcony to be about fifty feet to the floor of the steeple and the steeple about the same height above said floor—the house to contain fifty-seven windows—the windows in general to contain twenty-eight squares of ten-by-eight glass—three windows to be large and crowned and four round—the floor to contain about sixty-six pews as near 7½ by 5¼ feet as convenience will admit—the pulpit to be at the end opposite the balcony.*

Additional recommendations were made and decided on as to the sale of pews, workmanship of the building and a time period within which it was to be constructed. The site chosen was a lot owned by village merchant Richard Lang, located on the north side of the College Green, beside the College Barn. Lange was paid fifty pounds for the land. George Foot, who owned an adjacent lot to the east added some land as a gift to enlarge the church lot. An attempt was made to secure the "red house, the land and barn," that occupied the corner lot that, in time, would become the site of a small vestry building. This was the site of the so-called College Barn, and it would not be until 1841 that the church was able to acquire this adjacent property.

The construction of the new building began in the spring of 1795, and it was pushed rapidly forward such that on Sunday, December 13, 1795, the new facility was occupied and dedicated. The final cost stood at $5,000, which was more than the amount of money raised from the sale of pews. Therefore, the proprietors assessed themselves in proportion to their existing holdings and were able to retire the remaining debt by the time that the facility was completed.

The new church made for a commanding presence on the College Green, and it greatly helped further define and organize that important central space. Architecturally, the building unabashedly showed its Connecticut roots and was a good example of a meetinghouse of that day and age. Inside, a balcony extended across the south end of the building, and long galleries extended along the whole east and west sides of the space. Over the pulpit at the northern end was a sounding board. Soon enough, the building came to be extensively used and beloved by the college and the community at large.

The Green

As previously noted, when Reverend Dr. Eleazar Wheelock and others first arrived in Hanover in August 1770 to establish the college, the area that, in time, became the Dartmouth College Green was a dense virgin forest of white pine trees reaching as high as 270.0 feet and almost completely blocking any appreciable amounts of sunlight from reaching the ground. That fall, the first trees were cut and left where they fell, making a primitive and undefined clearing in the wilderness. The following spring, Hanover resident and land surveyor Jonathan Freeman laid out what would become the newly founded college and village with its central feature, the Green, a square of open space comprising about 7.5 acres.

For the next sixty years, although the college and village began to fill out around this space and provide it with definition, the Green remained riddled with stumps, was unkempt and ragged, with the main road running north out of the village cutting diagonally across it. The land had a downward slope to its southeastern corner and a swampy area that drained away in that direction. For a generation or more, it was a Dartmouth tradition for each graduating class to remove one stump. In 1807, the college trustees seriously considered utilizing the land for other uses and appointed a committee to study and "enquire into the propriety and expediency of taking up the present time any part of the College Green for the accommodation of the college." Thankfully, they thought it was better that it remain as originally envisioned by Freeman and Wheelock, and the following year, it was voted "that the executive authority procure it to be plowed, levelled, seeded and handsomely fenced, with walks and trees, if it could be done without expense to the college." However, due to the lack of funds to undertake such an expensive project, for another generation, the Green remained in its rough condition and a space for village cattle to graze, with the main road north to Lyme cutting diagonally cross it.

Finally, in 1836, largely through the efforts of Reverend Nathan Lord and Daniel Blaisdell, the Green came into its own, and the space that we today experience. Lord had become the college's new president in 1828 and would serve as such until 1863. Blaisdell had become the college treasurer in 1835 and served as such for the next forty years. With considerable effort and determination, these two men arranged for the College to pay one hundred dollars and for the balance of the expenses to be paid by subscriptions from citizens of the village and beyond. The work included eliminating the

diagonal road that had been there since the early 1770s and relying instead on the existing perimeter streets. Along this perimeter, they planned to erect a handsome fence of granite posts and heavy painted horizontal wood rails. The fence was intended to keep village livestock off of the space and did so until 1893, when it was removed save for one memorial section that survives to this day on the south side.

The building of the fence that, at long last, gave clear definition to this central space did not entirely put an end to roving village livestock, as the pasturage on the Green was claimed by some as a prescriptive right. As a result, differences between students and townsmen were not infrequent, and "cowhunting" was, for years, a favorite evening amusement among the students. Meanwhile, the space continued to be referred to as "the College Square," "the Common" and even "the Campus" until 1906, when the College Trustees voted to officially name the space "the College Green."

AROUND THE GREEN

When Jonathan Freeman, with, undoubtedly, impute from Eleazar Wheelock and others, laid out the village in 1771, with the Green as its central feature, it was envisioned that facing this space would be the college on the east side and residences on the other three sides. The southern space was to be the village, with additional residences, businesses and trades necessary to support the college.

The construction of Dartmouth Hall (1784–92) next to President Wheelock's house, erected in 1773, further established the location of the College on the low hill on the eastern side of the Green—as did the chapel in 1790 and the Academy and Commons Hall in 1791. However, the first substantial commercial activity occurred in the area at the northeastern area of the Green—not south of it on Main Street as initially planned.

The construction of these early college buildings brought many workmen to the Hanover Plain, and it was Colonel Arron Kinsman who was the first to take advantage of this by opening a store around the site of present-day Rollins Chapel. But it was Richard Lang from Salam, Massachusetts, who, in 1791, opened a store in a small two-story wood-framed building with a hipped roof on the site of present-day Webster Hall and Rauner Library. Lang was the village's first resident to engage in general merchandizing at a large and was highly successful scale. The building became known as

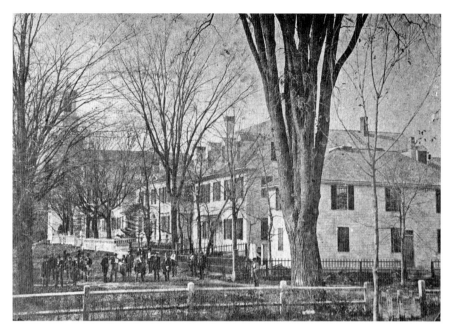

The earliest known photograph of Hanover, taken in 1854, looking west along Wentworth Street, shows village merchant Richard Lang's general store, which was known as Lang Hall. The store was erected in 1799 and was removed in 1865. Today, the site is occupied by Webster Hall and Rauner Library. *Courtesy of Dartmouth College.*

Lang Hall, and Lang used the building for retailing until 1820, when he moved his mercantile activities to Main Street. From 1830 to 1838, the building was a bookstore and print shop until it was converted into student rooms. In 1865, it was moved away.

It stands to reason that on the success of Lang's operation, which was located on the main road north out of the village toward Lyme, for a time, other commercial enterprises existed within this area of the Green. Until 1817, James S. Brown, a saddler, had a shop in his house that was located near the present-day east entrance of Baker Library, and during these early years, there existed other retail shops, a blacksmith shop and even a malthouse in this northeastern area of the growing campus. John Payne, who, in 1772, had opened an inn and tavern in his home situated just north of the present-day location of Wheeler Hall, sold the premises in 1796 and closed his operation that had been a source of concern to Eleazar Wheelock a generation earlier.

The first layout of lots around the Green, the acre of land fronting the north side, was given to Professor Reverend Sylvanus Ripley, Wheelock's

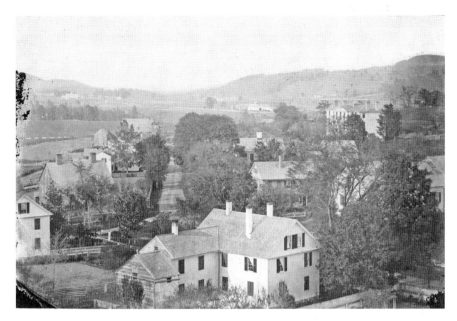

This image, looking east from the tower of the First Church of Christ at Dartmouth College circa 1865, shows the community of early buildings that were clustered along College Street and the Dartmouth Medical School facility in the distance. None of the buildings shown are still extant. *Courtesy of Dartmouth College.*

son-in-law who, in 1774, married Wheelock's daughter Abigail. Excluded was a small parcel at the northwestern corner on which the college's barn was located. Ripley had erected a splendid two-story hipped-roof house in 1786; however, he died early the following year, prior to its full completion. The residence was owned for many years by Mills Olcott, a well-known lawyer and the owner and developer of the canal locks on the Connecticut River around the White River Falls (present-day Wilder, Vermont). Beside it, as discussed previously, was erected, in 1795, the "College Church," and on the eastern side was erected, in 1802 by William H. Woodward, a fine residence that was long known as "Lord House" due to it being occupied for many years by college president Reverend Nathan Lord. On the present-day site of Webster Hall and Rauner Library, in 1824, a substantial wood-framed house that became known as "Rood House" (due to it being owned for many years by Heman Rood) was erected by Benjamin Perkins. The final building to be erected on what came to be called Wentworth Street, named after Dartmouth College benefactor and Royal Governor of New Hampshire John Wentworth II, was the vestry building for the church.

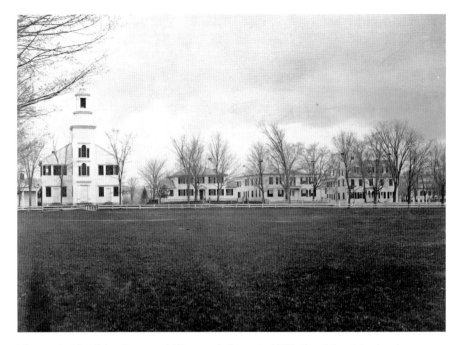

The north side of the Green and Wentworth Street in 1867. *From left to right*: church vestry (1841–1931), First Church of Christ at Dartmouth College (1795–1931), Choate House (1786–moved, 1927), Lord House (1802–moved, 1920) and Rood House (1824–1900). Lang Hall had been removed several years earlier. *Courtesy of Dartmouth College.*

When the church was constructed in 1795, an attempt was made to acquire the so-called College Barn lot, a small sliver of land measuring two by eight rods. This did not happen until 1840, when Mills Olcott purchased the lot for fifty dollars in 1834, and six years later, it was gifted to the church on the stipulation that it was to be the site of a vestry building and that such a building must be constructed within a year. Therefore, in 1841, the small single-story Greek Revival–style facility was erected immediately beside the existing church. Because of the new vestry building's diminutive size compared to the far larger church, village wags were soon refereeing to the pair of buildings as the "calf and cow."

Freeman and Wheelock appear to have also envisioned the west side of the Green as residential in character, with the exception of the graveyard that was laid out in the 1771 plan. As has been previously touched on, Comfort Seaver, a carpenter, came to Hanover in 1772 from Stillwater, New York, and was granted a half-acre lot at the southwestern corner of the Green, and beside him, on the corner of the lane that led to the

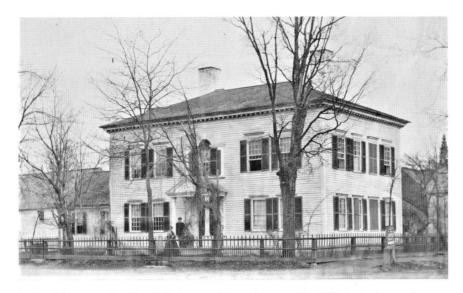

Richard Lang was the village's first successful merchant, and by 1795, he had erected this house on the site of present-day College Hall. The architecture of Lang's new home clearly reflected his Salem, Massachusetts origins. The building was moved away in 1875, and it still survives, situated on Sough Park Street, although substantially altered. *Courtesy of Dartmouth College.*

cemetery, William Winton, a mason, was granted an eight-by-ten-rod lot in 1774. Winton left Hanover to fight in the American Revolution, where he was wounded at Saratoga and died shortly thereafter in September 1777.

Comfort Seaver erected a house on his lot about 1774; however, it was not located on the corner of the lot beside the road that led down to the river, as was mistakenly shown on some early drawings of the village. This portion of Seaver's lot remained open until the property became acquired by Richard Lang, who, in 1795 erected a fine village residence for himself and his family.

It was not uncommon in earlier days to move wood-framed buildings instead of razing them when it was desired to make greater use of a site, and such was the case of the William Winton's house. By 1811, this property became owned by Dr. Cyrus Perkins. Perkins hired George Williston, an architect and carpenter who had recently come to Hanover, to remove the older building and design and erect an elegant new three-story home of wood frame construction. The Winton home was moved away to what was then considered the extreme end of "Back Street" on the outskirts of the village, where it is located to this day at 13 Maple Street.

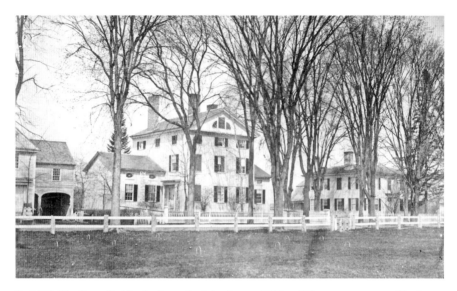

By 1815, Dr. Cyrus Perkins had acquired the former William Winton property and had the older house moved away so that he could construct this impressive new home. To the left is the woodshed of the 1774 Comfort Sever residence, and to the right is the Proctor residence, which was erected in 1810 by Professor Ebenezer Adams. *Author's collection.*

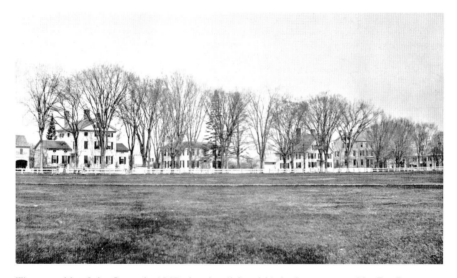

The west side of the Green in 1867, showing (*left to right*) the house erected by Dr. Cyrus Perkins (1815–moved, 1913), the house erected by Professor Ebenezer Adams (1810–1902), the house erected by Samuel McClure (1784–1910) and the brick house of Professor Oliver P. Hubbard (1842–1910). Moor's academy building was situated just beyond, obscured in this view by trees. *Courtesy of Dartmouth College.*

The lane to the cemetery was laid out at only one and a half rods wide. North of the lane, at the site of present-day McNutt Hall, were various shops in the early years. In 1785, land was granted to Asa Holden, who, by 1790, had established a "medicine shop," which later gave way to selling European wares and being a "vendue office," where every Thursday, at 2:00 p.m., there were auction sales held. Located behind this was a cabinet shop. In 1810, Professor Ebenezer Adams bought the property and, saving the existing gambrel roof building, erected a wood-framed two-story home in the front-facing the Green, with a low hipped roof and fine proportions.

North of the Adams House was a lot that was originally granted to Samuel McClure in 1784, on which he erected a house for his own use, and to the north, beside his new residence, he constructed a shop, which he occupied in his capacity as a tailor, a barber and the village postmaster. Around 1839, the shop building was moved away, and the northern part of the lot was acquired by Professor Oliver P. Hubbard, who, in 1842–43 had erected a very stately three-story brick home for his use.

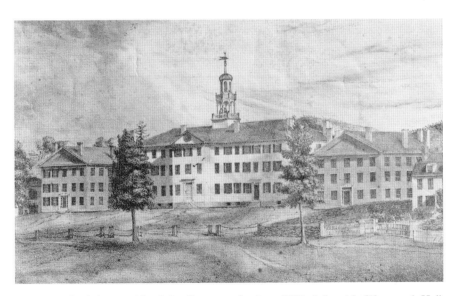

A lithograph of the east side of the Green, made about 1835. *Left to right*: Wentworth Hall (1828), the first Dartmouth Hall (1791–1904), Thornton Hall (1828) and the Wheelock House (1773–moved, 1838). The fence enclosed the "College Yard." *Courtesy of Dartmouth College.*

In time, the street that formed the west side of the Green became known as North Main Street and continued north toward its intersection with Rope Ferry Road. Increasingly, this area became largely residential and was primarily inhabited by professors at the college and their families. And like the area to the northwest of the Green, the early commercial uses scattered along the west side were gradually replaced by more substantial residences in support of the college, as commercial uses increasingly were relocated south of what became known as Wheelock Street.

By the time of the American Civil War, the Dartmouth College Green and its surroundings had become what Jonathan Freeman, Eleazar Wheelock and others had imagined ninety years earlier. And in doing so, it had achieved a combined layout and mix of institutional and residential buildings—in many ways, becoming the quintessential New England village, highlighted by the unique and stately dignity of the presence of "the College on the Hill."

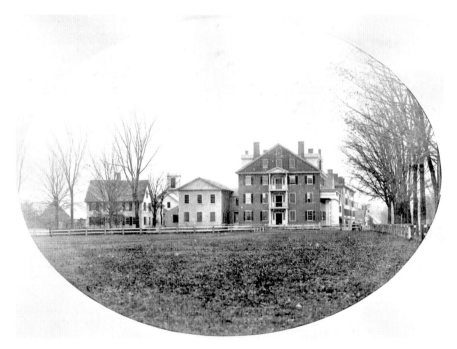

The south side of the Green in the late 1850s. The brick Dartmouth Hotel (1813–1887) can be seen to the right, the wood framed hotel annex is shown in the center and to the left is the house that was erected in 1773 by Dr. John Crane. These buildings were lost in the great hotel fire of January 4, 1887. The large livery stable in the background burned on January 29, 1859. *Courtesy of Dartmouth College.*

Lawyer and United States senator Daniel Webster was an 1801 graduate of Dartmouth College. During a lengthy hearing before the United States Supreme Court on March 10, 1818, of the much celebrated and all-important so-called Dartmouth College Case, Webster's powerful oratory in defense of the college, spoken to the towering figure of Chief Justice John Marshall, summed up the matter thus: "It is, sir, as I have said, a small college. And yet, there are those who love it." So, it had become Dartmouth College.

4

THE VILLAGE AT THE COLLEGE

1780–1865

Within the roughly six-mile-square block that is the Town of Hanover, by the 1780s, patterns of development and places of settlement were becoming increasingly more defined. In addition to continued land clearing and increased settlement along major roads that were being improved into something that approached being usable, the present-day village areas of Etna and Hanover Center were coming into being and, in time, would acquire their own unique identities. Located toward the center of the town, this area soon became the location of the town's government. In 1884, the name of Etna was agreed on for one of these village areas. Prior to that, Etna had been known as "Mill Village" or the "Mill Neighborhood," due to the series of water-powered mills that were located along Mink Brook. As Hanover continued to expand the number of school districts within the town, on occasion, Etna was referred to as "District Number Five." In contrast, the village that grew to serve the needs of the college that came to be referred to as "the Village at the College," was, from the start, a distinctly different settlement within the overall town known as Hanover, and within the Upper Valley Region.

THE DARTMOUTH HOTEL

As has already been noted, the first location of any business activity within the "Village at the College" was the two-story wood-framed tavern building

erected in 1771 by Captain Aaron Storrs on the present-day front lawn of the Casque and Gauntlet Society; however, the opposite side of the street, the present-day "Hanover Inn Corner," soon became the "heart" of the village. Around 1782, Captain Ebenezer Brewster, the college's steward, opened his home, which strategically faced the Green and Main Street and had been erected about four years earlier, as a tavern—today, the location of the Hanover Inn. Brewster was a successful tavern owner, in part, dispensing liquor to college students, providing rooming for weary travelers and increasingly becoming well engaged in local and regional affairs. By 1802, Brewster was leasing the property to a succession of tavern keepers, but the two-story building of simple residential size and proportions was no longer adequate for the increased patronage that it was experiencing. Therefore, in 1813, while the elder Brewster was lured out of town to visit a niece who was living upriver, in Haverhill, Brewster's son Amos had the old building moved to the northeast corner of South Main and Lebanon Streets and began constructing a totally new facility. By the time the old gentleman returned, there was little he could do other than complain loudly.

The new three-story brick hotel facility was a pleasantly proportioned example of Federal-style architecture with a low hipped roof and an elegant balustrade above the eaves. The name of the architect appears to be lost to time, but the design was, no doubt, inspired by contemporary buildings in lower eastern New Hampshire and Massachusetts. This was a time when generally older and smaller tavern stands were beginning to be replaced by more spacious and impressive "hotels," a word of French origins that offered an image of a more accommodating and up-to-date facility for the traveling public than the word "tavern," which harkened back to the days of simple, sparse and often very cramped accommodations and the hangout, as it were, of the local barroom trade. And this was the period of the rapid growth of turnpikes and stagecoach lines, both of which the village was experiencing and benefiting from.

Named the Dartmouth Hotel, the facility opened in September 1814 and gave a defining presence to the most prominent corner in the village. Although it was not the only hotel on Main Street, it set a pattern that has existed to the present day. Over the course of seventy-plus years, the property was owned and operated by a succession of inn keepers, all of whom were independent souls and none affiliated with the college. And over the decades, numerous alterations and additions to the building were constructed, such that by the mid-twentieth century the facility sported an impressive two-story Greek Revival–style portico that fronted on Main Street and small balconies

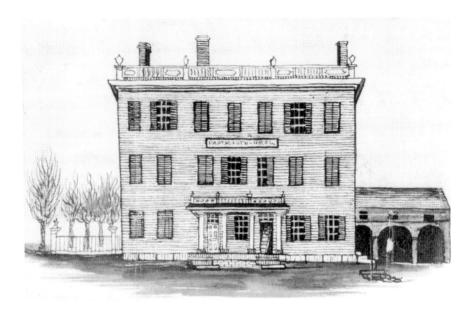

This sketch of the Main Street front of Amos Brewster's Dartmouth Hotel, constructed in 1813, was made by John Willard on March 25, 1826. Willard was a clerk in his uncle Dr. Samuel Alden's store, which was located directly across the street. On the right side, some of the stable facilities for customers and the stage lines that stopped at the hotel can be seen. *Courtesy of Dartmouth College.*

on the gable end of the building that faced the Green. Thankfully, in 1922, Professor Edwin J. Bartlett published a colorful and humorous account of life at the Dartmouth Hotel during the long tenure of Horace "Hod" Frary and his wife's operation. Bartlett arrived in Hanover in 1865 as a young man to start his studies at Dartmouth, and for two years, he lived at the hotel. His memoires, titled *A Dartmouth Book of Remembrance*, is a delightful narrative of not only the Hotel in the mid-century but of the village and the college as well. Of Hod Frary, he wrote: "Mr. Frary took the *Boston Journal* as others took alcohol or stimulating drugs. As he read it, he growled and muttered, grew violently excited, and finally flung the paper as far as he could across the room. No persuasion could induce him to change to a less irritating source of news."

One important function of the Dartmouth Hotel, prior to the development of railroads in the Upper Connecticut River Valley in the late 1840s, was its interface with the many stage lines that came into being to serve the region during the era of turnpikes (a roughly fifty-year period from the 1790s to the 1840s). The idea of turnpikes, privately owned and maintained toll roads,

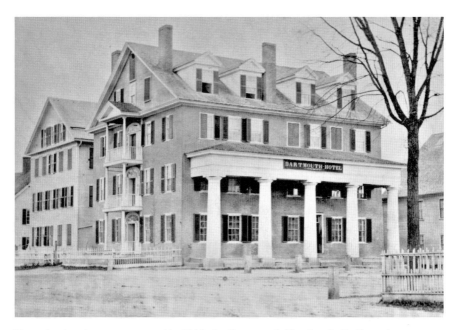

From the time it was constructed in 1913, the Dartmouth Hotel periodically underwent alterations and additions, and by the 1850s, the main building had assumed a very nice Greek Revival–style appearance. This image was made in 1865 and shows the large annex to the left. The facility was lost in the great hotel fire January 4, 1887. *Author's collection.*

was of English origin, and their development within the New England and middle Atlantic regions of the country became the first network of truly usable long-distance highways. Most of these owner-investor roads were monetary losers for their stockholders, although greatly stimulating to economic activity and significantly aiding travel convenience. One of the most important and profitable of this region's turnpikes was the Fourth New Hampshire Turnpike that traveled from Concord, New Hampshire, to West Lebanon, where it crossed the Connecticut River at Lyman's Bridge into Vermont. When the Fourth New Hampshire Turnpike opened in 1804, it included the so-called "College Branch," a spur built from Lebanon to the "College Bridge," across the Connecticut River at Hanover (present-day Heater and Mount Support Roads in Lebanon and Lebanon, South Main, and West Wheelock Streets in Hanover). On the Norwich side of the bridge, the Strafford Turnpike reached west into the interior of Central Vermont, and there was the Connecticut River Turnpike that paralleled the River from Thetford to Bellows Falls. The development of turnpikes greatly stimulated the establishment of stag lines, and soon, the Dartmouth

Hotel was a waypoint for many of the stage lines that ran between Boston and Concord through to Burlington and Montreal. Local stage lines also traversed the Connecticut River Valley in a north–south pattern that included stops in Hanover at the hotel. Behind the hotel, reached by a narrow alleyway off South Main Street, were sizable stable facilities for housing the multiple teams of stagecoach horses, as well as the horses of individual travelers staying at the hotel. The Dartmouth Hotel was a starting point for numerous stage lines, including some, like the stage to Concord, which headed out as early as 4:00 a.m. Concord was a long and hard day's ride, and Boston was reachable after a second long day on the road. The hotel's sizable stable facilities burned in January 1859; however, by then, the long-distance Boston-to-Montreal stage lines had been replaced by the development of railroads in the region around 1850.

In addition to stage travel, the turnpikes also greatly aided in the development of commerce within the village's shops on South Main Street. Merchants like Richard Lang employed teamsters to manage large freight wagons of goods, dry and otherwise, between the village and Boston and seaports on the North Shore. Lang, who had a brother living in Salem, Massachusetts, helped procure goods and have them ready for shipment to Hanover by four-horse teams and freight wagons that were capable of moving one and a half to two tons of goods. The trip between Hanover and Massachusetts typically took a week going one way, and Lang would attempt to move as much freight from the Upper Valley as what he planned to bring back. Other freight, goods that originated in New York, was seasonally moved on the Connecticut River between Hartford, Connecticut, and as far north as Wells River, Vermont. Beside the "College Bridge," at the base of "River Hill," there was a wharf maintained that flatboats navigating the river could stop at and load or unload freight destined for village merchants.

The Tontine

Immediately south of the half-acre lot on which Ebenezer Brewster's tavern stood (and, later, the Dartmouth Hotel) was a half-acre lot that was given to Alden Spooner, the first printer in Hanover, by the college in 1778. It does not appear that Spooner did much, if anything, with the lot, as he set up his printing press in a college building "on the Green." For thirty-five years, the lot was owned by a succession of persons, none

of whom did anything with it until 1813, when it came into the possession of Hezekiah Lemuel Davenport, who had first come to Hanover from Connecticut in May 1773 with tools and workmen to cut and erect the frame of President Wheelock's mansion, which was built that year on the site of Reed Hall. Later, in 1811, Davenport derived considerable profit from the construction of the medical school building. With those profits, he developed the largest commercial buildings in the village known as the "Tontine."

On this vacant lot, Mr. Davenport set about designing and constructing a large Federal-style four-story brick commercial structure, measuring 140 feet by 40 feet, that was first occupied by tenants in 1815. He chose to call his new building the "Tontine," perhaps an imitation of some large building in Connecticut that he was familiar with. As to the word's actual meaning, *tontine* was an investment plan devised in the seventeenth century for raising capital, and it was relatively widespread in the eighteenth and nineteenth centuries. It enables subscribers to share the risk of living a long life by combining features of a group annuity with a kind of mortality lottery. Ironically, the building proved to be too ambitious a project. It met with several misfortunes during construction and was the financial ruin of Mr. Davenport. Even before the building was complete, he sold the property to Joseph Emerson of Norwich and a Mr. Dame of Boston, who finished the upper story.

The design of the building was not convenient for its tenants, and not long after its construction, the southern end of the building settled as much as ten inches, which required considerable money to remedy. Yet for seventy-two years, the Tontine remained the principal business structure in the village. In earlier years, the upper floors were largely occupied by student rooms, such that, on two occasions, the College was induced to take the building for that purpose but declined. About 1860, when the first fraternities were established at Dartmouth, the Tontine was home to some of the earliest societies. Although the building had a troubled life, it was a lovable old arc and an architectural landmark until finally it was destroyed in the "Great Hotel Fire" that claimed the Dartmouth Hotel and much of the east side of village on a bitterly cold night, January 4, 1887. On the loss of the Dartmouth Hotel, Professor Bartlett later wrote: "The Frarys and their ever-to-be-remembered tavern held [an] important place in the community."

Between the Dartmouth hotel, the stable alley way and the Tontine were two wood-framed structures that, over the years, like the Tontine, had housed a variety of businesses, including a saddler's shop, a barbershop,

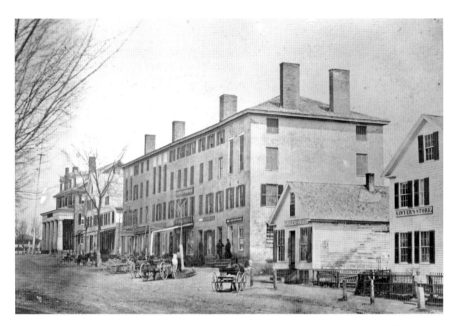

The east side of South Main Street can be seen in this circa 1865 image; at the far left is the Dartmouth Hotel, situated on the corner, and the large brick Tontine Block was completed in 1815. The Tontine Block was the largest commercial building in the village, and it housed many of its businesses. It was never a success, but it was a lovable old arc nonetheless. The building was destroyed in the Great Hotel Fire on January 4, 1887. *Courtesy of Dartmouth College.*

a drugstore, a jeweler, shoe and furniture stores, a bookstore and the first telegraph office in the village. These two buildings were among the six destroyed by the January 4 blaze.

The originating circumstances of the building that is now the site of the Ledyard Bank are no longer known, except that by 1842, Oliver Carter had a grocery and liquor store in this long one-story building with its gable facing the street, which he sold to G.W. Kibling, who continued to grow the business. By the 1860s, the property had been acquired by Albert Wainwright as the location of his tin shop. Wainwright enlarged the building in 1869 by increasing the width on the north side and adding two full floors. When the adjacent Tontine Block burned in the "Great Hotel Fire" of January 4, 1887, Wainwright's building was almost lost and would have been without the help of firefighting equipment that arrived barely in time from Lebanon. Today, the original building of humble but unknown origins and its 1869 additions is the 1991 home office of Ledyard Bank.

The land under Mr. Wainwright's tin shop, reaching to the corner of South Main and Lebanon Streets, was, at first, a one-acre lot that was given by the

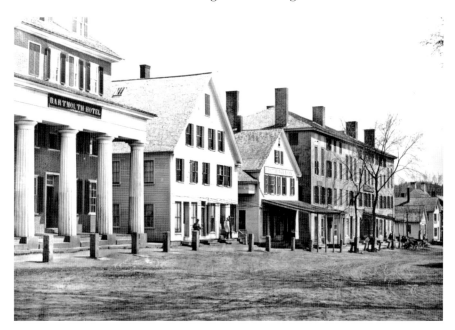

Between the Dartmouth Hotel and the Tontine Block were two wood-framed commercial structures that were owned by Dorrance B. Currier, and they were also lost in the hotel fire. The left-hand structure, beside the alleyway that went to the livery stables out back, was moved here from outside of the village in 1839. The building to the right was built in stages by Mr. Currier sometime prior to 1850. *Courtesy of Dartmouth College.*

College to Jabez Bingham in 1771 to encourage him to settle there as its farmer and animal husbandman. In addition to building a house for himself, located a short distance down Lebanon Street, by 1778–79, he had opened a store, but within a few years, he had sold the entire property. A succession of owners subdivided and further developed the property. In 1813, to make way for the new Dartmouth Hotel, the very corner portion of the lot on South Main and Lebanon Streets received the former Brewster Tavern building, which, once again, became a residence. Beside it, next to Wainwright's tin shop, a Greek Revival–style two-story wood-framed residence was erected, but almost nothing is known about it. In 1913, Brewster's former building was razed to make way for the new Dartmouth Savings Bank building, and in 1959, the building to the immediate north of it was also razed to allow for the expansion of the bank.

The east side of South Main Street, south of the Lebanon Street intersection, at one time had several nice period examples of regional architecture that greatly enhanced the village. On the corner stood the very impressive two-story brick residence that was constructed about 1835 by

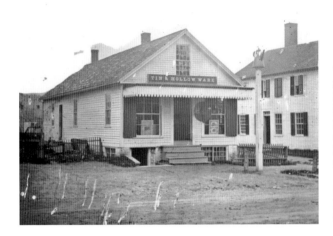

There is no record as to when this store building first appeared, located at 38 South Main Street. In 1869, it was expanded along the left side and two stories were added above. In 1991, it became the home of the Ledyard National Bank. *Courtesy of Dartmouth College.*

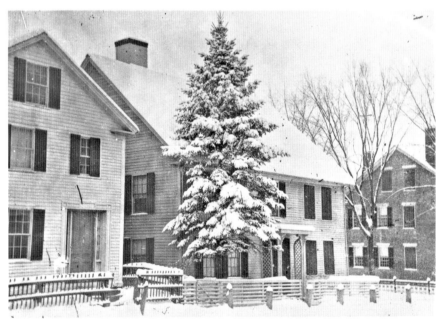

When Amos Brewster developed the new Dartmouth Hotel in 1813, he moved his father's old tavern, which had been erected in 1780, away, to the corner of Lebanon and South Main Streets. The old house was razed in 1913 to make way for the new Dartmouth Savings Bank. The house to the left was erected about 1820, and it, too, was razed in 1959 to make room for an addition to the bank. *Author's collection.*

Major William Tenney, a village blacksmith. Not too far behind the house was, for many years, a conveniently located brickyard. The lot had originally been granted in 1778 to Jabez Bingham, Eleazar Wheelock's nephew, but in spite of changing hands several times prior to Tenney acquiring it, it remained underutilized. The Tenney House was demolished in 1929 to make way for the northern half of the present-day post office building that still occupies the site.

The early history of the house that was once located immediately next to and south of the Tenney residence is somewhat obscure; however, by 1786, Lieutenant Benjamin Colt was the owner of the stately two-story wood-framed house that, in later years, was known as the Heneage House, the residence of Mrs. H.R. Heneage. Following Colt, the house was occupied by Eleazar Fitch, a hatter, and then, for forty years, it was occupied by Humphrey Farrar Esq., a prosperous and prominent village citizen. From 1836 to 1911, Albert Wainwright, the village tinsmith, and his family owned the house. In 1964, when it became necessary to expand the post office, the Heneage House was sacrificed, and the historic beauty of South Main Street suffered accordingly.

As originally planned, College Street not only formed the east side of the College Green and extended north as the road to Lyme, but it also extended south and crossed Lebanon Street before becoming a path that headed toward Mink Brook. Paralleling the southern end of College Street was a small and somewhat intermittent brook that furnished water for an early potash facility and washing place for the students. And in the vicinity of College and Lebanon Streets were several important early businesses, including a tailor and a shoemaker.

On the east side of College Street, at the present-day location of Wilson Hall, was an impressive residence that was erected about 1785 by Dr. Laban Gates. Of wood-framed construction, the original two-story building probably had a low hipped roof, similar to Professor John Smith's and merchant Richard Lang's houses. Then in the very early nineteenth century, the house was enlarged not only by adding a two-story bay of framing to the rear but by adding a gabled roof that allowed for a large third-floor "garret." And as was becoming fashionable at the time, stylish Greek Revival–style trim was added to the exterior of the building. The house certainly presented a handsome appearance as it looked west along the south side of the Green, toward the intersection of present-day Wheelock and Main Streets. The Gates family continued to own the property until 1845, when it became a rooming and tenement house occupied by students. In 1884, to make way

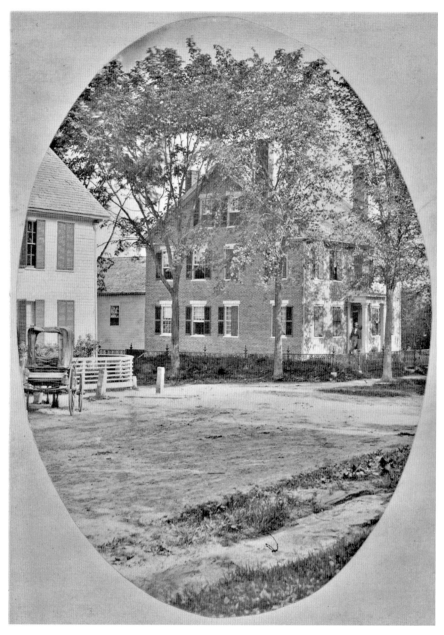

Looking across the intersection of Lebanon and South Main Streets, this circa 1860 view shows the corner of the former Brewster tavern building and the brick home of Major William Tenney, which was constructed in 1835. The Tenney House was taken down in 1929 and became the site of the present post office building, which was completed in 1931. *Courtesy of Dartmouth College.*

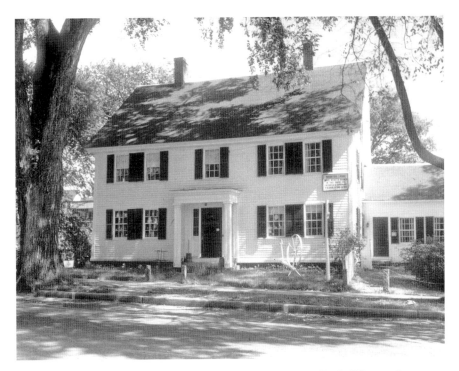

In the early 1960s, it was deemed necessary to expand the post office building, and as a result, the Colt-Wainwright-Heanage House was destroyed in April 1965 to make way for the fifty-two-by-sixty-foot addition. Erected in 1786, the destruction of this largely unaltered original building was a great loss for the village's main street. *Author's collection.*

for Wilson Hall, it was moved to 68 South Main Street and was eventually razed in 2007.

Surprisingly, the lot across from the Dr. Gates, at the corner of East Wheelock and South College Streets, facing the Green and now the location of the "Top of the Hop," remained mostly vacant and open until 1866, when Bissell Hall (as discussed in chapter 6) was constructed. The college relinquished ownership of the property very early on, and it is known that, for a time, there was a modest house located there that was owned by Jacob Kimball and Jeremiah Utley and used by them as a shoe shop. However, by 1840, the building was gone, and in 1842, the College acquired it to prevent it from becoming the site of an Episcopal church. And thus, it remained vacant until the construction of Bissell Hall in 1866.

Also on the eastern side of South College Street, at the corner of Lebanon Street, a new meetinghouse was erected in 1841 by the Methodist Church in Hanover, which had organized in the village area a year earlier

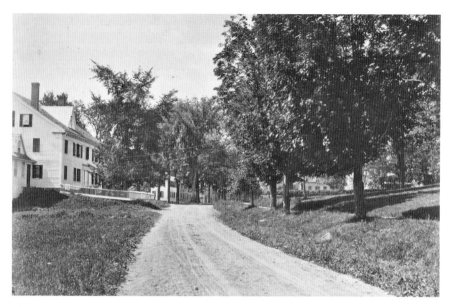

This interesting view, taken circa 1880, is looking west on East Wheelock Street, toward the Main Street intersection, and it shows, on the left, the substantial house that was erected by Dr. Laban Gates in 1785. In 1884, the house was moved to 68 South Main Street to allow for the construction of Wilson Hall. Wilson Hall is still extant. The Gates House was demolished in 2007. *Courtesy of Dartmouth College.*

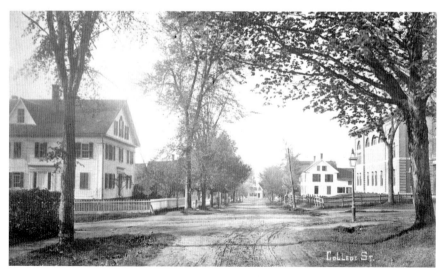

As it was originally laid out, College Street extended through to Lebanon Street, shown here in this circa 1880 view looking south. The 1785 Dr. Laban Gates House is shown on the left. Today, it is the site of Wilson Hall. The Hood Museum occupies the site of what was then called South College, which was closed in 1959, when Hopkins Center was under construction on the site of Bissell Hall (*right*). *Courtesy of Dartmouth College.*

as the First Methodist Episcopal Society in Hanover, New Hampshire. The new building cost approximately $2,000 and was used by the society until 1850–51. Because of increasing debt, the building was leased to the Episcopalians, who managed to purchase the property a year later. In 1854, the Episcopal church was officially organized as St. Thomas, and in 1861, the building was renovated at an expense between $1,200 and $1,400. One of the contributors to this effort was from England, the Earl of Dartmouth, who gave £100. In September 1876, St. Thomas moved into its new building, which was constructed on West Wheelock Street, and the old building was sold. At first, it was known as Kibling's Opera House, and then, with a large multistory addition to the front of the building in 1887, it became a commercial hotel with an opera house in the back. Finally, for many years, it was owned by the College and known as South Hall and was used as a dormitory before being completely razed in 1959 to make way for the construction of Hopkins Center.

On the corner of South College and Lebanon Streets, the Methodists erected this new church facility in 1841. In 1851, it became the home of St. Thomas's Episcopal Church. This photograph, taken circa 1865, shows the building before a belfry was added. On the completion of a new facility, located on West Wheelock Street, in 1876, the former church became an opera house. *Courtesy of Dartmouth College.*

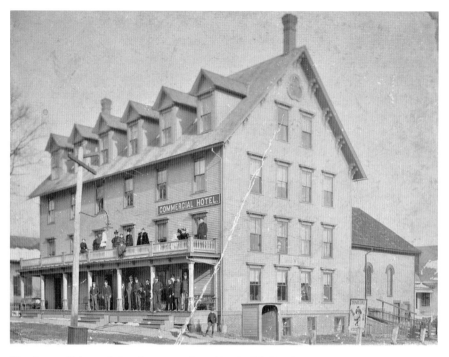

The former Episcopal church was purchased by the Kipling family, who, in addition to making the building an opera house, added a front hotel addition in 1887. The college eventually acquired the property, renaming it South Hall, a dormitory facility that included the opera house. Finally, in 1959, the old, worn building was razed to make way for Hopkins Center. *Author's collection.*

In the mid-century, the eastern side of South College Street was about the extent of the developed village area, with the exception of some residential development along Lebanon Street, around the intersection of present-day Sanborn Road, which was opened in 1906. From early on, from the intersection of South College Street, back up to South Main Street, there was a tight density of smaller wood-framed buildings. Much of this area was destroyed in the "Great Fire" of May 15, 1883, a blaze that started with children playing with matches in a barn on the south side of Lebanon Street, east of South College Street. Several times, the fire jumped across Lebanon Street; however, due to the heroic efforts of Dartmouth students and the arrival of firefighting equipment from Lebanon, the fire remained contained and did not reach South Main Street. Nonetheless, fourteen houses were destroyed, and twenty families were left homeless.

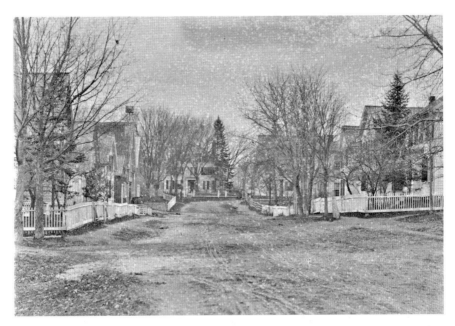

This early view of Lebanon Street, circa 1865, looks west, toward South Main Street and the large house built about 1842 by Alfred Morse. By 1969, the old house had become very altered and rundown; it was razed for the new Nugget Arcade building, which was designed by Frank J. Barrett, architect. It was developed by the Hanover Improvement Society and completed in 1970. *Courtesy of Dartmouth College.*

COBB'S STORE AND MORE

It would not be until the late nineteenth century, after the rebuilding that took place following the destructive January fire that claimed the Dartmouth Hotel and much of the east side of Main Street, including the Tontine and five other adjacent structures, that the west side of the street would begin to fill out and have the same architectural presence and density. Nonetheless, from the earliest days of village development, there was considerable enterprise and business activity on this side of the street, making for a fully active village center.

About twelve years after Captain Aaron Storrs opened his tavern on his two-acre lot at the southwestern corner of present-day South Main and West Wheelock Streets in 1771, he turned his attention to operating a ferry across the river to Norwich, which he then leased to the college. At first, Storrs's was the only tavern on South Main Street; however, after Captain Ebenezer Brewster opened his own house as a tavern in 1782, which

quickly provided the Storrs operation with some aggressive competition, Captain Storrs, probably after experiencing diminishing patronage, looked elsewhere for business opportunities. As Brewster's operation thrived across the street, Storrs remained a man prominent in local affairs and a member of the legislature in 1786, before moving to Norwich about 1789 and then to Randolph, Vermont, where he died in 1810. In 1787, probably in a settlement of debt, Storrs sold his village holdings to Samael Parkman of Boston, who, in 1793, conveyed the entire property to Rufus Graves, a 1791 graduate of Dartmouth College.

Graves was a young man of great energy and enterprise. In 1793, he built a large two-story wood-frame building with a low hipped roof beside the former Storrs tavern. There was a general store on the first floor with a large hall above. The store was a success, and soon, Graves was involved in other enterprises, including a tannery on the eastern side of the village and a potash making facility. Not only was Graves the first merchant located on South Main Street, but by doing so, he was the first competition to Richard Lang's operation that was located in the northeastern corner of the Green. Competition or not, it was soon evident that the village could accommodate more than one enterprise that was selling general merchandise and dry goods. In 1792, Graves joined with Ebenezer Brewster and Aaron Hutchinson, a lawyer in Lebanon, to construct a bridge over the river at the present-day location of Ledyard Bridge. The bridge, the second such crossing along the entire four-hundred-plus-mile-long River, was completed in 1796. The bridge was a daring single-span arch design and a business venture that was equally as daring, as it required securing capital in Boston. By 1800, Graves was overcome with debt and moved to Boston. The store and property were sold and acquired in September 1799 by Dr. Samuel Alden, who had come to Hanover from Stafford, Connecticut. Dr. Alden prospered by keeping both a general store and a drugstore. In time, he enlarged the building with a new and prominent gabled roof facing the street and large two-story columns across the front that gave the building an impressive and contemporary Greek Revival look. By 1823, Alden's business success had allowed him to construct a new two-story brick residence for himself and his family immediately behind the old tavern building that had been erected in 1771 by Aaron Storrs. The tavern had been built flush to both South Main and West Wheelock Streets. On completion of the new brick house, Alden moved his household belongings out the back door of the old house and into the front door of the new, and he then had the old building relocated to the northwest part of his garden that fronted on the "road to the river." After

being heavily altered over the years, the old house was finally razed in 1974 to provide space for a municipal parking lot. As for Dr. Alden's brick house, it changed hands at least once before becoming the home of the Casque and Gauntlet Society in 1893. The spacious front lawn, the site of Aaron Storr's 1771 tavern, remains a pleasing asset at the center of the village and a busy downtown intersection.

The store that Rufus Graves started and Dr. Samuel Alden successfully ran for many years, following Alden's death in 1842, came under the ownership of Samuel W. Cobb and, later, that of his son Walter D. Cobb. It is from this lengthy period of ownership that the property is best recalled. Quoting from Professor Bartlett's remembrances: "In Cobb's general store, you could buy anything, if Mr. Cobb, who did not like to be bothered, or his clerk, could find it." The upper floors of the building evolved into room that was rented to college students, and eventually, the great columnated edifice was taken down in 1903 to make way for the construction of the northern half of the Davison Block.

The original Storrs lot was two acres with considerable frontage on South Main Street. As a result, beginning with Rufus Graves, it became subdivided into smaller parcels with additional buildings, which included a barbershop, lawyer's office, tailor and more. As for the west side in general, during the last decades of the eighteenth and early nineteenth centuries, the buildout of the west side of South Main Street continued with a mix of smaller-scale wood-frame structures, the design and use reflective of a prospering New England village of the period. Thus, the west side of the street achieved a pleasant village density, a corresponding appearance and a pleasing mix of residential and small enterprise use. Unlike the opposite side of the street, until the last decade of the nineteenth century, the west side remained devoid of any larger buildings of masonry construction.

One of the earlier buildings was the residence of Professor John Smith, which was located on the site of the present-day municipal building. The lot, granted to him by the college, measured six by twenty rods, and about 1780, he had erected a two-story low-hipped roof residence of simple lines and proportions that was clearly reflective of its Connecticut origins. Smith was also the college librarian, and although he was not the first to sell books in Hanover (the first bookstore was located in Commons Hall in 1795), in March 1798, he opened the Hanover Bookstore in his home on the west side of Main Street. Although Professor Smith died in 1809, his wife, Susanna, continued the business and, later that year, moved it into a newly constructed, detached single-story shop located on the northern

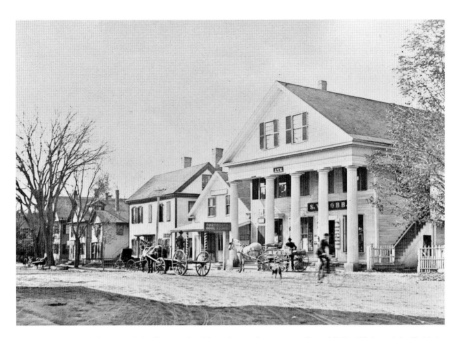

The west side of South Main Street, looking down the street, circa 1865. *Right to left*: Cobb's Store, originally built in 1794 by Rufus Graves and enlarged and altered with a colonnaded gabled roof circa 1810; M.M. Amarall's barbershop; the two-story residence of B.J. Gilbert, a lawyer, built about 1796; two small, early two-story shop buildings; and the house built about 1780 by John Young. *Courtesy of Dartmouth College.*

side of her home. In later years, the engaging little building of dignified proportions became a general store. Eventually, in 1869, the store building and the former Smith residence were moved away, and the property was redeveloped by the Episcopal Church.

In addition to Aaron Storr's tavern at the head of the road that led up from the river; John Payne's tavern, located immediately north of the college on the road to Lyme; and Ebenezer Brewster's tavern, opposite of the Green, there also existed a large tavern and coffee house that was long referred to as the "Lower Hotel," situated at the present-day northwestern corner of South Main and Maple Streets. The lot, measuring ten by sixteen rods, was originally granted to Charles Sexton, a blacksmith; however, by 1783, it had become the property of Gamaliel Loomis, who erected a large house on the corner prior to 1795. By 1797, James Wheelock, one of Eleazar's sons, had acquired the property, and in 1802, he had opened it as a tavern.

For the next seventy-five years, under various names and with many proprietors, the hotel continued, intermittently, as the Union House, the

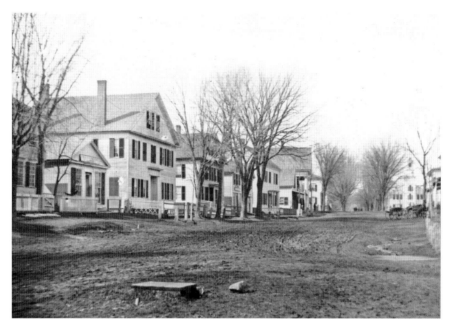

The west side of South Main Street, looking up the street, circa 1865. A corner of Professor John Smith's 1780 house is visible on the left. Also seen is Smith's book shop, the house built about 1820 by Abraham Dunklee, the entrance to Allen Street and the house that was built about 1780 by John Young. Lawyer Gilbert's house is visible beyond the two very early two-story shop buildings. *Courtesy of Dartmouth College.*

American House, the Hanover Inn and, finally, the Lower Hotel. The hotel's most prosperous period was from 1821 to 1838, when it was kept by Captain Ebenezer Symmes. It was he who enlarged the building and erected a two-story covered piazza across the front. Later, after a season of neglect, in 1868, the property was purchased by the College and turned into a dormitory called South Hall. It was mainly intended for the use of students who were enrolled in the newly established state agricultural college (more of which will be mentioned in chapter 7). The building was never successful as a dormitory, and after being deserted by the students, it became a tenement house. Following the destruction of the Dartmouth Hotel in the January 1887 fire, for a brief time, it was once again a tavern until it, too, became the victim of fire on July 11, 1888. By that time, no one was sad to see it as a complete loss, burned to the foundations.

As early as the 1790s, there probably existed a private lane off South Main Street, where Allen Street now intersects it. That was an access to an early house located at present-day 5 Allen Street of which little is known.

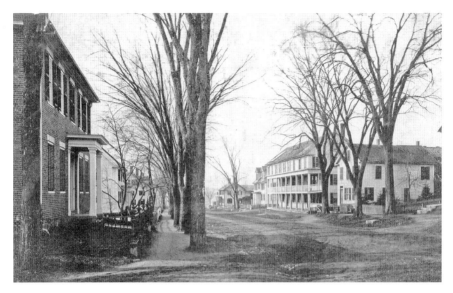

The west side of South Main Street, looking down the street from the Lebanon Street intersection, circa 1865. On the left is the front of the 1835 Major William Tenney House (1835–1929). Across the street is the Lower Hotel (1790–1888), which was later owned by the College and became known as South Hall. Little is known about the small two-story house beside the hotel. Both buildings burned the night of July 11, 1888. *Courtesy of Dartmouth College.*

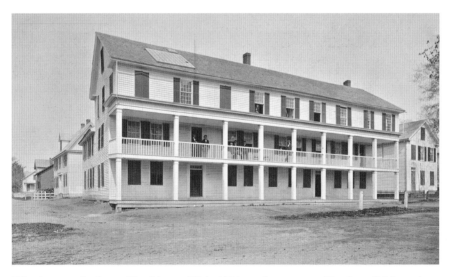

What became the Lower Hotel began life in 1790 as a home erected by Gamaliel Loomis, but by 1802, it had become a tavern. Over the years, alterations and additions were made under various owners and business operators. The Lower Hotel became Dartmouth's South Hall, and it burned the night of July 11, 1888, taking the two adjacent houses with it. *Courtesy of Dartmouth College.*

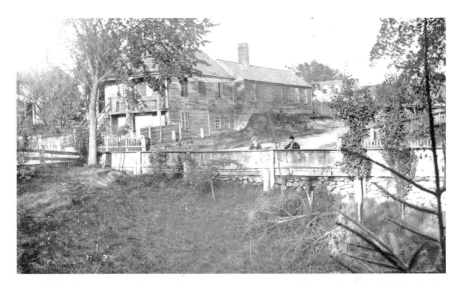

The intersection of Allen and School Streets, before Allen Street was extended westerly in 1877 for the new school that was built that year. The house at the corner was greatly enlarged over the years and became the Ashbel Hotel, which was finally torn down in 1974 and became the site of a municipal parking lot. *Author's collection.*

By 1835, there existed indications that the lane accessed a livery stable, and by 1869, the lane had been improved and extended to School Street. Also, around that time, it came to be referred to as "Allen Lane," in reference to Ira B. Allen, a former stage driver who had purchased Amos Dudley's livery stable operation. As the nineteenth century progressed, Allen Street became a hub of livery stable and related operations; however, as the early 1920s evolved, it was turned into automotive fuel, repair and storage facilities. The last of the livery stables burned May 13, 1925.

For several decades, at least, into the twentieth century, the southern extent of village development was about the brow of the hill at South Main Street. The area between the hill and Mink Brook was open farmland, and from Mink Brook to the village of West Lebanon, it also remained as such. Likewise, west of the South Main Street, the built-up village area mostly ended at School Street, which was formerly opened in 1843, although it had been traveled on by the public for some number of years prior to that.

From the start, the village that was planned to support the college was a dynamic, evolving and thriving place. In appearance, its architecture was pure New England vernacular. Lots were initially laid out and then further subdivided as needs and population increased. Buildings were constructed, modified, added onto and, occasionally, moved.

Into the twentieth century, the southern edge of the village was the brow of the hill, where South Main Street became West Lebanon Road. The area between the southern edge of the "Village at the College" and the village of West Lebanon was open working farmland. *Courtesy of Dartmouth College.*

In the wake of the favorable decision by the United States Supreme Court in the famous "Dartmouth College Case," which was decided in February 1819, increased stability and growth—and, slowly, even a hint of some modest prosperity—came to both the college and the village. Regional turnpikes were developed that, in turn, spurred the growth of stage lines, both local and regional, which further secured the success of the college and the village. The opening of regional railroads in the late 1840s increased this trend.

Through the nineteenth century, the symbiotic relationship between the College and its several schools and the "Village at the College" would grow and deepen, providing for a pleasing environment that looked completely natural and at ease, yet, at the same time, very unique.

5

THE PERIMETER LANDSCAPE

The total area of the town of Hanover, by the time several boundary disputes had been settled with adjacent towns, consisted of 50.3 square miles, including brooks and the Connecticut River (or 49.0 square miles of actual land area, which equates to 31,360 acres), in a shape that roughly approximates an eastward-leaning parallelogram. Within those four borders, the western of which is the river, Dartmouth College and the "Village at the College" were not only set in the very lower southwest corner of the town but, well into the twentieth century, remained quite separate from the remainder of the Town of Hanover as well.

Frederick Chase was Hanover and Dartmouth's first historian, and in his book *A History of Dartmouth College and the Town of Hanover New Hampshire (to 1815)* described the landscape of Hanover at the time of settlement thusly:

> *The face of the land throughout the town of Hanover was found to be greatly diversified. Along the river were generously narrow intervals, some of which have been since washed away, and immediately back of them high, rugged hills, through which in deep, narrow gorges numerous brooks rushed violently down to the river, affording at certain periods abundance of water-power. The hills, rising in what are subsequently three or four successive ridges, cumulate in Moose Mountain, which extends the whole length of the town near its eastern boundary, and reaches at one point the height of 2,350 feet above the sea. Except the intervals, the whole town to the very top of the mountain was covered with heavy forest, chiefly of*

hard woods—maple, beech, birch, ash, oak, and other varieties. Bass-wood and hemlock also abounded. White pines prevailed exclusively in several localities, especially along the river and in the valley of Mink Brook, and elsewhere in tracts of limited extent. These were often of great size and height, a hundred feet, or more, to the first limb, and were famous through all the region. It was not unusual that four trees could be felled in such a way as to fence an acre, one on each side of the tract. The largest specimens grew on the college plain.

Immediately following the chartering of Hanover and the neighboring towns, in 1761, seasonal work parties would journey up from Connecticut, first using the River and, later, the "Great Road" that followed the River's eastern bank, north of Charlestown. During the summer months, roads were cut out of the dense wilderness, and the landscape gradually started to open up. William W. Dewey (1777–1861) was brought to Hanover by his parents when he was about two years of age, in 1779. William's uncle, Simeon Dewey, constructed the first saw and gristmills in Hanover during the summer of 1769, and William's father, Benoni Dewey, a blacksmith, kindled the first ironsmiths' fire that fall. The Deweys were from Springfield, Massachusetts, and in 1782, Benoni had purchased two acres of land on North College Street, the present-day site of Sigma Alpha Epsilon fraternity and the White Church, where he erected a small frame house for his family and where his son William grew up. Benoni became a deacon in the Church and operated a tavern in the south end of the village from 1798 to 1809. In 1809, he won $500 in a lottery. With these proceeds, he erected a new two-story frame house that replaced, on the same site, his earlier home, from where he continued his tavern business. William Dewey ultimately succeeded his father; however, rather than becoming known for his time running the tavern, he became a chronicler of Hanover's early history. In 1964, the Hanover Historical Society edited and published Mr. Dewey's writings in a booklet titled *Dewey's Reminiscences: Being historical recollections recorded by William W. Dewey relating to the Village and town of Hanover, New Hampshire and to Dartmouth College.*

As the last decades of the eighteenth century advanced into the nineteenth century, the amount of land clearing in Hanover and the surrounding towns in the river valley continued unabated. William Dewey wrote of that period, a time when he was nearing his young adult years:

There was so much land cleared up every summer in this and adjacent towns that oftentimes, for a week in succession, the smoke from the burning

lands in the towns west of us would be so dense and black by mid-afternoon as to entirely obs[c]ure the sun from our view, and the darkness was similar to that occasioned by a dark thundercloud—Sudden thunder gusts and tornadoes were far more frequent in those days then they are at this day—and in a dry summer, when the fires set for burning some particular piece of land would escape by accident its intended bounds, it would often spread over a large extent of territory, and in a dark night, its appearance as it ranged over the high hills would present a sublime and almost terrific view of it—Our village has often been more than once well lighted at night by fires driving over the range of high land in sight a little more than a mile east of us.

To the immediate west of the "Village at the College" is land that drops steeply down to the Connecticut River. The eastern bank of the river in Hanover, from just south of the mouth of Camp Brook to beyond the Hanover-Lebanon town line, is part of a geological esker that discontinuously parallels the river from just south of North Thetford, twenty-four miles to Windsor. This esker was formed during the retreat of the last North American ice age and is a sinuous gravel ridge formed by glacial meltwater streams flowing either in crevasses on the ice or in tunnels beneath it that transported great amounts of course gravel. After the ice had disappeared from the region, the sites of these former stream channels were marked by these gravel ridges called eskers. Within the Connecticut River Valley, as the thick ice sheets melted and retreated north, releasing great quantities of melt water, for a period of time, much of this water became impounded behind natural till dams, the most notable being near East Hadden, Connecticut. The result was the formation of Lake Hitchcock and, slightly later, Lake Upham, which was formed by a till dam at about the Massachusetts-Connecticut state line. Between the time that these two lakes were in existence, large amounts of sediment were deposited, and at Hanover, they filled in behind the esker to form the so-called Hanover Plain. These geological events occurred between eleven thousand and seventeen thousand years ago, and as Lakes Hitchcock and Upham naturally drained, present-day Mink and Girl Brooks came into being, including the ravines and valleys that are now part of the village's topography.

In June 1770, when Reverend Wheelock and a small party of close confidants traveled up the Connecticut River to look at potential sites for the new school, on reaching Hanover, we can only assume that they climbed from the river up to the level plain that was about 155 feet above by either the deep ravine that, in time, became West Wheelock Street or the smaller

ravine area that is present-day Tuck Drive. In the early years, it was simply known the "path to the river." Later generations of college students called it Webster Vale.

In 1839, French artist and chemist Louis-Jacques-Mandé Daguerre demonstrated the world's first successful photographic process known as the daguerreotype, and a new age was born. We do not know when the first photographer arrived in the area, although the earliest known image of Hanover to have survived was taken in 1854, looking west along Wentworth Street at the College Green. It is known that by the later 1850s, professional photographers were focusing their lenses on aspects of the village and campus, including the landscape surrounding it, and by the 1860s, there was at least one professional photographer with a studio taking portraits of students and selling prints of the buildings and landscape that made up the village and its surroundings. As a result, there remains a much clearer early record of Dartmouth than exists for most smaller rural communities in the region.

About 1770, across the River in Norwich, John Sargent kept a tavern and established a public ferry at the present-day location of Ledyard Bridge. Sargent, however, was soon in trouble with Wheelock for selling liquor to Dartmouth students, which prompted Wheelock to secure from New Hampshire provincial authorities ferry rights "to cover the whole length of the township of Hanover." The College then leased ferry rights at that location until the first toll bridge was erected by Rufus Graves and other investors in 1796. It was this first bridge crossing, the second to span the Connecticut River Watershed, that prompted the Hanover selectmen, in 1797, to officially lay out the road that was until then described as "an old cart path up the ravine." Over the years, what eventually came to be known as West Wheelock Street was known as "the road to the ferry" and, later, River Street. The steep hill up to the village was known as River Hill, and after the opening of Connecticut & Passumpsic Rivers Railroad, with the establishment of the Norwich–Hanover station in October 1848, some referred to it as "Depot Hill."

The first bridge at this location, an open single-arch wooden span of 344 feet (36 feet wide), was short-lived. An undermined abutment caused it to collapse under its own weight in 1804. A second bridge at this location, also an open wooden span but with a center pier, lasted until 1839, when it was replaced by a third structure that was destroyed by arson on the early morning of August 6, 1854. More than its two predecessors, this third bridge was a constant source of much controversy, ranging from the cost of tolls to

West Wheelock Street, seen here in 1876, was, at first, just a path from the River up through a ravine. In 1797, it became an actual town road that was most commonly referred to as River Street before it was named for the founder of Dartmouth College. Once densely forested with tall white pines, one hundred years later, it was an eroding landscape. *Author's collection.*

the upkeep and safety of the span. Finally, it was decided by both towns and Dartmouth College to work together to construct a new bridge that would be "freed"—the first non-toll span along the entire length of the River. Noted bridge builders James F. Tasker (1826–1903) of Cornish and Bela J. Fletcher (1811–1877) of Claremont were hired to design and construct the new bridge at a cost of about $12,000.00 (Hanover, $8,500.00; Norwich, $2,000.00; and Dartmouth College, $833.33).

This was the era of the great covered wooden bridges, and the bridge that Messrs. Tasker and Fletcher erected was, in every way, a truly state-of-the-art structure. The massive wooden trusses were of a modified Town lattice truss design, the same as they had used at the Orford–Fairlee crossing several years earlier and that they later used in the Cornish–Windsor Bridge that was erected in 1866 and is still in service. Christened the Ledyard Free

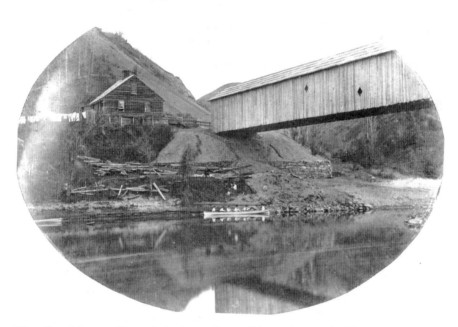

The old and the new. Shown is the former ferry toll house that was built in 1780 and destroyed by fire October 19, 1860. Beside it is the new Ledyard Bridge, completed in June 1859. The new bridge, 402 feet long, was the first non-toll or "free" bridge across the Connecticut River. It was dismantled for replacement in November 1934. *Author's collection.*

Bridge until its replacement in late 1934, more than its predecessors, this much-beloved span linked not only the two communities of Hanover and Norwich, but it, in part, connected the Village at the College with the larger world. Generations of Dartmouth students arrived and departed by crossing that bridge that led to the railroad station, and tons of freight came across Ledyard Bridge on its way from the numerous railroad freight houses in Lewiston, up the Wheelock Street Hill, to merchants on Main Street.

Before and after the construction of the first Hanover–Norwich bridge in 1796, other ferry crossings existed on the river between the two towns. The first of these was based at the mouth of Girl Brook and the Vale of Tempe and was known as a rope ferry because it relied on a heavy rope that was stretched across the river to help guide the boats crossing the flowing current. Although the records are very sketchy at best, it is believed that this ferry was in seasonal operation from about 1776 to 1783. It may well have been in operation prior to 1776, and it remained in operation until

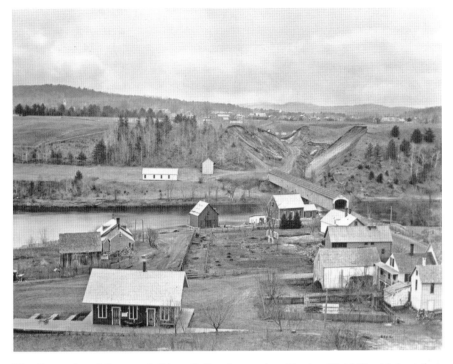

The Connecticut & Passumpsic Rivers Railroad opened on October 10, 1848, and about that time, it also erected the station that is shown in the foreground of this view that was taken in 1876. The village of Lewiston, Vermont, the Connecticut River, Ledyard Bridge and the eroding landscape along West Wheelock Street are all clearly evident. *Author's collection.*

as late as 1806. The record is clear that on February 14, 1795, Hanover selectmen General Ebenezer Brewster and Joseph Curtis "laid out a road or highway from the rope ferry so called to the northwest corner of the College Green." And it is known that the name "Rope Ferry Road" was first applied several years earlier.

It was not until around 1910 that what we now call Rope Ferry Road became a built-up street and was developed with suburban houses lining both sides. For many years prior, it was often referred to as Lovers' Lane, Old Ferry Road and Stump Lane. During the time of settlement that virgin land was being cleared, it was not uncommon that the large remaining stumps were pulled up by teams of oxen and then positioned tightly together on their sides at the perimeter of a field as fencing. Because both sides of the road that lead down to the ferry passed through cleared farmland—and remained as such until the 1890s and the beginning of development of this area of the village—it was lined with old stump fencing at the road's edge.

As previously noted in chapter 2, by the time of Reverend Wheelock's death in April 1779, through aggressive land purchases and exchanges, the Wheelock family controlled many hundreds of acres of farmland that surrounded the campus and village area, with the exception the land west of present-day school and south of West Wheelock Street. This land between the village and the River was within the five-hundred-acre governor's parcel that had been granted to the college, not Reverend Wheelock. However, the northern boundary of the governor's parcel was about present-day Webster Avenue. Therefore, the Wheelocks were free to acquire and control land beyond that line. This included all of the land north of present-day Webster Avenue, between the River and Rope Ferry Road, that became willed to Abigail Wheelock. From the east side of Rope Ferry Road to the road north to Lyme (present-day Lyme Road), there was acreage that became owned by Mary Wheelock Woodard. Although deed research has not determined when these two land areas went from Wheelock control to the ownership of others outside of the family, it is probable that by the early years of the nineteenth century, that had occurred. Regardless, until around 1900, this area remained open and productive farmland. Along Lyme Road, looking north from the college, was an uninterrupted series of farms on both sides of the road, stretching north, out of view. It was only when the college began aggressively expanding (following the installation of President William Jewitt Tucker in 1893) and the completion of the Mary Hitchcock Memorial Hospital, that the area of Webster Avenue, Occom Ridge, Occom Pond and Rope Ferry Road became eyed for development. The first house was built on Occom Ridge in 1897, and two years later, fourteen men acquired land along Rope Ferry Road and created the Hanover Country Club. What had been a swampy marsh-like area in 1900 was dammed and became the nine-acre Occom Pond.

West of the Vale of Tempe and Girl Brook and bordering the river lay about forty-five acres that was the southwestern portion of a farm owned by Frank Hutchinson known as Grasslands Stock Farm. Hutchinson had died, and to settle his estate, this portion of the farm was put up for sale. Because it was heavily forested with mature white pine trees, it attracted the attention of the Diamond Match Company, which made an offer for the timber. This immediately caused local concern, as folks realized that clearcutting this parcel would result in an ugly scare along the river and potential erosion and damage to the water quality and wildlife. More than $4,000 was raised with which to secure the land, and an agreement for its purchase by an association of subscribers was signed on December 1, 1900. Five years later,

on October 2, 1905, the Pine Park Association was organized, and to this day, it maintains ownership of the property.

What is today referred to as Lyme Road (or by the State of New Hampshire as NH Route 10) is, at least in part, one of the earliest roads that was cut through the dense wilderness that was Hanover in its earliest days. At that time, the furthermost development of anything that even remotely resembled a road ended at Fort Number Four in Charlestown. North of there was some amount of a very primitive trail that paralleled the river and had once been used by Native Americans, but there was nothing else. Following the charter of Hanover and the surrounding towns on both sides of the river, it was decided that a road needed to cut north from Fort Number Four. Begun in 1762 (and perhaps a bit tongue-in-cheek), this first attempt at a road into the wilderness was soon referred to as the "Great Road." By the middle 1760s, it stretched north from Fort Number 4 at Charlestown to Haverhill, which were situated within the "Little Cohas Intervals." The

This circa-1860 view is looking north from the College Park, across the Vale of Tempe and up Lyme Road. Three farms are visible—the closest, located at present-day 25 Lyme Road. In the distance, the Warden-Garipay Farm on Reservoir Road can be seen on the right, and the Grasslands Stock Farm once located at present-day Fletcher Circle can be seen on the distant left. *Author's collection.*

This view, circa 1870, from the College Park is looking to the east, up East Wheelock Street. To the far left is A.P. Balch's farm, with the stone house still standing at 1 Rip Road. All of the land on the right (south) side of East Wheelock Street became part of the New Hampshire College of Agriculture and the Mechanical Arts. The farmhouse in the foreground still remains at 2 Smith Road. *Courtesy of Dartmouth College.*

proprietors of Hanover and Lebanon took this matter very seriously and played a significant role in the road's development.

East of Lyme Road, the ownership of land by the Wheelock family probably continued into the early years of the nineteenth century. Between Lyme Road and East Wheelock Street, extending up Balch Hill, lay the contiguous lands of Eleazar Wheelock Jr., which he inherited after his father's death in April 1779. The historic record is not entirely clear, but the road north, toward Lyme, may well have been a section of the so-called Great Road, the first road cut in the region north of Fort Number Four at Charlestown. It is known that the road very closely followed the river as it threaded its way north; however, exactly how it passed through the village and campus area is not clear.

On the other hand, the road that is now called East Wheelock Street, including Balch Hill, was laid out by the selectmen November 20, 1787, to run from Jeremiah Trescott's home to Dartmouth College. This, however,

was not the first road specifically laid out in an attempt to connect the college with the interior areas of the town. On July 7, 1775, the selectmen laid out the road from "Hill's Mills" (Etna) to Dartmouth College. Today, this is Greensboro Road and Lebanon Street.

The land between East Wheelock and Lebanon Streets, including all of the college's present-day athletic fields and extending up into the area known as Balch Hill and Velvet Rocks, was inherited by John Wheelock, who, on the death of his father, became the second president of Dartmouth College. Most of this land had been acquired by the New Hampshire College of Agriculture and the Mechanical Arts and was part of that school's operation during the time that it was located in Hanover. In 1893, when the school relocated to Durham, New Hampshire, this area began to be gradually broken up and subdivided, continuing into the 1970s with the Low and Haskins Roads neighborhoods.

Eleazar Wheelock's son James Wheelock inherited the land that stretched from the southern side of Lebanon Street, around the southeastern side of the village, to South Main Street and the road to West Lebanon. The southernmost extent of this land holding was at about the edge of the present-day Buell Street neighborhood. Sometime in the mid-nineteenth century, this expanse of farmland became owned by one of Hanover's most prominent and interesting citizens: Dorrance B. Currier (1846–1818). Mr. Currier was a Hanover native, and although he was never directly affiliated with the College, he played an outsized roll in village affairs as a wide-ranging real estate and business entrepreneur. During much of his life, he maintained a large farm at the edge of the village. The farmhouse and outbuilding were located on the east side of South Main Street, at the brow of the hill, where the Dorrance Place neighborhood is currently located. Following Mr. Currier's death in 1918, the farm buildings were taken down, and the large amount of farm acreage that extended along the east side of Lebanon Street to the top of what was known as "Sand Hill" was broken up and subdivided.

The last Wheelock family–owned parcel of farmland surrounding the Village at the College was the expanse of land along both sides of Mink Brook to the Hanover-Lebanon town line and, at one time, extending into Lebanon. Much of this area was cleared very early on, following the College's settlement on the Hanover Plain, and it was put under cultivation to support the College. Ralph Wheelock inherited this farm from his father, Eleazar, and farmed it until his death in the early 1820s, when it became the property of Ruben Benton about 1826.

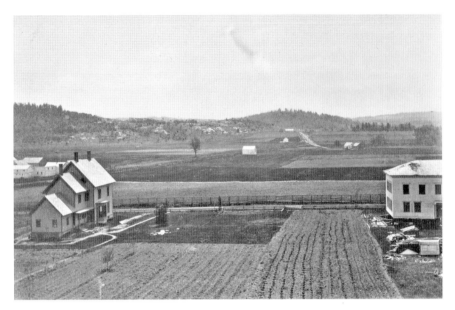

Looking south from the College Park, across East Wheelock Street, toward Lebanon Street, this view shows the cultivated fields of the New Hampshire College of Agriculture and the Mechanical Arts. To the right is the former home of Richard Lang, which was recently moved from the present-day site of College Hall. The denuded hillside of Velvet Rocks is apparent in the distance. *Courtesy of Dartmouth College.*

Looking east along Lebanon Street, circa 1865, Velvet Rocks can be seen in the distance. To the immediate left are the fields that became part of the New Hampshire College of Agriculture and the Mechanical Arts. On the right are fields of the large farm that were owned by Dorrance B. Currier—partially the present-day site of the Dresden School complex. *Courtesy of Dartmouth College.*

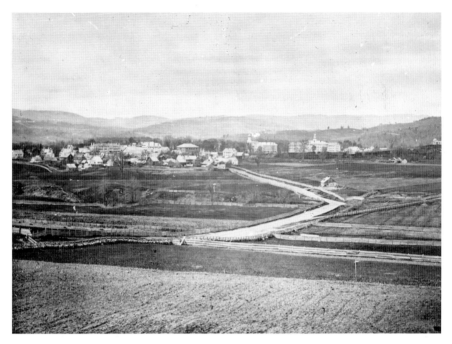

Looking from the top of Lebanon Street ("Sand Hill"), back toward the village, in 1867. To the left is the pastureland of Dorrance B. Currier's large farm, and to the middle right are the cultivated fields that became part of the New Hampshire College of Agriculture and the Mechanical Arts when it became located in Hanover in 1868. *Courtesy of Dartmouth College.*

The Bentons were among the earliest settlers in Hanover, settling in the eastern vicinity of the town near to Moose Mountain and the Etna Highlands area. About 1826, Ruben Benton moved into the "Village at the College" and, at about the same time, acquired the former Wheelock farm. He was a civic-minded and respected individual who served on the town select board. In 1840, when his farmhouse was destroyed by fire, he rebuilt it in brick that, today, is the lovely one-and-a-half-story brick Greek Revival–style house that is still extant at 104 South Main Street. Approximately twelve years later, in 1852, Ruben's son Charles continued to improve and increase the size of the farm, including building the impressive barn that was still in use by Jim Stone in 1948. And like his father, Ruben, Charles was very active in town affairs, serving the community in many capacities, including as a representative in the New Hampshire State Legislature. A son, Charles F. Benton, was also actively involved in running the family farm with his father, Charles. The Bentons were noted breeders of Merino sheep with, at times, 225 head or more grazing in the pastures along Mink Brook. On May 26,

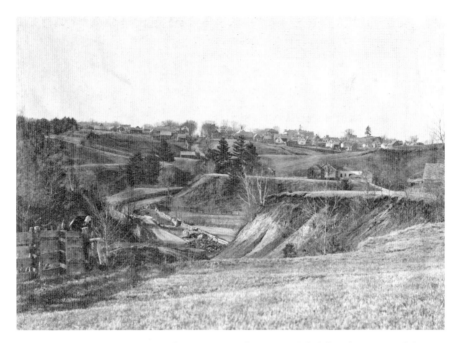

Looking north from the Hanover-Lebanon town line, across Mink Brook, up toward the village, in 1867. To the mid-right of this view is the Charles Benton Farm, with the 1840 brick farmhouse still standing at 104 South Main Street. Beyond, above the Benton's farm, are fields of Dorrance B. Currier's farm. The farm buildings were located at the top of the hill, in the village. *Courtesy of Dartmouth College.*

1989, Elizbeth L. Benton, the widow of the late Charles Benton, sold the farm to Dartmouth College for $4,500, probably to settle Charles's estate. At the time of the sale, there were ten Benton relatives who had to sign off on the sale. Excluded from the sale was the brick farmhouse and about an acre of land on which it sat.

There is a strong possibility that what became, in time, South Main Street, from the intersection of present-day Wheelock Street, south to the Hanover-Lebanon town line, was earlier part of the Great Road, that first road cut in 1762 from Fort Number Four, north to Haverhill and the Lower Coos. Unfortunately, that will never be known for sure; however, on July 7, 1775, the Hanover selectmen accepted the layout of the road "from Capt. Storrs's house to Mink Brook Meadow near Lebanon line, which included the main street as laid out four years earlier by Jonathan Freeman."

6

THE VICTORIAN ERA

1865–1900

T he term *Victorian* does not describe a style of architecture but, instead, a period of history that had sweeping and long-lasting effects across the face of the globe, including Hanover, New Hampshire, in rural Northern New England. The name of the era comes from Queen Victoria, the English monarch who ruled all of the British Empire (which was then at its height worldwide) from 1837 until her death in 1901. As the world's leading superpower, Victorian-era Great Britain brought about great changes in the arts, culture and technology that had noticeable and lasting impacts in multiple ways that had never before been seen. This was especially true in the field of architecture, both domestically and civically, throughout the western world. Often referred to as the "romantic" styles, architectural tastes of the Victorian period ranged from Gothic and Italianate to Second Empire (French), Queen Anne, Eastlake (Stick) and even some "Oriental" styles.

In Hanover, as in much of northern New England, the cultural imprint on architecture by the Victorian Period was not noticeable until the years following the American Civil War, a brutal war that raged from April 1861 to April 1865. And during those four prolonged years of war, both Hanover and Dartmouth College gave mightily to President Lincoln's persistent call to preserve the Union. By the time peace was restored at Appomattox Court House in Virginia on April 9, 1865, Hanover had enlisted 154 men to all branches of the Union's armed forces (counting reenlistments, 183

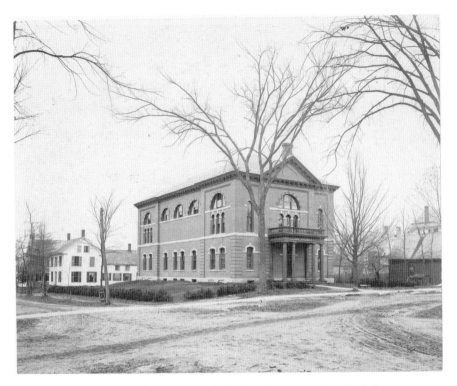

Bissell Hall (1867–1959), built on the site of Hopkins Center, was the gift of George H. Bissell, class of 1845. The Italianate-style building was designed as a gymnasium by architect Joseph R. Richards of Boston and cost $23,850. Mr. Bissell, a native of Hanover who grew up very poor, made a fortune as one of the first people to recognize the commercial value of petroleum. *Author's collection.*

men). Of that total, about 50 died or were wounded during the conflict. And during those years, Hanover citizens, on repeated occasions, voted to raise or borrow in excess of $78,000 for recruitment and bonuses, leaving a war debt of $42,000 when, in April 1865, the guns fell silent and Abram Lincoln lay dead from an assassin's bullet. For Dartmouth College and the Medical School, the total contribution of 652 men, including alumni, was, indeed, impressive. They, in part, represented 204 commissioned surgeons or assistant surgeons, 30 as second lieutenants, 47 as first lieutenants, 67 as captains, sixteen as majors, 21 as lieutenant colonels, 24 as colonels and 4 as brigadier generals. Dartmouth was able to boast that it had contributed a larger percentage than any other college in the North.

With the return of peace, the village and the College very quickly began to see new buildings with new architectural styles grace the Hanover Plain.

GEORGE BISSELL AND BISSELL HALL

George Henry Bissell (1821–1884), a native of Hanover and a 1845 graduate of Dartmouth College, was an entrepreneur and industrialist who is often considered the father of the American oil industry. While growing up in Hanover, George lost his father at the age of twelve, and his mother did laundry for students to earn a living, but it was up to him to work his way through Dartmouth. After graduation, he worked as a journalist and spent time as a teacher, school principal and superintendent before settling in New York City in 1853 to study law and languages in his spare time. Living in New York allowed Bissell to easily visit Hanover and maintain his numerous acquaintances, including Professor Dr. Dixi Crosby. During a visit in 1853, Bissell exhibited samples of western Pennsylvania "rock oil" in Crosby's laboratory at his home on North Main Street. Bissell was aware of the primitive oil gathering industry that was then taking place, in which blankets were used to soak up oil that naturally flowed on the surface of the ground. The oil-soaked blankets were then draped over wooden barrels to drain, and the "refined" oil was then used for medicinal purposes—hence Dr. Crosby's interest in the samples that he had in his Hanover laboratory. Bissell reasoned that the oil could be refined to a greater degree and made into kerosene, then in great demand for lighting, and could replace the whale oil and coal oil that was then commonly used for illumination.

Recognizing the potential for rock oil, in 1854, Bissell and his law partner, Jonathan Eveleth, purchased a 105-acre farm in Western Pennsylvania and formed the Pennsylvania Rock Oil Company, the first oil exploration company in the United States. Bissell and Eveleth then hired Yale University chemist Benjamin Silliman Jr. and coal oil chemist Luther Atwood of Boston to evaluate the suitability of the rock oil for making a refined oil suitable for illumination, which was positive. In 1856, after seeing pictures of derrick drilling for salt, Bissell conceived of the unusual idea of drilling for oil, rather than mining it or digging for it as was done with salt wells. Therefore, Bissell and Eveleth pursued the idea and sought investors. This included a group from New Haven, Connecticut, that eventually formed the Seneca Oil Company. Although Bissell and Eveleth had a royalty dispute with the investors in Seneca Oil Co., a business relationship resulted.

On August 27, 1859, the company first succeeded in striking oil on a farm in Titusville, Pennsylvania. As a result of the business relationship between Pennsylvania Rock Oil Co. and Seneca Oil Co., Edwin Drake became involved in the enterprise through his employment with Seneca Oil Co., and

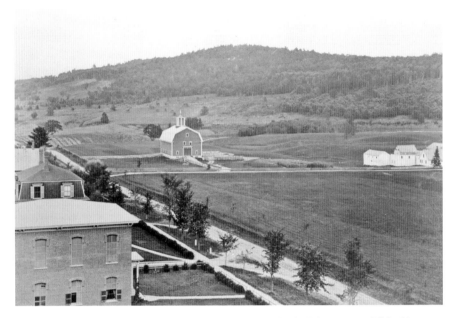

The New Hampshire College of Agriculture and the Mechanical Arts was established in Hanover in 1866, and by 1879, when this view was taken from Culver Hall, the first of a complex of farm buildings had been constructed on the east side of South Park Street. All of the land shown in the fore and background was part of the farm. *Courtesy of Dartmouth College.*

Drake played a critical role in the first successful oil well in the region. Bissell, through Pennsylvania Rock Oil Co., invested heavily in the surrounding area and soon found himself a wealthy man.

Dartmouth president Reverend Asa Dodge Smith understood the necessity of having a gymnasium on campus, and George Bissell, then a man of wealth, wanted to give back to his native community and alma mater. The Boston architectural firm of Richards and Park was hired, and Joseph R. Richards designed the new ninety-foot-by-forty-seven-foot two-story facility. On the ground floor were six bowling lanes, and the second floor was an open gymnastic hall. The initial design was to be an all-granite building; however, to save money, brick masonry with granite trim was substituted. Nonetheless, the final cost of the building when it was completed by Ivory Bean, also of Boston, was $22,006.44. Work was begun in May 1866, and the building opened for students in March 1867. Ninety-two years later, the building was razed to make way for the construction of the Hopkins Center, and the name Bissell Hall was transferred to one of the new Choate Road dormitories constructed in 1958.

THE NEW HAMPSHIRE COLLEGE OF AGRICULTURE AND THE MECHANICAL ARTS

During the Civil War, one of the most consequential pieces of Congressional legislation, the Land-Grant Agriculture and Mechanical College Act of 1862, also known as the Morrill Act, came about. The origins of this far-reaching and progressive legislation had roots in the 1830s in the upper midwestern region of the country. At that time, a movement had begun advancing the idea that the creation of public agricultural colleges was necessary to advance the county's development. The act stated it was clearly in the public's best interest to establish and fund such institutions.

In 1855, Justin Smith Morrill (1810–1898) took his seat as a new congressman, representing Vermont in Washington. Morrill, a self-made man in all respects, had been very successful as a small-town merchant in his hometown of Strafford, Vermont, such that he was able to retire at the age of thirty-eight. The draft of a bill originating from Illinois, calling for the creation of agricultural colleges, was being discussed in the halls of Congress; however, to gain broader support, it was thought that the bill would be best introduced by an eastern congressman. Believing deeply in the advancement of educational opportunities, Representative Morrill introduced the bill in 1857, and it passed both houses of Congress in 1859. President James Buchanan did not support the bill and vetoed it, and for the next several years, it lay dormant.

Morrill amended and resubmitted the bill in 1861. The new bill proposed that the newly created public colleges would teach military tactics and engineering, as well as agriculture. Aided by the secession of the Southern states that had not supported the earlier bill, what became known as the "Morrill Act" readily passed through Congress and was signed into law by President Abraham Lincoln on July 2, 1862. As for Morrill, in 1867, Vermont elected him to the Senate, where he served until his death in 1898. During that time, he was responsible for legislation that made meaningful amendments to his original legislation.

In concept, the mechanism behind the Morrill Act was quite simple. Every state was eligible to receive thirty thousand acres of federal land per each member of Congress based on the 1860 census. Proceeds from the land, by sale of lease, were to endow and maintain a college for that state. The purpose of that college, established and overseen by each state, was to teach both men and women the agricultural and mechanical arts and to promote a liberal and practical education for the growing middle classes,

both rural and urban. As a result, the land grant colleges transformed engineering education in America and boosted the United States into a position of leadership in technical education. Before the Civil War, American colleges trained students in classical studies and the liberal arts. Education was for the affluent, and entrance requirements often included proficiency in the dead languages of Latin and Greek, therefore excluding all of the working classes. American engineers were mostly educated on fortress construction at the United States Military Academy, and their instructors were the authors of most engineering texts of the day. The Morrill Act changed all of that.

Overall, the Morrill Act allocated 17,400,000 acres of land, which, when sold, yielded $7.55 million. By 1879, twelve states had used their grants to establish new agricultural and mechanical arts colleges; nineteen had given to existing state universities or colleges; and six had given to existing private colleges. New Hampshire sold its land grant of 150,000 acres for $80,000 and chose to establish a new school but in a unique relationship with an existing private institution: Dartmouth College.

General David Culver had been a successful businessman in New York City before retiring to Lyme, New Hampshire. He offered to gift his entire four-hundred-acre farm, valued at $20,000, and $30,000 in cash so that the state would locate its proposed new school there. However, by June 1866, the Culver estate was being challenged in court, and a competing offer was made by Dartmouth College, then the only college in the state. The legislature decided on July 7, 1866, to associate the new agricultural school with Dartmouth, an older and already established institution, and locate it in Hanover, not Lyme. Soon, extensive contracts were executed between the state and Dartmouth, and planning for the new school proceeded accordingly. In concept, the new state school was to act in concert with Dartmouth, rather than establish itself as a separate institution. Dartmouth, looking to benefit from the arrangement, was to receive the proceeds from the sale of the state's land grants. This fund would go toward the new agricultural curriculum and the State's scholarship students. In return, the new school would be allowed to use Dartmouth's existing facilities and professors—a much better arrangement than the state could otherwise afford. Five members of the new school's board of trustees were to be appointed by the State of New Hampshire, and four were to be selected from Dartmouth's Board of Trustees. The president of Dartmouth would also serve as the president of the new state school.

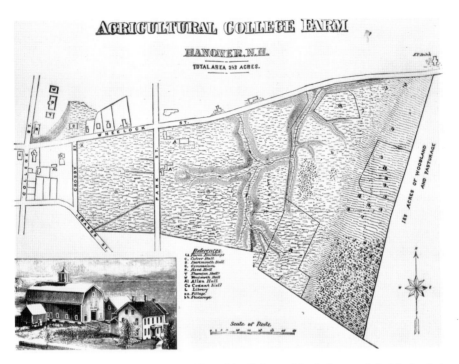

A map showing the extent of the New Hampshire College of Agriculture and the Mechanical Arts when it existed in Hanover from 1866 to 1893. The map was created circa 1885.

The presence of the state school in Hanover was noticeable for the buildings that were erected and the quantity of land that school acquired to be used as part of its educational operations. An important part and central focus of the new school was the experimental farm, which utilized the 25-acre "front field," located where present-day Alumni Gymnasium and Memorial Field now stand, stretching east from Crosby Street and south from East Wheelock Street. The land was purchased from S.M. Cobb in August 1869 for $3,625. In its entirety, the state farm owned about 330 acres of land. In addition to the front field, the state paid $7,000 for the former 135-acre Chase farm that stretched to the east from South Park Street, to Balch Hill, now home to Chase Field and the Valley Road neighborhood. In 1873, the state paid $6,234 to add an adjoining 185 acres. In total, the school actively worked 77 acres of fields and 251 acres of pastureland and woodlot.

When the Chase farm was acquired, those buildings were generally in poor condition, although, at first, the school used them. Gradually, during the early 1870s, these buildings were replaced. The first was a modern fifty-by-one-hundred-foot barn that some criticized as being an overly theoretical extravagance. Soon, however, additional farm buildings followed, including a new superintendent's house, a dairy, a poultry house and other outbuildings. The last building that the state constructed at the farm was named the New Hampshire Agricultural Station, which was completed in 1889. This impressive masonry building, featuring large arched window openings on its first floor, facing South Park Street, is still extant. Its purpose was to allow students to experiment with all aspects of farming: plant development and structure, animal husbandry and diseases, dairy techniques and crop rotation.

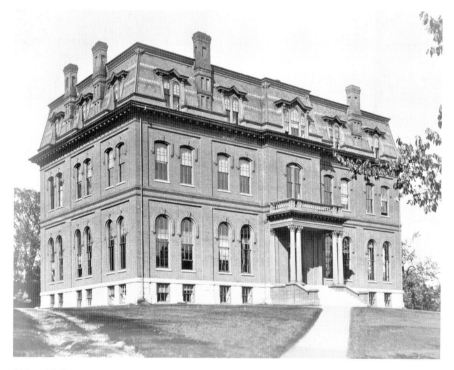

Culver Hall (1871–1929) was the flagship building of the New Hampshire College of Agriculture and the Mechanical Arts. Located on the north side of East Wheelock Street and positioned to look down Crosby Street, Culver Hall was designed by architect Edward Dow of Concord. By 1929, when Culver Hall was torn down, it was an unwanted and thought of out-of-style old Victorian frump. *Courtesy of Dartmouth College.*

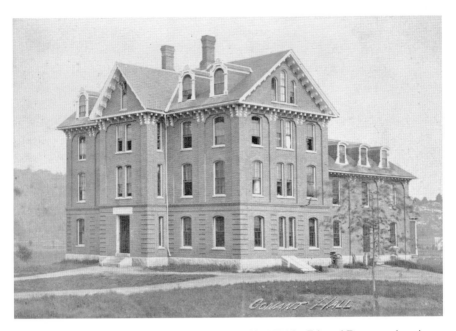

The Italianate-style Conant Hall was also designed in 1874 by Edward Dow as a dormitory and dining facility for students attending the New Hampshire College of Agriculture and the Mechanical Arts. The front portion of the building was torn down in 1925 after the completion of Topliff Hall. The rear portion still remains as Hallgarten Hall. *Courtesy of Dartmouth College.*

As part of the Dartmouth campus, the state constructed several impressive buildings. The first was the largest: Culver Hall, which was erected on a sloping site on the northern side of East Wheelock Street, overlooking and facing south, down the newly laid out Crosby Street. This new classroom building was the most modern building in Hanover and one of the finest in all of New Hampshire. It was used intensely by both Dartmouth and the state school. Designed by Edward Dow, a Concord-based architect of wide reputation, the masonry four-story structure featured a stylish Mansard roof and gas lighting—the first building in Hanover to do so. The gas plant was located across the street, where the present-day heating plant now stands. The cornerstone was laid in June 1871, and the building was completed two years later. The building contained the two schools' joint chemistry laboratory and departments of mineralogy, geology and natural history. In 1877, when Dartmouth's Thayer School of Engineering needed space, the state allowed it to use space in the building.

The second major building constructed by the State was Conant Hall, which was situated on the south side of east Wheelock Street, across from

Culver Hall, the site of present-day Topliff Dormitory. This was a five-acre parcel made up of vacant land from both the Gates and Allen lots (now the site of Wilson Hall) that was purchased by the state in 1873. John Conant of Jaffrey was a generous benefactor of the school during its years in Hanover, and he gifted more than $70,000 during that time. After learning that students were boarding in houses scattered throughout the village area, he donated $5,000 for the purpose of constructing a new "boardinghouse," estimated to cost $12,000.

Conant Hall was also designed by Edward Dow; however, because it was to serve as a residential and dining facility (and so as not to convey the sense that it was a public building like Culver Hall across the street), Dow chose to give it a domestic air. The building had thirteen suites for students, and on the first floor, it had a dining room that could feed 135 students from both colleges. Much of the food was harvested from the state school's adjacent experimental farm. When it opened in the fall of 1874, the cost of the completed building that served as the residential heart of the state school was $22,358.

As important as the agricultural functions of the school were, the teaching of mechanical arts was important as well. South of Conant Hall was Allen Hall, a wood-frame workshop building that was constructed about 1874, and an additional classroom and workshop building that was constructed in 1888. In this latter building were a steam boiler, engine and other pieces of machinery.

Certainly, in concept, having the New Hampshire College of Agriculture and the Mechanical Arts in Hanover, in partnership with Dartmouth College, was a sound idea. For a time, there was even the idea of merging the Chandler School of Sciences and the Arts, a Dartmouth affiliate, with the mechanical arts branch of the state college. However, Samuel Colcord Bartlett (1817–1898), a graduate of Dartmouth's class of 1836 and the eighth president of Dartmouth College (from 1877 to 1892), was never convinced that either the Chandler School or the New Hampshire College was pulling its weight. He repeatedly reminded students from both schools that they were not part of Dartmouth but, rather, an independent school. Of the state's agricultural course of study, whose students he referred to as "aggies," he said that it was only intended for men suitable "for highway surveyors, selectmen, and perhaps, members of the legislature." And clearly, the male and female students were socially distinct from those young men enrolled at Dartmouth. As early as 1885, the state began to investigate relocating the school from Hanover to a new location. At the

height of its popularity, in 1880, the school had a maximum of forty-two students enrolled, and among the farmers of the state, there was considerable dissatisfaction with the schools' progress.

Benjamin Thompson of Durham, New Hampshire, died in January 1890. He was a bachelor and left to the State of New Hampshire property appraised at $408,220.71, including a large farm valued at $18,300.00. The bequeathment was conditioned on the New Hampshire College of Agriculture and the Mechanical Arts being moved to his farm in Durham within two years. So, the last student graduated from the school in Hanover in the spring of 1893, and Dartmouth College purchased some, but not all, of the state school's property. Dartmouth paid $15,000.00 for the state's real estate located south of East Wheelock Street and west of South Park Street, including Conant and Allen Halls. In accordance with the original contract between the two schools, Dartmouth paid the state $15,000 for Culver Hall that was located on Dartmouth-owned land. The Thayer School of Engineering purchased the experiment station building on South Park Street for $3,000.00, and this became the school's first permanent home. Dartmouth chose to buy only twenty-two acres of the large experimental farm, and the farm buildings, located east of South Park Street, were acquired by John M. Fuller, which he later sold to Dartmouth in 1921. About that year, the barn and outbuildings were taken down, and the farmhouse was razed in 1962. The front portion of Conant Hall was razed in 1925, on the completion of Topliff Dormitory; however, the rear kitchen section still remains behind the newer L-shaped dormitory, known today as Hallgarten Hall. The Allen Hall shop buildings were taken down in 1916 and replaced by the college's own shop buildings. Culver Hall was completely demolished in 1929. By then, it had become just an old unwanted Victorian frump on the newly evolving Dartmouth campus. In 1923, the state renamed the New Hampshire College of Agriculture and the Mechanical Arts the University of New Hampshire. It appears that the state school recalls its early history in Hanover better than Dartmouth does. However, although few traces of the state school remain today, much of the layout of the present-day expanded Dartmouth campus is a direct result of the large land purchase that the school was able to make in 1893 as the state school left Hanover for Durham.

The Chandler School of Sciences and the Arts

One can certainly debate the reasons why Moor's Indian Charity School was unsuccessful, but it was becoming increasingly clear that the school, as a part of Dartmouth College in Hanover, New Hampshire, was no longer able to justify keeping the so-called Academy Building, located on the western side of campus on North Main Street, open. As a result, the school was closed for good in 1849, only twelve years after the handsome Greek Revival–style building had been constructed. However, it would not sit vacant for long because, in 1852, it was reopened as the home of the College's new Chandler School of Sciences and the Arts.

Abiel Chandler of Walpole, New Hampshire, was a graduate of Harvard (class of 1806) who, after his graduation, was first a teacher before becoming a successful businessperson in Boston. On his death in 1851, he bequeathed to Dartmouth College the sum of $50,000 for the establishment and support of a permanent scientific department or school. As the will directed, the instruction should be given in the "practical or useful arts of life composed chiefly in the branches of mechanics and civil engineering, the invention and manufacturing of machinery, carpentry, masonry, architecture and drawing, the investigation of the properties and uses of the materials employed in the arts, the modern languages and English literature, together with bookkeeping and such other branches of knowledge as may best quality young persons for the duties and employments of active life." Furthermore, Chandler stipulated, "No other higher preparatory studies are to be required in order to enter said department or school than are pursued in the common schools of New England." This was a lesser requirement than what was needed to enter Dartmouth College at that time. And there were some other strict conditions for accepting Mr. Chandler's very substantial gift.

With some amount of hesitation and debate, the College's Board of Trustees found it hard to decline such an offer, and in 1851, it voted to establish a department called the Chandler School of Sciences and the Arts, and the following year, the school opened with nineteen students in the former Moor's Academy Building, renting it for $175 a year. At first, the school operated at a loss and was a drain on the college; however, by the 1860s, the school had begun to show an annual surplus.

Due to the growth and success of the school, it was decided in 1871 to substantially remodeling Chandler Hall—as it was then often referred to—to provide more floor space and to give the aging building a fresh

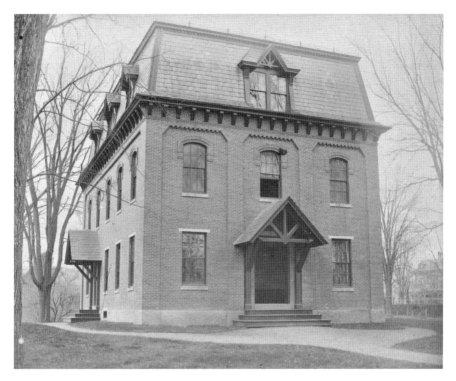

Ammi B. Young's 1837 academy building was substantially remodeled in 1871 at a cost of $7,037.32. The remodel included a new third floor, and the entire building was the home of the Chandler School of Science and Arts and renamed Chandler Hall. All aspects of Young's Greek Revival architecture were erased, as that earlier style had fallen from fashion and favor. *Courtesy of Dartmouth College.*

contemporary "French" look. This writer does not know for sure who played the role of architect for this clever makeover; however, it was probably Frank A. Sherman, a professsor at the school. Regardless, when complete, little of Ami B. Young's earlier, beautifully proportioned masterpiece remained. To create a new third floor, the belfry and the classic gable roof and pediment were removed. The height of the second-floor window openings and the brickwork were extended up to create arched windows and corbelled masonry that supported heavy ornate cornicework and a mansard roof with ornately embellished double dormers for the third floor. Throughout the building, the delicate twenty-over-twenty window sash was replaced by a six-over-six sash, representative of the period, and classically proportioned exterior doorways gave way to contemporarily styled replacements with heavy timber-bracketed hoods. The remodeling cost $7,037.32.

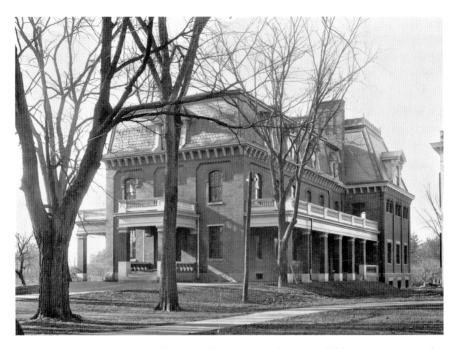

By 1898, it was time to expand Chandler Hall again, and a large addition was constructed across the back side of the building, with new entry porches along the sides. Designed by architect Charles Alonzo Rich, by the time the building was torn down in 1937, it was being referred to as the "ugliest building in Hanover." *Courtesy of Dartmouth College.*

From the start, the Chandler School was always treated by the College as the poor relative—just as what happened to the State's agricultural college. The students at Dartmouth were categorized as either "Chandler" or "Academic." When Dartmouth worked with the State to set up the agricultural school in 1866, it was suggested that Chandler School might be combined with the new state college, but that never happened. Finally, in 1893, the new president of Dartmouth College, Willian Jewett Tucker (1839–1926), resolved the matter. The school became part of Dartmouth, offering the Chandler Scientific Course. That was the same year the New Hampshire College of Agriculture and the Mechanical Arts departed for its new campus in Durham.

Architect Charles Alonzo Rich (1854–1943) of the New York City–based firm of Lamb & Rich, was an 1875 graduate of the Chandler School, and in 1893, he was hired by the college to prepare its first master plan. Between that year and 1914, Rich was to design two dozen new buildings on the Dartmouth campus, including major additions and alterations to the Chandler School

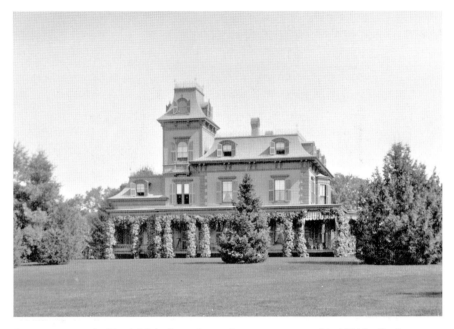

For many years, the North Main Street house that was constructed in 1864 by Professor Henry Fairbanks of the St. Johnsbury scale manufacturing family was the home of Mary Maynard and Hiram Hitchcock. The property included sweeping lawns and views of the River. In 1920, the house was razed for the development of Tuck Drive. *Author's collection.*

facility in 1898. The new work cost $28,000 and included a large four-story addition on the rear and long flanking porticos of each side of the existing building, with an ornated entry porch also being added to the front. As welcomed as this additional space might have been, by 1935, the building had become an unused and unwanted orphan, and the Trustees ordered its demolition at their October 1936 board meeting. Writing in his 1932 *History of Dartmouth College*, Leon Burr Richardson said, "What had been a simple, harmonious edifice became unquestionably the ugliest building in Hanover."

THE MARY HITCHCOCK MEMORIAL HOSPITAL

In August 1770, when Reverend Dr. Eleazar Wheelock, his son-in-law Sylvanus Ripley and a small gang of laborers arrived on the Hanover Plain and set to work establishing Dartmouth College, with them was Dr.

John Crane, Wheelock's fifty-nine-year-old personal physician and close confidant. Crane was granted a choice lot on the south side of the Green, and by 1773, he had erected a fine two-story framed house, from where he practiced medicine. Thus, integral with the founding of Dartmouth in Hanover, the medical profession has always been present in the campus and village area, and the rural region at large. During the American Revolution, Doctor Crane went on to serve three years as a surgeon in the Massachusetts Sixth Regiment and as a procurer of medicines, reportedly in high quantity and at a good price. Other practicing physicians soon settled within the region, including Dr. Laban Gates, who, in 1785, built for himself and his family an impressive two-story framed house on the present-day site of Wilson Hall, on the southeastern corner of the Green. However, it was Dr. Nathan Smith who, by establishing the Dartmouth Medical School in 1797, ushered in a new era of medical importance for Dartmouth College, the village and the region at large.

By the early decades of the nineteenth century, the medical school was attracting men of talent and sufficient background who were both gifted professors of medicine and very capable physicians. Among these men was Dr. Dixi Crosby, who, in 1850, opened the region's first hospital in his house on North College Street, across from the medical school. Unfortunately, with Crosby's retirement in 1870, the hospital, such as it was, closed. Fifteen years later, in 1885, Dr. Carleton P. Frost, then the Dean of the Dartmouth Medical School, together with a group of local physicians, organized the Dartmouth Hospital Association. Their goal was to construct a modern hospital within the campus/village area that would not only care for the sick but also play a part in educating the next generation of doctors. During the American Civil War and in the decades that followed, significant advancements were made in medicine and in treating the injured and the sick, and this undoubtedly played a role in these men's thinking. It was not long after the formation of the Dartmouth Hospital Association that a small tract of open farmland was purchased on the northern edge of the village, situated between the road north to Lyme and the old road that ran north, down to the Connecticut River and the site of the old Rope Ferry, which had, by then, been long ago abandoned. And with the goal of eventually constructing a hospital facility on this site, a building fund was started that, at first, had only a small sum of money on hand. The prospect of raising additional funds looked bleak, indeed. However, Hiram Hitchcock would soon change that.

The story of Hiram Hitchcock (1832–1900) and Mary Maynard Hitchcock (1834–1887) is a fascinatingly rich tale of the intertwined lives of two persons who, unfortunately, cannot be sufficiently accounted for in the space provided within these pages. They were both born to respectable families in Drewsville, New Hampshire (Drewsville is a village within the town of Walpole), and were educated in the local schools. Hiram attended Black River Academy in Ludlow, Vermont, in preparation for going to college, which he never did. Instead, after he and Mary were married, they settled in New Orleans, where Hiram began what was a remarkable career in the hotel business. After only a few years, they were back up north in New York City. There, Hiram and two other investors built the Fifth Avenue Hotel, the largest and, quickly, finest hotel in the city. Business was so good that, in 1866, at the age of thirty-four, Hiram was able to retire, and he and Mary chose Hanover as their new home. The Hitchcocks purchased the spacious home of Professor Henry Fairbanks,

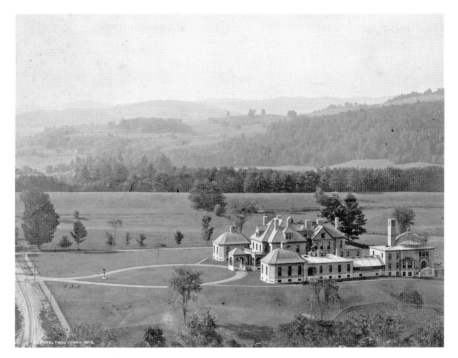

When the new thirty-six-bed Mary Hitchcock Memorial Hospital was opened in May 1893, it was a state-of-the-art facility in every respect, located on the northern edge of the village and campus area. In the late 1890s, residential development began along Occum Ridge, and in 1900, Occom Pond was created by damming up a marsh area. *Author's collection.*

which had been recently constructed on North Main Street in the very fashionable "French" style and included extensive landscaped grounds that reached down to the River. The house was located where Russell Sage Dormitory is today. For the Hitchcocks, the setting in Hanover was, no doubt, reminiscent of similar mansions that were still standing at that time along Broadway, overlooking the Hudson River in Westchester County.

Hiram continued to be involved in his many New York–based activities, but both he and Mary plunged into regional affairs in Hanover and beyond in New Hampshire. Hiram was elected to the state legislature and became a member of the Governor's Council, and he served on the Board of Trustees for the New Hampshire College of Agriculture and the Mechanical Arts in Hanover and on the Board of Trustees for Dartmouth College from 1878 to 1892. Their considerable business interests in New York City and beyond meant that they divided their time between Hanover and the city, all the while keeping up with a busy social schedule and a wide circle of friends and acquaintances.

Unexpectedly, Mary died in 1887 in New York of unknown causes. She was only fifty-five, and she and Hiram had no children who had survived into adulthood. In his grief, Hiram looked to memorialize her life. He paid to redecorate the church that overlooked the northeast corner of the Green and paid for a new organ. But this was not enough to satisfy the grief that Hiram continued to experience.

Dr. Carlton P. Frost, a man instrumental in the formation of the Dartmouth Hospital Association and a friend of the Hitchcocks, along with several other Hanover doctors, approached Hiram, and he agreed to give a hospital to the community in her name as a living memorial to her life. A corporation of twenty men was set up and chaired by Hiram Hitchcock, and the first meeting was held on September 2, 1889. During the meeting, twelve trustees were elected to oversee planning for the new facility. The Dartmouth Hospital Association donated its land and then went out of existence. Hiram purchased additional land, thereby making the site for the new building five and a half acres.

The firm of Rand & Taylor of Boston, Massachusetts, was hired to design the new facility. George Dutton Rand was a noted hospital architect of his day and had recently completed work on the State of New Hampshire's Insane Asylum. That may have been how he came to Hitchcock's attention. Regardless, the building that Rand designed was not only a state-of-the-art facility, but it was truly innovative for its time. The plan was for four distinct buildings: a south-facing central administrative building with an elevation

of two stories and an attic; two one-story men's and women's pavilions connected to the central building by open twelve-foot-wide corridors that also served as sunrooms; and a surgical building that was especially designed for the purposes of the medical school. Connecting the surgical building to the east pavilion was an east-facing conservatory for growing fresh plants and flowers and providing a place of rest and pleasure. The overall style of the building was unique and fresh for the day and was based on the architecture of the early Italian Renaissance. The exposed foundations were faced with rough-faced granite that supported the exterior masonry walls that were faced with Pompeian mottled brick trimmed with terra-cotta ornamentation. The roofs were covered with red Spanish tiles. The entire building complex was of fireproof construction and was the first in America that was specially designed utilizing the patented Guastavino vaulting system as manufactured by the Guastavino Fireproof Construction Company of New York, which had been established in 1889 by Rafael Guastavino (1842–1908), an architect and builder originally from Valencia.

The building's interior featured richly inlaid floors, quarter-sawn oak wainscotting, Corinthian columns that supported high-arched ceilings and a central fireplace and mantle of highly polished Sienna marble. The building's heating and ventilation systems were as innovative as the architectural design. The operating theater, located under the domed roof and skylight of the surgical building, was the first of its kind in in America. Well lighted both naturally and with electricity, it contained 150 seats for medical students and visiting doctors to observe operating procedures. From start to finish, design through construction, every detail was carefully overseen by Mr. Hitchcock. Construction was started in 1890, and on May 3, 1893, the finished thirty-six bed facility was dedicated. In total, it was estimated that Hiram Hitchcock spent $200,000 on this memorial to his beloved wife, Mary. Set on beautifully landscaped grounds, the building was a handsome addition to the town, and it brought fame, as architectural magazines in North America and abroad praised the building for its combined elegance and utility. Today, only the western pavilion and a portion of a connecting sunroom survives.

From the earliest days of settlement on the Hanover Plain, there have been noted physicians associated with, first, the college and the medical school and then, later, with the Mary Hitchcock Memorial Hospital. The last names of Smith, Crosby and Frost are storied within the history of medicine in Hanover, as is the name Gile. John Martin Gile (1864–1925) was born in Pembroke, New Hampshire, and he was a graduate from Dartmouth in 1887 and from the medical school in 1891. He began his

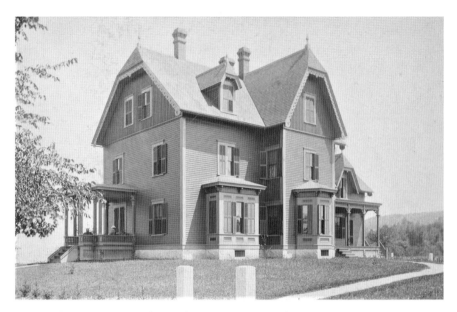

Frank A. Sherman was a professor of mathematics at the Chandler School. He apparently had an eye for contemporary architecture. He not only designed the new village school in 1877, but in 1883, he designed his new home, situated at the corner of North Main and Maynard Streets. By the 1920s, it had become the Sigma Phi Epsilon fraternity house and was remodeled in the very chic English Tudor style of the day. The building remains extant. *Courtesy of Dartmouth College.*

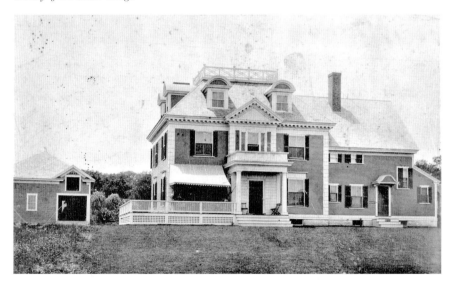

In 1896, Dr. John M. Gile had constructed for his family this Colonial Revival–style home, situated on the south side of Maynard Street. Dr. Gile was a major figure at the new hospital across the street. In its later years, the house was used by the hospital as Fowler House, but it was eventually demolished in 1992. *Courtesy of Dartmouth College.*

career back in Hanover in 1896, practicing medicine as a surgeon; he eventually became dean of the medical school in 1910. By the time of his death in 1925, he was regarded as one of the leading surgeons in the State, and he generously gave his time, both professionally and civically. John Fowler Gile (1893–1955), John Martin Gile's son, followed his father in the regional medical field and also became a much-respected figure.

Through the nineteenth century, the Dartmouth Medical School remained a small but well-respected college of medicine, occupying the single building that had been constructed in 1811 and overlooked North College Street. In 1871, the building was extensively altered as the result of a generous gift from Mr. E.W. Stoughton, a lawyer in New York City, in the amount of $12,000. The stipulated purpose of Mr. Stoughton's gift was for the establishment of a museum of pathological anatomy; however, there was not space within the existing building for such a museum, so the decision was made to open up the center section of the existing building, raise the roof by a story and include a four-sided lantern that thoroughly illuminated the interior with

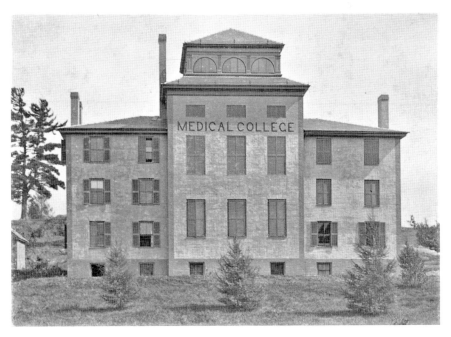

The original Dartmouth Medical School building, occupied in 1811, received alterations and an additional floor in the center section of the building in 1871. By 1963, the old building was obsolete and no longer needed; therefore, it was demolished. *Courtesy of Dartmouth College.*

abundant natural light. Other alterations were made to the building, including the refitting of a large lecture room on the first floor and the construction of dissecting rooms in the basement. The halls leading to these rooms were made convenient and attractive with a wainscotting of black walnut. The end result was such that the school's catalog boasted that "the facilities for teaching and for the accommodation of students have been greatly increased." During the next five years, the number of medical school students nearly doubled. The building was completely demolished in 1963.

BUTTERFIELD HALL

Butterfield Hall, although it was, perhaps, the shortest-lived of any major building ever erected on the Dartmouth's campus, marked the beginning of the "new Dartmouth," a refounding of the 124-year-old institution that had started in 1893. That year, the college installed Dr. William Jewett Tucker (1839–1926) as its ninth president. Tucker, of the class of 1861, was responsible for bringing the college's curriculum, facilities and every aspect of its organization into a new and modern era. When he assumed the office, the college was in debt, with only slightly more than 300 regional students. By 1909, when he stepped down, more than twenty new buildings had been constructed, including a modern central steam heating plant; the student body had grown to more than 1,100 students from across the country and foreign nations; the faculty had grown from 26 to 81 persons; and the curriculum had been significantly broadened to offer a modern liberal arts education.

In early 1893, as the New Hampshire College of Agriculture and the Mechanical Arts was preparing to leave Hanover for Durham and the Chandler School of Sciences and the Arts was, at last, being integrated into the Dartmouth curriculum, the college hired Charles Alonzo Rich (1854–1943), a noted architect from New York City and a partner in the firm Lamb & Rich, to prepare a master plan to help guide the anticipated growth that was soon to follow. Rich had grown up in the upper valley and was an 1875 graduate of the Chandler School at Dartmouth. It was clear that the campus was going to be substantially expanded, and the centerpiece of that was a new formal quadrangle, located immediately north of the existing Green, that would be lined with new buildings on three sides.

Coinciding with the hiring of Rich to prepare a master plan for the College, in January 1893, news was received that Dr. Ralph Butterfield of the class of 1839 and a resident of Kansas City, Missouri, had died. His will made the College his residuary legatee, divesting his property for the foundation of a professorship or lectureship in paleontology, archaeology, ethnology and kindred subjects and for the construction of a building that, in part, was to house a museum to which Dr. Butterflied had given some notable collections. From this bequest, the college received a bit more than $141,000, of which $87,350 was used in the construction of the new Butterfield Hall.

Charles Rich was commissioned to design the new building—his first major work on the Dartmouth campus. By 1914, he had designed a total of two dozen buildings for the Dartmouth campus. However, what became Butterfield Museum was, perhaps, his most unique design—it was also the shortest-lived of his major Dartmouth commissions. It was decided to place the new building at the center of the proposed new quadrangle, set well back to the north, facing the Green. The long-range plan was that, eventually, the houses lining Wentworth Street would be moved away, and the vista from the new museum building to the Green would be opened up. Rich chose to design the building in the Beaux-Arts style that was becoming increasingly popular in America. It originated as an academic architectural style taught at the Ecole des Beaux-Arts in Paris. It drew on the principles of French neoclassicism and incorporated Gothic and Renaissance elements with such modern elements as iron and glass. The most striking and unique feature of Rich's design was the use of yellow or "buff" Roman brick, similar to the Marry Hitchcock Memorial Hospital, which had been completed several years earlier and was within sight of the new Dartmouth quadrangle. Limestone and terracotta was combined with the brick masonry to make for an ornately trimmed, cutting-edge and contemporary building.

The cornerstone for Butterfield Hall was set during the summer of 1895, and the building was completed the following year. It was also planned that a similar piece of architecture, in the form of an ornately domed buff-brick building to be called Alumni Memorial Hall, would soon be erected on the corner of North College and Wentworth Streets as part of the new quadrangle development. Alas, when such a building was finally built in 1907, it was considerably toned down and named Webster Hall.

There is no indication that the building was not well received, although noted architectural critic Montgomery Schuyler wrote in 1910 that the

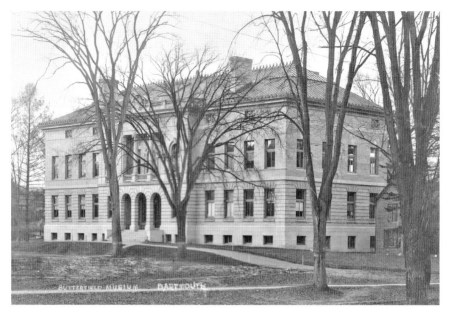

The short-lived Butterfield Museum, which was constructed in 1896 and demolished in 1926, was located on the lawn area in front of Baker Library, facing the Green. As substantial as the building was, its yellow brick looked out of place, and by the 1920s, it found itself in the way of an even more substantial library. *Courtesy of Dartmouth College.*

building appeared to have been designed without any later buildings in mind. By 1925, planning was underway for a new library facility, which the college badly needed. Prevailing architectural tastes had turned away from the Beaux-Arts style that had been so favored by the previous generation of architects and planners, and Colonial Revival architecture was the preferred look, especially for college campuses. At Dartmouth, it was agreed that Butterfield Hall, then considered as fine a building as then stood on the campus, would be razed, and eight other structures be moved away or torn down for the construction of Baker Library. While the new library was under construction, in 1926, Butterfield Hall was demolished. So short-lived was the building that, in 1933, when Rich was compiling a list of his work in Hanover, he could not even recall the building's name. However, in September 1939, work was begun on a new dormitory located on the north side of Tuck Drive that would be named for Dr. Butterfield, in remembrance of his generosity to the college almost fifty years earlier.

Steam Heat

Until 1823, Dartmouth Hall, that was, for all intents and purposes, "the college," was heated by unsafe and inefficient wood-burning fireplaces. That year, the Trustees voted to brick up all of the fireplaces and start heating with stoves. By 1869, coal began to be available in Hanover, transported by rail to the Lewiston Depot in Norwich. Thus, a hotter heating source than wood became available on the Hanover Plain to burn in stoves and furnaces. The first coal-fired steam boiler with radiators was installed in Reed Hall in 1875 at a cost of $2,400, and although it was a considerable step forward, it was a major expense.

When the Trustees and the new president William Jewitt Tucker made the decision, in 1893, to substantially grow, modernize and, in the process, virtually remake the college, this presented a series of questions that needed to be addressed. The first was how to secure an abundant and adequate water system. This was done in cooperation with the Village Precinct of Hanover, and the result was the construction of a 137,000,000-gallon reservoir that was about two miles from the village/campus area and a gravity distribution

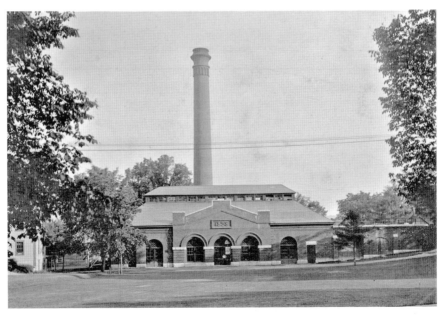

Part of the modernization of Dartmouth College, initiated in 1893, was the development of a coal-fired central heating plant to provide steam heat to all of the campus's buildings. The new facility was designed by Charles Alonzo Rich in 1898 and is still extant; however, due to alterations and additions, it is hardly recognizable today. *Courtesy of Dartmouth College.*

system. The total cost was $65,000; the college put in $25,000, the precinct put in $20,000 and the balance was raised by bonds.

The second question to be resolved was that of an efficient central heating system that could reliably serve multiple buildings—both already existing and those planned to be constructed. The answer was the construction in 1898 of a new central coal-fired steam-generating heating plant, designed by Charles Alonzo Rich and located on the site of the former gasworks on East Wheelock Street. This state-of-the-art facility cost $89,000, had eight boilers and fed steam into 7,900 feet of new pipelines that were buried about the campus area. In 1904, an electric plant was added, with cables costing $34,000, that furnished power to all of the college's buildings.

Fraternities

The first Greek letter fraternal society organized on the Dartmouth campus was Zeta chapter, Psi Upsilon, which arrived in 1841. Soon, others followed, meeting in rented halls and spaces within the village area—several or more in the upper floors of the Tontine Block. The Kappa Kappa Kappa Society was the first to build its own hall in 1860, located on South College Street. The Italianate-style single-story hall (basically, a single room box-shaped building) came to be owned by the Dragon Society, which, in 1917, substantially remodeled the modest building with a classically inspired colonnade front portico with a pediment roof. The building was razed at the completion of Hopkins Center and the elimination of South College Street in 1962.

Not to be outdone by their Tri-Kapp brethren, members of Alpha Delta Phi (ADP), also an early fraternity on the Dartmouth campus, in 1872, constructed a building of their own, the second in the village. Unlike the Tri-Kapp facility, this was far more than a wood-framed meeting hall. The ADP House was of brick masonry construction, comprised two stories and had additional rooms beyond just the meeting hall; thus, it was the forerunner of the modern fraternity house that, during the twentieth century, became so common on the Dartmouth campus. The building of inspired Italianate design was located at 9 East Wheelock Street and cost about $4,000 to construct. It was razed in 1921 to make way for the much larger Georgian Revival–style building that still occupies the site.

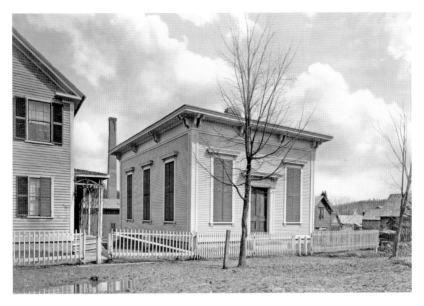

The Kappa Kappa Kappa Society (Tri Kap) Hall was erected in 1860 and located on South College Street. The building was razed after the Hopkins Center was constructed in 1962 and South College Street was eliminated. The brick chimney beyond was part of an early gas plant that was constructed in 1872 for making illuminating gas from oil. *Courtesy of Dartmouth College.*

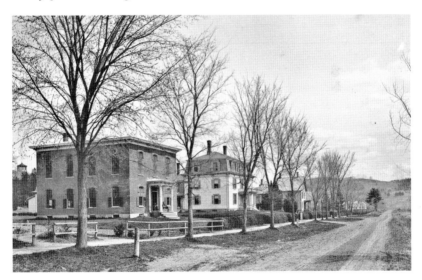

The north side of East Wheelock Street, looking east, circa 1880. The Alpha Delta Phi fraternity house, constructed in 1872, is shown on the left. Beside it is the residence of Dr. Charlton P. Frost. This was originally the home of Richard Lang, constructed in 1795 on the site of College Hall. It was moved to this location in 1875 and was substantially remodeled. In 1927, it was moved again to South Park Street. *Courtesy of Dartmouth College.*

THE WHEELOCK

When Amos Brewster had his father's old tavern moved away and, in its place, opened the new Dartmouth Hotel in September 1814, the substantial brick building was, by its architectural presence and social function, the anchor that defined the heart of the village and campus for the next seventy-four years. And as the hotel expanded and the village and campus grew over the decades of the nineteenth century, one aspect remained woefully inadequate: a reliable water supply that could be used for firefighting should the need arrive. The village area came close to being lost to fire on May 5, 1883, when a major blaze broke out on the southern side of Lebanon Street. But luckily, it was contained after considerable property loss occurred. Not quite four years later, on a bitterly cold night, at 2:00 a.m., a fire broke out in the Dartmouth Hotel that raged uncontrolled for seven hours due to a lack of water and firefighting equipment. By the time it was finally brought under control, the chief corner of the village and the east side of South Main Street lay in smoking ruins, including the hotel. What had started as a pleasing Federal-style building had, by the mid-century, been transformed into an impressive Greek Revival porticoed edifice with a very commanding presence. However, subsequent additions and alterations to the building, while enlarging its capacity and increasing its profitability, had so architecturally mutilated this important village landmark that it was only mourned as a business loss—and hopefully a temporary one at that.

The owner of the hotel was a nonresident and chose not to rebuild. This, in turn, presented a problematic question for the college: where would students, guests and visiting alumni be housed? After the corner lot sat vacant for more than a year, the College Trustees chose to buy the site for $5,000 and erect a new hotel to house one hundred quests at a cost of no more than $25,000.

The college hired architect Lambert Packard (1832–1906) of St. Johnsbury, Vermont, to design the new facility. Packard was a well-respected regional architect, favored by the influential Fairbanks family, who had been commissioned to design Bartlett Hall, which was built in 1890. W.J. Bray, also of St. Johnsbury, was selected as the general contractor to build the new hotel, and construction work began in May 1888, to be completed a year later, in time for commencement. Almost from the start, there were problems. At night, townspeople stole lumber in such quantities that Bray offered to give it to them for free if they would only ask in advance. The

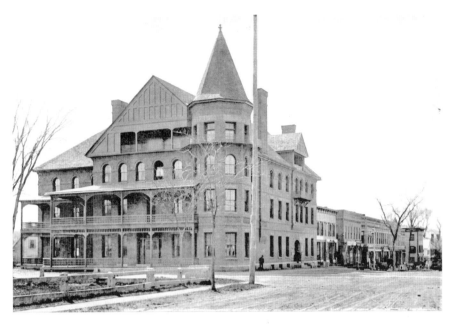

The Wheelock, which replaced the Dartmouth Hotel that burned on January 4, 1887, was designed by architect Lambert Packard of St. Johnsbury, Vermont, and opened in 1889. The building was substantially remodeled in 1902 and razed in June 1966. *Courtesy of Dartmouth College.*

middle portion of the building settled alarmingly, and the interior framing, built from unseasoned lumber, moved and cracked plastered walls and, at times, pinched doors closed. Faulty chimney flues would not draw and were sources of fires. When completed, the handsome Romanesque Revival–inspired brick and red sandstone building named The Wheelock was well over budget at a final cost of $41,940 and was the source of numerous lawsuits.

AROUND THE VILLAGE

Hanover, be it the Village at the College or the remaining rural areas of the town, in the years following the American Civil War, never saw the dynamic wealth creation that many communities in the New England region experienced. That wealth was based, to varying extents and depending on location, on agriculture, natural resources extraction, manufacturing and

transportation. Alas, Hanover was without the broad meadows of much of the Connecticut River Valley that were needed to be able to support larger-scale agriculture, nor did it have the significant waterpower of the River and its larger tributaries to provide a basis for textile and tool manufacturing. And although it can be argued that Moose Mountain contains veins of high-quality granite, Hanover was never destined to become a center of quarrying like other regions of New Hampshire and Vermont. In the mid-1840s, at the time of the first railroad boom in Western New Hampshire, there were preliminary studies done that examined routing the Northern Railroad of New Hampshire from Concord, along Mink Brook in Hanover, across the Connecticut River and into Vermont near present-day Ledyard Bridge, but those plans were abandoned in favor of West Lebanon. Hence, Hanover, then as now, was destined to be just a college town. And for all time, thanks should be given to James Murch and other Hanover proprietors who, in working with Reverend Eleazar Wheelock caused that to happen.

Although it can be argued that Hanover was somewhat limited in resources and therefore destined to only play a role as host to a regional educational institution of gaining stature, that did not prevent the College and village from showing signs of architectural prosperity, progressivity, refinement and even occasional wealth. And certainly, the greatest and most prominent display of this, at the time, was the house erected by a local man who went off and made a comfortable fortune: Adna Perkins Balch (1817–1889).

Balch made his fortune in railroad development in the years immediately following the American Civil War. When he returned to Hanover to live in comfortable retirement, he purchased the choice corner lot that was first developed by Richard Lange in 1795. Lange's house, once considered tasteful and elegant for its late Georgian–based design, was, by 1875, considered out-of-fashion. Balch had the old building moved away, and in its place on the corner of North Main and West Wheelock Streets, he erected a large home for himself in the Second Empire, or "French" style, then the height of architectural style and good taste. The prominent corner property soon came to be known as the "Golden Corner," in part due the golden-yellow color scheme on the exterior of the building, and perhaps this was also due, in part, to the inescapable display that Balch was making. In retirement, Mr. Balch was very engaged in local affairs, but in 1887, the property came into the possession of Hanover merchant Frank W. Davison, who converted the first floor into a dry goods store and leased the second floor to Delta Kappa Epsilon fraternity. The life of the building proved to be short-lived when a fire partially destroyed it in February 1900. The College immediately

purchased the property and set to work having a college hall designed and constructed that same year.

The construction of the "Golden Corner"—Adna Balch's stylish new residence—was not the first building to break with tradition on the west side of the Green. The Dartmouth Savings Bank was first organized January 1860, and ten years later, with Dartmouth College, it constructed a new facility beside and to the north of the Balch House, facing the Green. It was located on the site of Comfort Sever's house, which had been erected in 1774. Prior to being moved away in 1870 to West Wheelock Street to make way for the new bank building, starting in 1851, the former Sever House had been used by the college as the office for Daniel Blaisdell, the college treasurer. Therefore, when the new bank building was developed, it included space for the treasurer's office. Unfortunately, little else is known of this building, which lasted only forty-three years, including who the architect was. When Parkhurst Hall was completed in 1911, the College Treasurer moved there, and when the Dartmouth Savings Bank constructed a new facility on the northeast corner of Lebanon and South Main Streets in 1913, the old bank building was demolished. Today, the site is occupied by Robinson Hall.

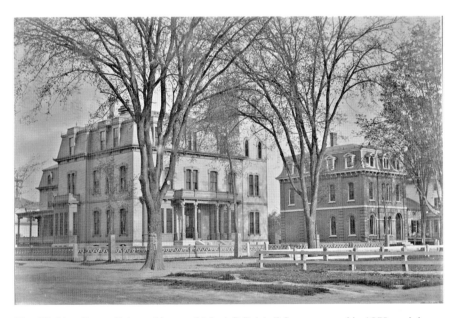

The "Golden Corner," the residence of Mr. A.P. Balch (*left*), was erected in 1875, and the Dartmouth Savings Bank (*right*) was constructed in 1870. The mansion burned on February 8, 1900, and was replaced by College Hall. The bank was torn down in 1913 and replaced by Robinson Hall. *Courtesy of Dartmouth College.*

There were some practical reasons—beyond the purely stylistic—why Second Empire "French" style of architecture became popular for a time. The generally square overall building shape offered economies of space utilization and construction, and the most noticeable feature, the dormered mansard roof, with its steeply sloped sides, offered an abundance of usable space within the enclosed attic area.

Reverend Henry E. Parker, class of 1841 and a professor of Latin at the College, in 1868, had erected a sturdy and spacious home on North Main Street, at the present-day site of Silsby Hall, and in 1874, Mrs. Sarah Swett, the widow of Franklin P. Swett, constructed a fashionably spacious house in the Second Empire style at 9 South College Street. It is reasonable to think that the size of the Mrs. Swett's residence may well have been to provide housing for paying students at both Dartmouth and the state college.

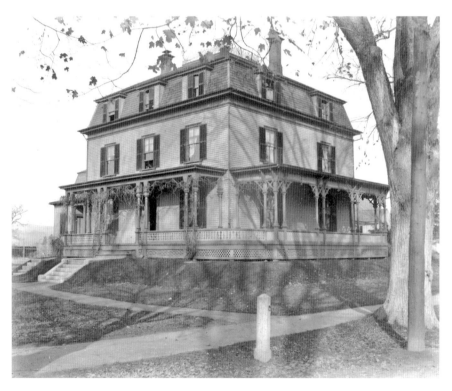

The residence of Reverend Henry E. Parker, a professor of Latin, was built in 1868 on North Main Street. The property became owned by the Kappa Kappa Kappa fraternity in 1894 and then by the College in 1924. By 1926, the Second Empire–style building was gone—an unwanted old Victorian. *Author's collection.*

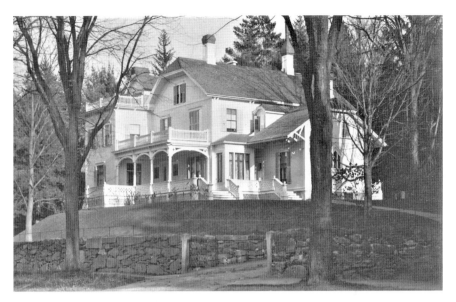

Arthur S. Hardy was a professor of civil engineering and mathematics who, in 1876, had constructed this rather eclectic residence. William J. Tucker purchased the property in 1893, when he became the College President, and in 1909, the College purchased it from him for use as the college president's home. The house and its detached stable facilities were razed in the 1970s and 1980s. *Owner's collection.*

One of the more eclectic homes erected during this postwar period of expressive architectural styles was that of Arthur S. Hardy, a Dartmouth professor of civil engineering and mathematics, at 43 North College Street in 1876. When William J. Tucker came back to Hanover to assume the office of the College President, he purchased the home from Hardy and undertook renovations and additions to it. It remained Tucker's personal residence until his retirement in 1909, at which time, Tucker had a new residence constructed on Occum Ridge, designed by Charles Alonso Rich. Dartmouth purchased the property from Tucker and used it as the official president's residence, naming it "Dartholm," probably a reflection on the building's architecture and setting. Following the construction of a new president's residence on Webster Avenue in 1926, the old house continued to serve numerous functions until it was razed around 1980.

It was the Puritan Massachusetts Bay Colony that was the birthplace of public education, available to all, and so it became throughout New England. Each individual town, under the dictates of state law, was responsible for establishing and maintaining adequate school districts. Given the rural character of most of New England, it was not unusual that there were

numerous school districts established within any one town, and Hanover was no exception. By the mid-nineteenth century, there were eighteen school districts within the town, and not surprisingly, District No. 1 was the Village at the College. In its earliest days, the education of the village youth was entrusted to the College; however, by 1807, this had become unsatisfactory. The following year, after much debate, a small piece of land was purchased at the intersection of present-day West Wheelock and School Streets, and a modest single-room wood-frame building was erected. By 1839, the village had outgrown this facility, and it was sold and moved away, and a new single-story two-room Greek Revival–style brick building took its place, and it is still standing at this location. This writer has never been able to definitively confirm it, but by all indications, Ami B. Young, who, during that time, designed the college's Reed Hall on the east side of the Green, was the architect of the new school building.

In 1877, the subject of a new village schoolhouse once again came to the forefront, and the outcome was the construction of a new facility on Allen Street, which had recently been extended west, beyond School Street. The plans and specifications for the new building were prepared by Professor Frank A. Sherman, and the three-story brick masonry building was constructed by Mead, Mason and Company of Lebanon at a final cost of $10,933.04. The old facility on School Street was sold to the village precinct for $1,000. The new modern building comprised of four excellent classrooms, with a capacity of forty seats in each and a large hall for larger gatherings.

The effect of the new school facility on the community was soon apparent. By 1888, a regular high school was established, growing out of what had been a "higher department." But by 1896, due to the enrollment of 183 pupils, with as many as 55 to 65 students per room, it was necessary to expand the building with a matching three-story addition on the back that provided three finished rooms and unfinished attic and basement spaces at a cost of $96,988.91. Lyman Whipple of Lebanon was the general contractor.

Along with a modern school building and curriculum for the village's youth came other village improvements during the last decades of the nineteenth century. A gas company was chartered in 1872, and soon thereafter, four gas posts for street lighting were erected by a vote of the village precinct. The gas company was never on a paying basis, but it continued along until the availability of electricity in 1893. This was made possible by the establishment of the Mascoma Electric Light and Gas Company, whose generating plant was located mid-way between Lebanon and West Lebanon.

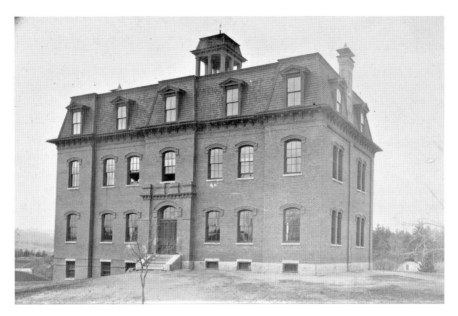

The new village elementary school on Allen Street was constructed in 1877, after Allen Street had been extended beyond its intersection with School Street. Frank A. Sherman was a professor of mathematics at the Chandler School at the College, and he designed the new facility. In 1896, a matching addition was made to the rear. The building was demolished in 1936. *Courtesy of Dartmouth College.*

The first telegraph office in the village was located in a building beside the Dartmouth Hotel in 1852, and the first telephone, a single telephone line located in E.P. Storrs Dartmouth Bookstore, was in use in 1891. At first, it was on the Lebanon exchange, and later, it was changed to the White River Junction exchange. In 1901, the first telephone exchange was established in the village with 26 subscribers. In 1905, that quickly grew to 86 subscribers, and the first automatic switchboard was introduced. By 1912, a central office switchboard had been installed to serve 264 subscribers.

The ongoing story of South Main Street—that is, the center of the village— is the story of older buildings being replaced by newer structures. Some of these buildings became accidentally lost over the years due to fire; some were removed from the street to new locations; and some were deliberately torn down in the name of progress and greater utilization of the site.

By 1869, the house and little bookshop that Professor John Smith had erected for himself about eighty-nine years earlier were, no doubt, becoming dated, but someone thought that they still had value. Therefore, when the Episcopal Church acquired the property, the present-day site of the Hanover

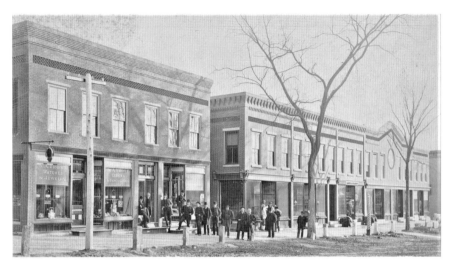

Following the "Great Hotel Fire" of January 4, 1887, the east side of South Main Street was promptly rebuilt. Unfortunately, the brick Frost Building and a wood-framed building to its left (out of view) were destroyed by fire in 1936 and replaced by the present-day Lang Building, which became owned by Dartmouth College and named for Richard Lang, the village's first successful merchant. *Courtesy of Dartmouth College.*

municipal building, the old buildings were moved away, and that year, a new rectory was built on the site. The new two-story wood-framed building featured the latest in Eastlake-style architectural trim and embellishments. Two years later, a small, detached chapel building was erected beside the rectory, and a highly decorative fence and gate were put up along the front of property at the sidewalk. The overall presentation—rectory, chapel and site landscaping—could best be described as very storybook-like in appearance. Almost sixty years later, in 1927, to make space for the new municipal building, the former rectory was moved to the rear of the site and given a bit of a "colonial" makeover, and the little chapel moved down to Currier Street, then newly opened up, and made into a village home of modest proportions. About 1959, the old rectory building was torn down to create parking, and the former chapel building was razed in 2007 as part of Dartmouth's South Block revitalization project.

As early as 1840, there is evidence of Catholicism in Hanover; however, its presence was slight and did not warrant the development of a parish and a church facility. Reverend Louise M. LaPlante, pastor of Sacred Heart Church in Lebanon, purchased a small parcel of land on the southern edge of the village in July 1887, and by that December, construction was complete enough that the first mass was celebrated there on Sunday

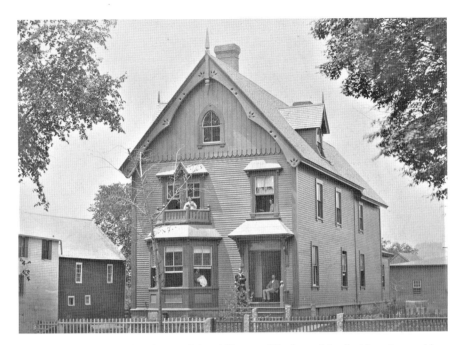

In 1869, the Episcopal church owned the old home of Professor John Smith and moved it to Maple Street. In its place, the church erected this eclectically trimmed rectory. A small chapel building was added in 1871. The house was moved back from the street in 1928, and the chapel was moved away when the present municipal building was constructed. About 1959, the house was torn down to make way for a municipal parking lot. *Courtesy of Dartmouth College.*

January 1, 1888. The Hanover church was made a parish, separate from Scared Heart, in May 1907, and the steady growth of the parish during the following fifteen years required a larger place of worship. All of the land area that had been Dorrance B. Currier's large village farm was beginning to be broken up and subdivided; therefore, in September 1922, a new site was purchased from the Currier estate at the southern corner of Lebanon Street and Sanborn Road. In 1925, on the completion of the new stone church, designed by Larson & Wells Architects, the old wooden building located on South Street was decommissioned; its steeple was removed, and it became a boardinghouse. The building was demolished in 2007 as part of the college's South Block revitalization project.

From the beginning, when Aaron Storrs first opened his tavern in 1771, commercial trade has been more concentrated at the northern end of South Main Street, then further down the street, especially south of the Lebanon Street intersection. As described previously, the property

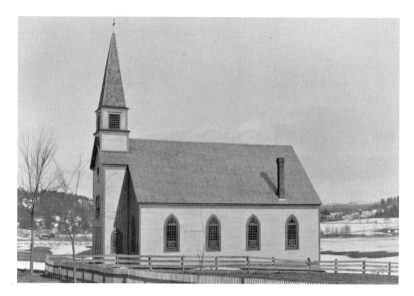

The Catholic church, in 1887, erected this new facility on East South Street, which was then the edge of the village and Dorrance B. Currier's farm. In 1922, the property was sold, the steeple was removed and the building was made into apartments. In 2007, it was demolished as part of Dartmouth's South Block redevelopment project. *Courtesy of Dartmouth College.*

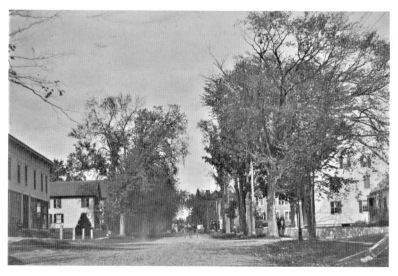

Looking north, up South Main Street, circa 1900. The Tavern Block can be seen on the left, and the Heanage House can be seen on the right. Following the 1888 fire that destroyed the Lower Hotel and several adjacent buildings, Dorrance B. Currier constructed this new two-story block in 1894. By 1957, it had become rundown and was razed to make way for a parking lot. The Nugget Theater was built north of the Tavern Block in 1951. *Courtesy of Dartmouth College.*

that became known, for many years, as the Lower Hotel, then, later, South Hall, which had its last debut before burning in a fiery blaze on the night of July 11, 1888, had a storied and checkered past. After the fire that totally consumed the old building, the lot sat vacant until village entrepreneur Dorrance B. Currier erected a replacement two-story wood-framed commercial structure that became known as the Tavern Block. The ground floor was arranged for stores, of which there were numerous occupants that came and went, including a restaurant or two. The upper floor was mostly used as lodging for the restaurant.

Overall, the building was of uninspired design, architecturally borrowing several Italianate design elements, like the heavily bracketed roof-edge cornice. The exterior walls were clad with stamped tin imitation brick, and the general construction quality of the building was somewhat lacking. By 1957, the building, an unsuccessful commercial property, had become rundown and an eyesore on Main Street. The Hanover Improvement Society, formed in 1922, stepped forward and purchased the property. The building was razed, and until 1973, when construction of the current multistory brick bank building was begun, the site was a municipal parking lot.

THE TWENTIETH CENTURY

The twentieth century was a millennium of profound change across the face of the globe. And those winds of change blew across the Hanover Plain, greatly impacting both the "College on the Hill" and the "Village at the College." However, as the new century dawned, it was already clear that some of those patterns of change that were to define much of the new century were ongoing, and their impacts were already becoming noticeable. The plans that Dartmouth College Trustees and President William Jewitt Tucker had begun to implement in 1893 were moving forward and already leaving a mark on the much beloved "College on the Hill." There would be no turning back as this new era moved forward. And as it had been for 130 years, the "Village at the College" would continue in its unique symbiotic relationship with the college while it, too, experienced evolutionary changes and endeavored to meet the new challenges that lay ahead.

If ever there was a "watershed year" for this symbiotic relationship since its initial founding of 1770, that would be 1893—the year that the New Hampshire College of Agriculture and the Mechanical Arts left Hanover for its new home in Durham and became the University of New Hampshire; the year that the decision was made to completely remake the College both academically and physically; and the year when the College and the village collaborated in developing a modern water system that provided greatly improved fire protection and sanitation for both. Without this improvement, the sustained twentieth-century growth and

development of the College and the village would not have been possible. The relocation of the state college to Durham freed up 343 acres of land in the village for non-state uses. And the remaking of the College would allow Dartmouth to position itself as a world leader in higher learning.

VILLAGE SCHOOLS

As previously noted, the Village Precinct of Hanover, New Hampshire, was first organized October 29, 1855, and was an area defined as being one and the same with Hanover's School District No. 1. At that time, the authority of the Precinct was limited and remained so for more than fifty years. At the annual precinct meeting that was held on March 19, 1901, as allowed by state law, the voters chose to adopt a new charter that better defined, enlarged and confirmed the powers and authority of the Village Precinct, with its three elected precinct commissioners. Simply stated, the Village Precinct of Hanover, New Hampshire, a legally incorporated governmental body, became like a smaller town within the far larger Town of Hanover, also an incorporated governmental body, the area of which was far beyond that of just School District No. 1. At that time, within what was referred to as the "Town District" (everything but School District No. 1 at the village), there were ten rural school districts, with simple one- or two-room schoolhouses. By 1900, School District No. 1 in the village had its own Board of Education—six elected members who had full oversight of the individual district.

The construction of a modern school building on Allen Street in 1877, its enlargement in 1896 and the addition of a high school curriculum in 1888 all combined to further establish School District No. 1 at the village as a fine public school. The school could boast that it had a total of 140 students between the ages of five and fifteen and 44 students over the age of fifteen. Of the high school students, 27 were non-village residents and were paying an annual tuition fee of twenty-two dollars. Courses in Greek, Latin, French, chemistry, physics and the natural sciences were offered. The annual report that year noted, "One young lady entered college from our high school last fall, and several more expect to enter later."

When the Board of Education issued its annual report for 1911, it made it painfully clear that, due to the overall success of the district, especially the high school curriculum, the single building on Allen Street had become critically overcrowded. Furthermore, it was noted that the need for a new

facility to accommodate the high school was urgent and should receive immediate attention. By that time, total enrollment had reached 300 students: 247 students between the ages of five and fifteen and 47 students at high school age. Of that total, there were 17 tuition students in the lower grades and 30 students in the high school grades. The April 27, 1911 edition of the *Hanover Gazette* reported that, according to the latest figures from the United States Census Office, the population of the Village Precinct stood at 1,340 persons, not including Dartmouth students.

At the annual meeting of the inhabitants of School District No. 1, which was held on the evening of March 27, 1911, in the College's Bissell Hall, it was voted to elect a committee of six to consider a site for a new high school building, to secure plans and specifications for the new facility, to invite bids for its construction and to report back at an adjourned future meeting. Furthermore, it was voted that the new building be of "brick, tile, or cement" construction and not exceed $30,000 in cost.

Since the time that the new school building of 1877 had been constructed, the school district had come to acquire a significant amount of land across Allen Street and bordering the east side of Prospect Street. This was called the School Common, and it was here, facing the existing grade school building situated on the north side of Allen Street, that the new high school was located. The architect was E.J. Wilson from Boston, and the general contractor was J.H. Davidson, also from Boston. The new facility was completed at a cost of $30,048.50, including architectural fees. The first students occupied the building after the spring recess in 1913. That fall, of a total student population of 340 students enrolled in School District No. 1; 101 students (including 35 tuition students) were enrolled at the new high school. Furthermore, 7 well-qualified teachers were providing instruction in mathematics, Latin, history, English, French, "commercial courses," chemistry and music. Within the remainder of the town, the number of rural school districts had been reduced to seven, the largest being Etna.

The new high school building was well designed, constructed and received by the village residents; however, the standards and demands on public education were rapidly changing. With the completion of the new high school, the original 1877 building, with its 1896 addition, again became just the grade school facility for the village. But by the end of the decade, it was becoming clear that the older facility, as good a building as it was when it was constructed, was becoming very dated and inadequate. Therefore, at the 1919 annual school district meeting, a committee was appointed to study the matter and instructed to report back the following year.

The village's new high school opened in the spring of 1913 on the south side of Allen Street. The facility was of a pleasant contemporary design by architect E.J. Wilson of Boston, Massachusetts; however, within twenty years, it was obsolete. Following the construction of a new facility on Lebanon Street, the old building was demolished in 1936. *Author's collection.*

A plan was prepared by the Hanover firm of Larson & Wells, Architects and Engineers, to substantially enlarge the existing 1877 building located on the north side of Allen Street and to address fire safety and sanitation issues. The scheme was very cleaver in that it was a complete architectural makeover of a Second Empire–style building that had, by then, become, in the eyes of the public, just an old Victorian-era frump. The proposed new look would feature a fresh contemporary Colonial Revival look, then fashionable on the Dartmouth Campus and beyond. The proposed price tag was $54,000. It was pointed out that a comparable new building would cost about $150,000. The village did not buy the proposal. Instead, in 1924, it built an entirely new grade school on Lebanon Street at a cost of $98,500 on land that had formerly been part of Dorrance B. Currier's farm. That building remains in use to this day.

The 1913 high school building ended up being short-lived. Even with the old former grade school building located across Allen Street, increased enrollment and the need for additional curriculum, by October 1931, a comprehensive report was issued recommending an entirely new high school facility to be located on Lebanon Street, beside the new grade school, at a

projected cost of $180,000. That new building, designed by Wells, Hudson and Granger Architects, was constructed in 1935 at a cost of $203,849 and is still extant. In 1936, the two Allen Street buildings and land were sold to local contractor H.W. Trumbull for $3,000, and they were demolished. Today, not a trace of them remains.

ALLEN STREET

Allen Street was, in the 1790s, a small privately owned lane that was created to reach an early house located off the main street, behind John Walker's house. By the 1830s, it had been opened up to access Amos Dudley's livery stable, that, in time came, to be owned by Ira Babcock Allan, a much-beloved former stage driver and local personality. As business increased, the large livery stable building was moved from the north to the south side of the lane, and the roadway as extended through to School Street in 1869. The decision to construct a new elementary school to the west of School Street in 1877 required extending what had come to be called Allen Street, further opening up the western area of the village to residential development.

By the early twentieth century, Allen Street was the home of Hemp Howe's busy livery stable, with stagecoaches that carried mail and passengers between the village and the railroad station in Lewiston; a Chinese laundry; several little eating establishments, including a lunch cart; and the Ashbel Hotel on the corner of School Street. At the site of the present-day Gitsis Building, the corner of Allen and South Main Streets, the village precinct had purchased, in 1906, the former William Walker House, erected by John Young in the 1780s. The precinct made it into precinct offices, the police station and, in the rear, space for the fire department. The precinct sold the so-called Walker House to George Gitsis in early 1929, on the completion of the present municipal building, and he opened a restaurant in it. The venture was short-lived, as the building burned in 1930 and was replaced that year by the present-day Gitsis Building. The largest of the livery buildings, formerly operated by Hemp Howe, became the Inn Stables; located on the south side of Allen Street, where it burned on May 13, 1925. In 1922, livery stable owners Frank Tenney and Charles Nash, realizing the growth in automobile ownership, moved the circa-1795 Allen House away to the western end of Allen Street

Construction has started on the new Musgrove Building in this view looking down Allen Street during the summer of 1914. To the left is the Episcopal church rectory, which was moved back in 1928 for the construction of the new municipal building. It was razed in 1959. Beyond is Hemp Howes Livery Stable, which burned in 1925. To the left is the Walker House/precinct building, which housed the precinct offices and the police and fire departments. It burned in 1930. *Courtesy of Dartmouth College.*

and erected a large automotive service facility at 5 Allen Street called the Inn Garage. At the southwestern corner of Allen and South Main Streets was shoemaker Abraham Dunklee's house, which was erected about 1820. By 1899, it had become acquired by Frank A. Musgrove, who operated his printing business there. The building partially burned on May 3, 1914, and was replaced that year by the present-day Musgrove Building.

The Hanover Inn

The storied history of the Dartmouth Hotel through the decades of the nineteenth century has previously been touched on, including its dramatic and fiery destruction during the early morning hours of January 4, 1887, and its subsequent phoenix-like rebuilding by the College as The Wheelock.

When the doors of the new hotel opened in time for commencement in June 1889, it was not by wanting that Dartmouth College found itself in the hotel business. Rather, it was realized by the Trustees, at that time, that an accommodating and commodious hotel facility in the village, well-run and convenient for quests to Hanover and Dartmouth alike, was important.

As a result, the new hotel was sometimes run by lease and sometimes by a manager hired by the College, but it was rarely run to the satisfaction of the public and usually at a loss to the College. So unsound and inadequate was the new building that, within about twelve years, it required a major renovation at a price well above the initial cost of construction. Architectural tastes were quickly changing, and at that time, the architecture of the building was altered accordingly to assume a more preferred and subdued Colonial Revival–styled appearance. The prominently placed octagonal corner tower feature was reduced by a story and downplayed with a more moderately pitched conical roof. New stepped brick gables were added. The stick-style multistory porches that overlooked the Green were removed and replaced by a gracious ground-level Colonial Revival–style porch with an inviting porte cochere. The architect for these renovations was probably Charles Alonzo Rich, who, at that time, was doing other major work on the campus. To complement the extensive physical makeover, when the building reopened in 1902, it was renamed the Hanover Inn, as it remains to this day, owned and operated by Dartmouth College. Gone were the days of leased management—replaced by a salaried manager.

By the 1920s, no doubt due, in part, to the explosive popularity of the automobile and the increased tourist trade that resulted, a large five-story addition was made to the eastern side of the original building that was constructed in 1924. The new addition was designed by architect Jens Fredrick Larson, and it added multiple guest rooms, a spacious and elegant dining room and a modern kitchen at a cost of $204,000. The new wing was designed in the Colonial Revival style that was much favored by both the public and the architects of Mr. Larson's generation.

Jens Fredrick Larson (1891–1981) would go on to leave an outsized imprint on the built environment of Hanover and Dartmouth between the years of 1919 and 1942, and therefore, he deserves some amount of brief additional mention. He was born in Waltham, Massachusetts, but during World War I, in 1915, he went to Canada to join the Canadian army and was sent to France. After serving with the field artillery for nineteen months, in 1916, he was transferred to the Royal Flying Corps, where he served with distinction until he was hospitalized due to a crash

in April 1918. After returning to Canada, he settled in Hanover in 1919 and assumed the role of architect in residence at Dartmouth College. This was also the time that Dartmouth's new president Earnest Martin Hopkins (1877–1964) was beginning his work of further transforming the campus, following what had previously been accomplished by his predecessors, Presidents Tucker and Nickols. Tucker served from 1893 to 1909, and Ernest Fox Nickols (1869–1924), a noted educator and physicist, was the college's tenth president until 1916, when Hopkins assumed the position.

President Hopkins was to serve the College as its eleventh president, from 1916 until he retired in 1945, and between 1919, when Mr. Larson became the college architect, until 1942, when he moved to New York City, Larson, with Hopkins's vision and guidance, designed more than thirty new buildings on the Dartmouth campus. Larson's first commission was the Topliff Dormitory, located on East Wheelock Street, and his largest and most prominent commission was Baker Library, which was completed in

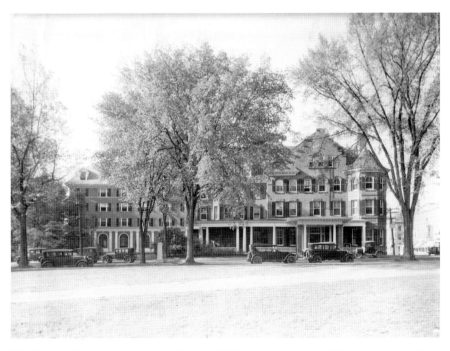

The Hanover Inn, as it appeared in the later 1920s, after the main building was substantially remodeled in 1902. A wing designed by architect Jens Fredrick Larson was added of the eastern (*left*) side in 1924. Clearly, Colonial Revival–style architecture had triumphed over the Romanesque-inspired work of architect Lambert Packard's original building. *Courtesy of Dartmouth College.*

1928. After moving his family and practice to New York City, Larson went on to enjoy a distinguished career, and his work included commissions at Colby College, Bucknell, Princeton, Lehigh, Louisville and McGill Universities. He eventually settled in North Carolina, where he designed the new Wake Forest College campus in Winston-Salem and retired in the 1970s.

By the 1960s, it was clear that the original 1889 Hanover Inn building, while extensively remade in 1902, was antiquated and in need of replacement. Following the June commencement in 1966, the old building was demolished and replaced by the current and the fourth facility to offer victualing and lodging at this site. The architects for the new and far larger building simply applied the same façade design from Larson's 1924 addition forty-two years earlier, and it still remains.

The Nugget Theater

The technology that gave birth to the motion picture industry originated in the last decade of the nineteenth century and came into its own in the first years of the new century. *The Great Train Robbery*, made in 1903, is considered the first commercially viable film made in the United States, and by 1907, multi-reel films were becoming the norm. By 1910, motion-picture attendance in the country was in excess of 16 million persons, and by 1916, there were more than twenty-one thousand movie theaters nationwide. This craving for new public entertainment did not go unnoticed for long in Hanover.

In parallel with motion pictures was the coming of the automobile. In the United States, from a humble start of about 4,000 new automobiles produced in 1900, production soared to more the 485,000 cars and trucks by 1913, and it continued to climb. It seems that the public could not get enough of either of these new technologies. The rapidly increasing number of motorists on the road, many passing through Hanover and stopping at the Hanover Inn, had caught Frank W. Davison's attention. Mr. Davison was a successful businessman with a dry goods and department store on the west side of South Main Street, located in the three-story brick Davison Block beside the Casque and Gauntlet Society building. Davison was thinking of constructing a steel-and-concrete parking garage behind his business block, suitable for motorists spending the night at the Inn. However, being an astute entrepreneur, he was also toying with the idea of developing a motion-picture theater in place of

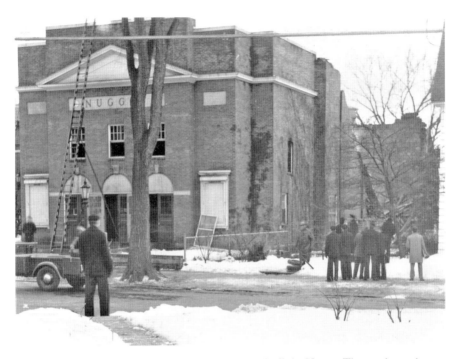

The cause of the fire and explosion that blew the roof off the Nugget Theater, located on West Wheelock Street, in the early morning hours of Friday January 28, 1944, was never determined. The front lobby area of the building remained and was transformed into a Western Union Telegraph office until it was taken down in 1968. *Author's collection.*

the garage. This, in turn, caught the attention of Elijah William "Bill" Cunningham, Dartmouth class of 1918, who was a football star from Texas. Cunningham caught wind that Davison had applied for a building permit to construct a parking garage.

Bill Cunningham convinced Mr. Davison that a movie theater was really what the village needed, and he said that if Davison built it, he would run it. As early as 1914, the idea of having a movie theater in the village was being debated, and not everyone was sold on the idea. Into this debate stepped the Precinct Commissioners, who required that any party proposing such a new facility must first submit a business plan with a license application. Mr. Davison and his only son, Frank F. Davison, applied, as did a group of twenty Dartmouth and community residents—the "petitioners"—who proposed, with a somewhat involved scheme, to run the theater to the benefit of the town. Following much public debate, by the spring of 1916, the Davisons won out and had their license from the Commissioners, so they proceeded to immediately construct the new facility.

The new theater facility was austere to the extreme. Located behind the Davison Block and accessed by a narrow alleyway between the Davisons' commercial block and the Casque and Gauntlet Society, the metal-and-concrete rectangular-shaped building had 571 seats, all made of wood and iron, bolted to the floor. A twelve-foot-by-sixteen-foot screen was at the south end, with a small orchestra pit for the musicians who "played the movie" and a small lobby and ticket booth at the other end. The new theater opened on September 13, 1916, and was called The Nugget. The elder Davison's son, Frank, had spent time out in Montana, ranching and prospecting, and hence, it was the younger man's choice of the name. The movie shown on opening night was *An Alien*, starring George Beban, and both the event and the new facility were greeted with great reviews.

After six years of running the theater, the elder Davison was getting along in years and was looking to be relieved of the responsibility that, on occasion, was not without some amount of controversy. Therefore, in 1922, he offered his movie franchise to the Town for nothing, as long as they would take it over. This presented the Precinct Commissioners with a problem: they found themselves with a movie franchise that they were specifically prohibited from operating per the terms of the Town Charter. The way out of this predicament was the formation of the Hanover Improvement Society, which was incorporated July 7, 1922, with the purpose of running the Nugget Theater. The Davisons continued to own the building and rented it to the newly formed nonprofit civic society. As early as 1874, there had existed organizations within the community for the promotion of village beautification and betterment, and this was largely an extension of those earlier efforts.

The Nugget continued to thrive as the only regular source of entertainment in town. In 1927, the facility was substantially modernized, with the seating increased to 616, an enlarged lobby and a classically styled colonnaded front-entrance portico that faced West Wheelock Street and provided a fresh, welcoming new look, instead of the former entrance at the end of a service alleyway. Even during the depths of the Great Depression, ticket sales remained strong, such that, in 1938, a second substantial renovation of the building was undertaken. A large balcony was added that increased seating to about 900; the lobby was expanded, with two stairs that served the balcony area; and a lounge and modern air-conditioning equipment was added. By this time, the original spartan building of the Davisons' had become as fine a modern and impressive movie house as there was in the Upper Valley Region, and it had become a valued village asset.

During World War II, the theater gained even more importance because it was the main source of entertainment for the many servicemen stationed at the College. Full houses of those in uniform, students and village residents were the norm; however, this was to be short-lived. During the early morning hours of Friday January 28, 1944, Village Night Patrolman Archie Thornburn was walking his beat about 4:30 a.m., along Allen Street, when he noticed smoke escaping from under the roof of the theater. On investigation, he found a fire raging inside the building and immediately called in the alarm. Before firefighters were able to arrive, just ten minutes later, internal combustion precipitated an explosion that blew out the roof and the righthand wall. Firefighters with six fire trucks, five from Hanover and one from Lebanon, labored until the late morning to extinguish the flames. The damage was estimated at $75,000, but thankfully, no one was injured. Although the cause of the fire was never determined, it is believed that the fire originated from a cigarette that was discarded in peanut shells after the last show the night before. For the next seven years, movies were shown at Dartmouth's Webster Hall until the construction of a new facility was completed on South Main Street. The lobby area of the old theater was not totally damaged and was fixed up and served as a Western Union Telegraph Office until 1968, when it was razed and replaced by the elevated Banwell Building. Behind the Davison Block, the foundations of the movie house auditorium can still be seen.

THE AUTOMOBILE

The history of the twentieth century is a compilation of many major storied events that conspired to shape our present world, and certainly, one of those is the story of the automobile. For more than one hundred years, its impact has been felt worldwide, including in the village of Hanover.

Tradition has it that the first automobile seen in Hanover arrived one fall day in 1901, and it was by the future president of Dartmouth College Ernest Martin Hopkins. He was engaged in conversation at the Wheelock and Main Street intersection when a primitive one-cylinder "curved dash" Oldsmobile came up the Wheelock Street hill from Vermont, went through the intersection and then headed north, up Lyme Road. Who the driver was and where he was from, no one knows. Nor do we know who had the first gas pumps in town or who the first dealer in new automobiles was.

As to the latter, that may well have been Samuel Rogers, an engineer at the College's steam-heating plant who, for many years, operated Roger's Garage on Lebanon Street within the shadow of the heating plant's tall brick chimney. Regardless, it was not too long before the automobile became a common sight in the village, and that only increased during the 1920s with the massive proliferation nationwide in the number of Americans who owned at least one—if not two—of these motorized conveniences.

The fact was not lost on New Hampshire lawmakers that the state's highway infrastructure was not adequate to handle the rapidly increasing amounts of automobile traffic. As early as 1909, the state legislature passed the so-called "Trunk Line Law," which laid out three north–south trunk line highways and provided funding for same. The western trunk line, over time, became much of what is present-day New Hampshire Routes 10 and 120, and it ran from the southwestern region of the state, up through Newport and Lebanon and what is now Route 120 into Hanover, where it connected with the Lyme Road and continued north into the White Mountains as Route 10.

The proliferation of automobiles rapidly increased after World War I, with motorists joyfully out on the road on business, sightseeing and vacationing. This increased the need for refueling and vehicle maintenance facilities which proliferated during the 1920s. The proprietor of a local hardware or general store, as an example, could, for very little money, purchase an underground gasoline storage tank with a hand pump from a national oil company, install this new equipment out front for the convenience of passing motorists and easily drum up additional business. This, in turn, caused erratic and often dangerous driving patterns by motorists that occasionally injured pedestrians and created potential new fire hazards, as automobiles were not only being refueled but maintained and repaired. Furthermore, although the advent of the automobile had not initially spawned what, in time, would come to be referred to as "urban sprawl," by the 1920s it was certainly enabling it, with new suburban residential neighborhoods rapidly overcoming the former farmland on village perimeters, like Hanover.

The United States Supreme Court case known as *Village of Euclid, Ohio v. Ambler Realty Co.*, which was decided in 1926, was to have a major impact on land use and planning in twentieth-century America. It was the first significant case regarding the relatively new practice of land zoning and served to substantially bolster zoning ordinances in towns nationwide.

Ambler Realty owned sixty-eight acres of land in the village of Euclid, Ohio, a suburb of Cleveland. The village, in an attempt to prevent industrial Cleveland from growing into and subsuming Euclid and to

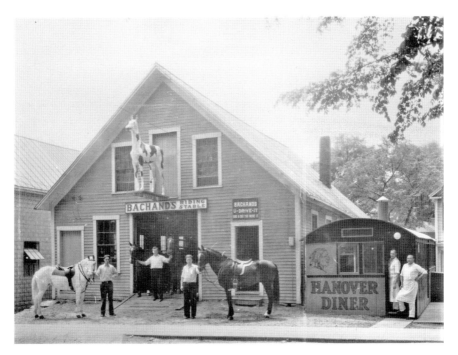

By the mid-1920s, Bachand's Riding Stable at 5 Lebanon Street was still renting out horses but also had automobiles to rent. Diners were a new fad then, and an early version was set up beside the old livery stable. By 1963, the diner was gone, and the former stable building was gone by 1972. *Author's collection.*

prevent the growth of industry that might change the character of the village, developed a zoning ordinance based on six classes of land use, three classes of height and four classes of area. The property in question was divided into three use classes, as well as various height and area classes, thereby hindering Ambler Realty from developing the land for industry. Ambler Realty sued the village, arguing that the zoning ordinance had substantially reduced the value of the land by limiting its use, amounting to a deprivation of Ambler's liberty and property without due process. During the early 1920s, the lawsuit wound its way through the Ohio courts and eventually found its way to the U.S. Supreme Court.

The court ruled that zoning ordinances, regulations and laws must find their justification in some aspect of police power, and they must be asserted for the public welfare. Benefit for the public welfare must be determined in connection with the circumstances, conditions and the locality of the case. At the time of *Euclid*, zoning was a relatively new concept, and indeed, there had been rumblings that it was an unreasonable intrusion

into private property rights for a government to restrict how an owner might use property. The court, in finding that there was valid government interest in maintaining the character of a neighborhood and in regulating where certain land uses should occur, allowed for the subsequent explosion in zoning ordinances across the country. The court has never heard a case seeking to overturn *Euclid*, and today, most local governments in the United States have zoning ordinances to some degree.

Within the Village Precinct of Hanover, New Hampshire, by 1922, a large automobile repair and storage garage with gas pumps had been constructed at 5 Allen Street, named the Inn Garage; it was the outgrowth of an earlier-established livery stable. By the late 1920s, gas stations developed by national oil companies were starting to appear at the intersection of South Park (NH Route 120) and Lebanon Streets, on the route of the western trunk line and at the intersection of Lebanon Street and Greensboro Road. The appearance of the entrances into the village and Dartmouth College were, indeed, changing.

On May 20, 1931, the Village Precinct, with broad voter support, adopted its first comprehensive zoning ordinance, one of the first in both states. The

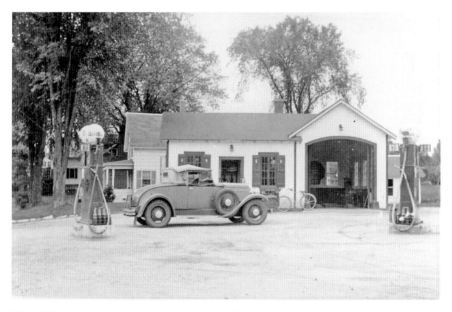

The 1920s saw a very sharp increase in automobile ownership and the growth of oil company–owned service stations. This Shell Oil Company facility was built in 1929 at the intersection of Lebanon and South Park Streets. It was replaced by a larger facility in 1954, and in the early 1990s, a new drive-up banking facility for Ledyard National Bank took its place. *Author's collection.*

Precinct was zoned into four districts: one and two family, general residential, educational and business. Filling and gas stations, public garages, factories, lumber yards and lunch carts were only allowed in the business district and required "special permission" from the Precinct Board of Adjustment.

The onset of the Great Depression, following the collapse of the of the stock market in October 1929, hit the American auto industry hard but not enough to dampen the public's love of automobiles. As the 1930s advanced, and the economy slowly began to come back, oil companies continued to develop sites for fueling, servicing and storing automobiles. After months of heated debate before the Precinct Board of Adjustment, Miss Nellie Newton sold her corner lot on Maple and South Main Streets to Gulf Oil Company, which then proceeded to raze her old house and construct a modern auto service facility. What was once a state-of-the-art building, designed at a time when many motorists put their cars into storge during the winter months, had become obsolete by the early 1960s. Because motorists were no longer storing their cars during winter months, a much smaller building, strictly for quick repairs and maintenance, was needed, and far more ground area was needed for gas pumps and maneuvering

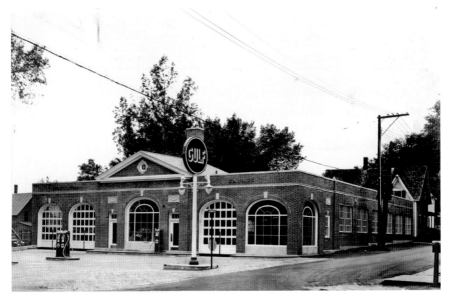

Gulf Oil Company designed and constructed this handsome facility to fuel, repair and store automobiles in 1935 at the corner of South Main and Maple Streets. By 1963, this substantial Colonial Revival–style structure had become obsolete and was razed, replaced by the present-day gas and convenience store facility. *Author's collection.*

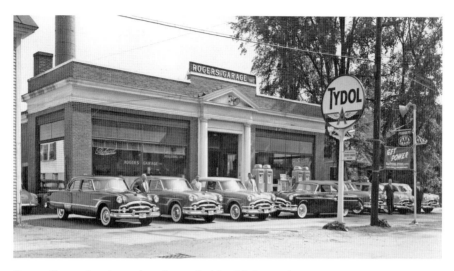

Rogers Garage Inc., located on the north side of Lebanon Street, constructed this impressive showroom addition, designed by Wells & Hudson Architects, in 1931. The building is shown here with new 1953 Packards out front. By 1966, the building was gone. The corner of South Hall can be seen to the left, and the chimney of the college's heating plant can be seen in the rear. *Author's collection.*

motorists. In 1963, the obsolete twenty-eight-year-old building was replaced by a new facility; that, too, became obsolete within several decades, and it became a convenience store with gas pumps. Increasingly, automobiles no longer required as much service, and the service work that was required was being done at area auto dealerships.

Along with the early proliferation of the number of automobiles on the nation's roads was the proliferation of automobile brands in dealer show rooms, which peaked in the 1920s. A list of automobile and truck brands sold at one time in Hanover is not known to this writer; however, in the years immediately following World War II, Raymond P. Buskey was selling Kaiser-Frasier cars at the Inn Garage on Allen Street. Until the business was reorganized and moved to a new location on Route 120 in Lebanon and became Hill Crest Motors, Roger's Garage, located on Lebanon Street, which sold a variety of makes. What is believed to have begun as an REO dealership matured into selling and servicing Packards and Chevrolets, as well as some European brands, like Renault and Peugeot. Packard was gone as a noted American brand by 1958, and in 1966, the dealership facility, designed by Wells & Hudson Architects and constructed in 1931, was razed as part of Dartmouth's ongoing redevelopment of Lebanon Street, which started with Hopkins Center.

THE WAR YEARS AND THE G.I. BILL

World War II raged across the globe for six years, beginning on September 1, 1939, and ending on September 2, 1945. In its wake, an estimated 70 to 80 million people were dead. That appalling number represented approximately 50 to 55 million civilian deaths and 21 to 25 million military deaths. Of that total number worldwide, in the United States of America—as best as will ever be known—the country had suffered 407,300 military and 12,100 civilian deaths. In addition to the number of war dead, the country experienced 671,801 returning military wounded from both theaters of war.

As life in Hanover attempted to return to some sense of normalcy, a committee of the community's citizens published a little booklet titled *How They Served: Men and Women of Hanover, New Hampshire Who Served in World War II, December 31, 1945, Published by the Town of Hanover*. It listed those 19 men, with a photograph of each, who never returned to Hanover, as well as the 431 citizens from Hanover who served in all branches of the armed services. Although they were not listed, from the college, 11,091 students and alumni served, and 301 of those men died in service.

Before the attack on Pearl Harbor on December 7, 1941, by the Japanese and the subsequent declaration of war by Germany on the United States, the citizens of the country, including in the community of Hanover and Dartmouth, had rightfully debated the question as to what role the nation should play in a world that appeared to be, once again, coming apart at the seams. World War I and the 181 Hanover citizens who served in the armed forces were still fresh memories, as it was for the 3,407 college students and alumni who, too, had served. Of that total, 111 had died in service; however, after the attack on Pearl Harbor, that debate ceased, and Hanover and Dartmouth College gave mightily to the four years of war effort.

In the early years of the war, Dartmouth College president Earnest Martin Hopkins was appointed to several advisory positions by the Roosevelt administration, which required his absence from Hanover for periods of time. This coincided with a dropping student enrollment at the college as the country became engulfed by the war effort. The financial implications of this were of great concern to both Hopkins and the trustees; however, it would be the navy's V-12 College Training Program that would not only offset those potential losses, but for about three years, it would give the campus and village the look of a navy base.

The V-12 Navy College Training Program was designed to supplement the force of college-educated commissioned officers in the United States

Navy, which it was feared might decrease substantially after the draft age was lowered to eighteen years of age during November 1942. Between July 1, 1943, and June 30, 1946, more than 125,000 participants were enrolled at 131 colleges and universities in the United States—Dartmouth being one with the largest program. Numerous participants attended classes and lectures at the respective colleges and earned completion degrees for their studies. The program's goal was to produce officers who were technically trained in fields such as engineering, foreign languages and medicine. The navy predominantly chose small, private colleges for V-12 detachments. Of the 131 institutions selected for line units, approximately 100 could be considered "small," and 88 were private institutions. After the V-12 Program got underway on July 1, 1943, public and private college enrollment increased by 100,000 participants, helping reverse the sharp downward wartime trend.

On April 5, 1943, Dartmouth College was selected to participate in the V-12 Program. The Board of Trustees established the Naval Training School (V-12) at Dartmouth as an instrument for the administration of the navy V-12 unit, and the size was set at 1,300 trainees. Ten days later, it was announced that Dartmouth, in fact, would have 2,000 V-12's—the largest unit in the country. The Navy V-12 unit opened on July 1, 1943, with an influx of 2,042 navy and marine trainees arriving on campus. The dormitories, which had become quiet due to dropping enrollment rates on campus, were once again alive: nine were occupied by the Navy, three by the Marines and one by the Army. The V-12 Program was in operation for seven terms, until the summer of 1945 term. The program was a financial lifesaver for the college, especially in the later years of the war. Army and navy reimbursements to Dartmouth in the fiscal year of 1943–44 totaled $1.154 million and covered about half of that year's operating expenses.

During the depths of the war, on June 22, 1944, President Franklin Delano Roosevelt signed into law the Servicemen's Readjustment Act of 1944, better known as the "G.I. Bill." The law provided for a range of benefits for servicemen who were returning to civilian life after the war was over; and benefits included low-cost mortgages, low-interest loans to start businesses or buy farms, one year of unemployment compensation and dedicated payments of tuition and living expenses to attend high school, college or vocational school. These benefits were available to all veterans who had been on active duty during the war for at least ninety days and had not been dishonorably discharged. By 1956, when the initial bill expired, 7.8 million veterans had used the G.I. Bill for educational benefits; some

2.2 million attended colleges or universities, and an additional 5.6 million attended some kind of training program.

With the end of the war in September 1945 and the close of the V-12 Program, Dartmouth College experienced not only a return to prewar enrollment levels, but for the first time, ex-servicemen were attending Dartmouth due to the G.I. Bill. This influx of a new mix of students, many of whom were slightly older, married and with young families—and some being first-generation college students—presented a housing problem in Hanover, as on other campuses nationwide. With financial assistance from the Federal Housing Development Agency, Dartmouth chose to address the problem with the construction of two temporary housing projects called Wigwam Circle and Sachem Village.

The Wigwam Circle cluster was located behind the Thayer Engineering School, overlooking West Wheelock Street and the Connecticut River, and it consisted of nine multifamily buildings arranged in a circle and an additional thirteen buildings placed around the perimeter. In total, the project consisted

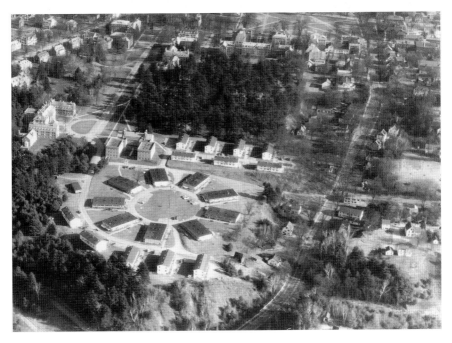

The two hundred housing units that made up the Wigwam Circle Married Students Complex was completed in late November 1946. This aerial photograph was taken a year or so later. By 1958, the building were mostly gone, replaced by a group of dormitories of postwar modern design. *Author's collection.*

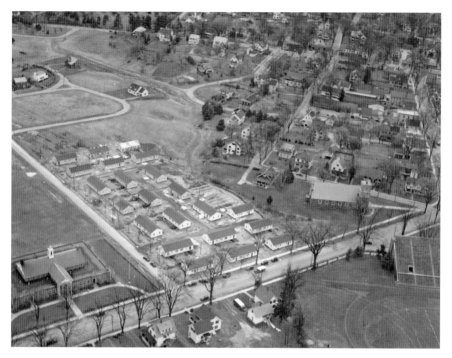

This aerial view shows Sachem Village, a complex of forty-eight units of married student housing, which was under construction in 1947, when this photograph was taken. Located on Lebanon Street, between the elementary school and St. Denis Church, the twenty-four-duplex buildings were moved to a new site off West Lebanon Road in 1958. *Courtesy of Dartmouth College.*

of two hundred housing units, and in spite of nationwide labor and material shortages, it was ready for occupancy by late November 1946. On the east side of the village, on Lebanon Street, beside the elementary school, there was Sachem Village, a cluster of twenty-four two-family units that provided housing for forty-eight young families.

By the mid-1950s, both Wigwam Circle and Sachem Village, which were only intended as temporary housing, had served their initial purpose well, but pressing needs within the village and on campus dictated that, once again, it was time for change. In 1958, the buildings that made up the Wigwam Circle complex were razed and replaced by a new cluster of undergraduate dormitories. That same year, on land in Lebanon that had once been the Gould Farm, on the east side of West Lebanon Road, all twenty-four buildings that made up Sachem Village were relocated to a newly created Sachem Village—still intended for married students. Since then, this off-campus complex has, on numerous occasions, been

redeveloped and expanded. Today, none of the original buildings remain. To partly compensate for the loss of the Wigwam housing, in 1958, the Rivercrest complex of fifteen two-family units was created north of the campus, next to Lyme Road on the former Record Farm. That complex, too, has since been razed.

LEBANON STREET

Lebanon Street, like South Main Street, has made and remade itself several times over the past 250 years—sometimes due to the destructive force of accidental fire, but more often due to the changing needs and aspirations of property owners. And if there ever was any manufacturing activity within the village, it was along Lebanon Street.

Walter H. Trumbull was an enterprising carpenter from Etna who, in 1917, established his own general contracting business. Meeting with quick success, in 1921, he purchased a former blacksmith shop at 9 Lebanon Street, beside Bachand's Riding and Livery Stable. As Trumbull's construction business continued to grow, so did his presence on Lebanon Street, with a full-service carpentry shop, retail building materials, lumber storage and maintenance facilities for his growing fleet of construction-related vehicles. By the 1950s, the business had become Trumbull-Nelson Construction Company Inc., one of the area's larger employers. The front building that housed the carpentry shop and company offices was just a portion of what occupied the site, which stretched to East South Street. Concerned by the potential threat of fire, combined with the Dartmouth Ski building next door, which manufactured wooden skis, the Hanover Fire Department periodically held special fire drills in case an accidental fire should break out.

In 1970, Trumbull-Nelson developed a new complex outside the village, along Lebanon Street, at the site of the former Precinct Farm Company, better known at the time as the "pig farm," where Hanover and Dartmouth's food waste was "recycled" by numerous hungry pigs who were then sold for slaughter. Just as the pig farm was replaced by new commercial business development, so, too, was the former Trumbull-Nelson complex razed to be replaced first by a parking lot and drive-up banking facility. In the late 1990s, the site was redeveloped again by Dartmouth College with a new three-story commercial building and an attached parking garage.

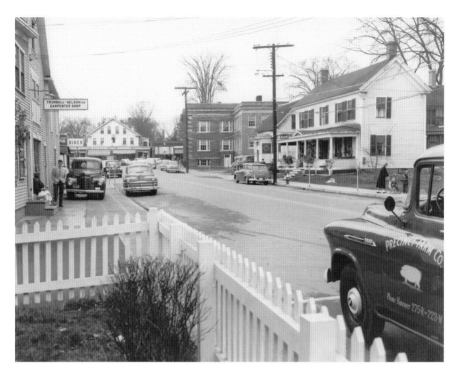

Lebanon Street, looking toward South Main Street, in 1956. *Left to right*: Trumbull-Nelson (gone by 1972), the Hanover Diner (gone by 1963), the old Morse House (demolished in 1969 to make way for the Nugget Arcade building), the rear of the Dartmouth Savings Bank (expanded in 1959) and buildings that were demolished in 1959 to make way for the Hopkins Center. *Author's collection.*

The Dartmouth Co-op was founded in 1919 by John Piane (1891–1968), a 1914 graduate of Dartmouth College and a first-generation Italian American from Manhattan's Lower East Side. This was during the same time that Fred Harris, class of 1911, founded the Dartmouth Outing Club in the winter of 1909–10. Harris, a native of Brattleboro, Vermont, began making his own wooden skis for use on local hills and farm fields.

In addition to attending to a full range of outfitting needs of Dartmouth students, the co-op began selling wooden skis made by the Gregg Ski Company of St. Paul, Minnesota, and by 1937, a time of a rapid rise in the popularity of skiing, it published its first *Dartmouth Ski Catalog*. The co-op offered not only Gregg-made skis, but Kandahar bindings. This prompted sporting goods dealers across the country to begin searching for a source of supply for ski equipment, and as Dartmouth was, in many ways, the cradle of the sport in this country, their attention turned to Hanover. There, they

found the co-op supplying ski equipment to Dartmouth students, and the desire of dealers to purchase similar equipment on a wholesale basis led to the founding of a wholesale division. By the 1940–41 ski season, Dartmouth Skis Inc. had been established and was offering some of America's finest ski equipment prior to the development of the non-wooden ski.

At the outbreak of World War II, the allied armies fighting in northern Europe, such as the Soviet Union's massive army, needed wooden skis, and Dartmouth Skis, along with others, became an established manufacturer. About 1946, Dartmouth Skis decided to construct a new ski manufacturing facility to capitalize on the sport that was increasingly becoming a national winter pastime. Behind an older existing building located at 3 Lebanon Street, next to Trumbull-Nelson's carpentry shop and the Hanover Diner, a new two-story reinforced-concrete-and-steel building was constructed to manufacture wooden skis.

By the 1960s, the company had moved to larger quarters, located on the Mount Support Road in Lebanon. About 1968, the old wood-framed house that faced Lebanon Street was taken down, and the former ski manufacturing facility was converted into an office building, set back from the street with

The Dartmouth Skis Inc. factory, located on Lebanon Street, shown circa 1964. Around 1963, the Hanover Diner, located to the left of where the 1959 Ford Station Wagon is parked, had been removed. These buildings beside the ski factory were owned by Trumbull-Nelson Construction Company Inc. and were gone by 1972. *Courtesy of Dartmouth College.*

a spacious front lawn area. The year 1990 brought changes again when the building became the rear half of the new Hanover Park complex. By 1970, on a summer day when downtown windows and doors were open, the whining sound of saws shaping wood in Trumbull-Nelson's carpentry shop and next door at the Dartmouth Ski factory were no longer heard, and the fire department was able to relax a bit.

Main Street

South Main Street, the very heart of the village, continued its periodic evolutionary makeover throughout twentieth century, with both gains and losses—some losses more painfully felt then others. One of those losses was not only that of a building, but of a business that was a beloved village institution.

The historic record is not entirely clear as to exactly when the little wooden single-story building, long and narrow in plan, first appeared at 42½ South Main Street, or who was responsible for putting it there. It is known that, in 1897, Angelo Tanzi, a stonecutter from Italy, purchased what had been a harness shop with a blacksmith shop out back and opened a fresh fruit and vegetable store. Angelo married a local woman, Della Woodward, and between them, they raised a large family in Hanover, including three sons, Leon, Charles and Harry. Harry, the oldest, came into the business in 1920, and in 1927, when Angelo retired, he took over the family business with his two brothers and called it Tanzi Brothers. From that time on, Tanzi's was an institution known and beloved by generations of Hanover residents and Dartmouth graduates worldwide.

Tanzi's was, in the truest sense of the word, an institution, with the three lively brothers and Charles's wife, Harriet, holding court and keeping track of all the comings and goings in the village and on campus, dispensing sharp wit, wisdom and general banter, all in a manner not too dissimilar to their contemporaries in Hollywood—the Marx Brothers. They also supplied generations of young Dartmouth men with ample quantities of beer. When celebrities and noted college alumni were in town, they always made a stop at Tanzi's. If one wanted to learn the latest village news, Tanzi's was where they headed. Late on a workday afternoon, it was not uncommon to see a sawdust-covered carpenter from Trumbull-Nelson's carpentry shop around the corner on Lebanon Street, buying beer beside a professor's wife buying fresh vegetables for the nightly dinner table, all engaged with the Tanzi's in lively banter and an occasional bit

This quiet afternoon view of the east side of main street, taken by David Pierce in 1956, shows (*left to right*): the corner of the Hanover Hardware Store building (now Ledyard National Bank), Tanzi Brothers Grocery Store (burned 1974), Eastman's Drug Store (razed in 1959) and the Dartmouth National Bank building (expanded in 1959 and further renovated in 1977). *Author's collection.*

of "fresh" conversation—usually with ringleader Harry Tanzi at the center of it all. Tanzi's was so much a part of village life that, for many years, Harry was referred to as Hanover's honorary mayor.

June 30, 1969, was a very sad day on Main Street. It was the day that Tanzi's forever closed its doors, and the brothers and Harriet retired. The loss was felt by many of Hanover's residents and by many well beyond Hanover's borders. Many who had frequented this institution during their years on the Hanover Plain realized that a sea change had taken place and that Hanover would never be the same. The little fourteen-by-forty-two-foot building, akin to a stage set where a big slice of village life had been played out with lively hilarity for more than seventy years, fell silent. The premises was purchased by Arthur Gault to house his specialty shop; however, in 1975, several days after Christmas, the little building was destroyed by fire.

David Peirce was a professional photographer who came to Hanover in 1941 and became fascinated with photographing the village, including Tanzi's. The Hopperesque image above was taken by Peirce on a quiet

Sunday afternoon in 1956, when the stores on Main Street were typically closed. Tanzi Brothers is shown to the left. In the middle is Grant Eastman's drugstore that included a lunch counter run by Agnes Berwick that looked out onto Main Street. Like Tanzi's next door, Agnes's lunch counter was always lively with banter and news. The building was taken down in 1959 to make way for a large addition to the Dartmouth Savings Bank building, shown on the right. In 1977, the bank building was extensively renovated again. Partially visible to the left, beside Tanzi's, is the Hanover Hardware Store. Today, it is the location of Ledyard National Bank.

Hopkins Center for the Performing and Creative Arts

The pages of this book make clear that from the time of the college and village's occupation of the Hanover Plain, an ongoing process of physical betterment, improvement and remaking has continued to leave its imprint on both the natural and the built environment. And there have been numerous factors that have influenced this process of change—be that accidental fire, changing needs and demands, changing architectural tastes, the advancement of technology and more. However, as a community, the village was never visited by the forces of post–World War II urban renewal planning and redevelopment, as many communities experienced in the mid-century, unless, perhaps, one considers the development of the Hopkins Center for the Performing and Creative Arts between the years 1958 and 1962 urban renewal.

The construction of Bissell Hall as a gymnasium facility was a welcomed addition to the campus when it was completed in 1867, but the building became somewhat of an orphan on completion of Alumni Gymnasium in 1909. Regardless, the building then served as quarters for the Thayer School of Engineering until the completion of the Horace S. Cummings Memorial building in 1939. Although the removal of the Thayer School did not render the old building vacant, it certainly put its future into question. Furthermore, the land next to Bissell Hall had remained underutilized, even though it was located in the center of the village.

Early in his presidency, Ernest Martin Hopkins began to visualize a performing arts center for the college, believed by him and others to be essential for a modern liberal arts institution like Dartmouth. Gradually,

the idea of the "Dartmouth Center" began to take hold in Hopkins's and the Trustees' collective minds; however, other pressing priorities faced the growing college: a nationwide economic depression and the outbreak of World War II continued to cause this much-needed addition to the campus to be delayed.

Remarkably, at the Trustees' June 1944 meeting, with the college's finances noticeably improved in large part by the navy's V-12 Program, it was approved that, as soon as wartime conditions would permit, planning for the new auditorium-theater—the new "Dartmouth Center," estimated to cost $1.3 million—was to move forward. In the coming years, little was done, and in 1945, Hopkins retired, and the presidency of the College was assumed by John Sloan Dickey. The idea of creating the new facility, however, was not dead—just dormant. Some architectural studies of the proposed new facility had been made by college architect Jens Fredrick Larson before he moved to New York City. The site was Bissell Hall and the underutilized land next to it, but the proposed design, in its dated

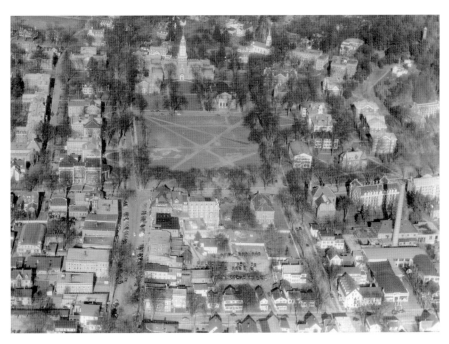

This 1950s aerial view, looking north toward the center of the Dartmouth campus, shows the four-acre area that included fourteen buildings that, starting in October 1958, was cleared to become the site of the proposed $8 million Hopkins Center for the Performing and Creative Arts. In the foreground is Lebanon Street. *Courtesy of Dartmouth College.*

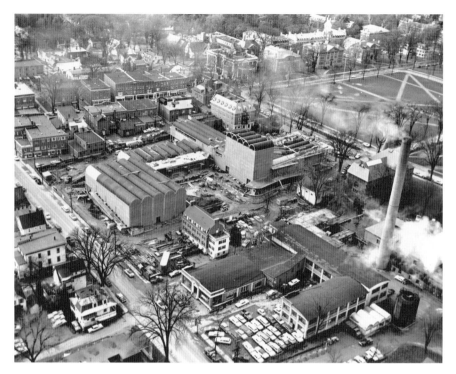

Looking in a northwestern direction in the spring of 1961, this view shows Hopkins Center under construction and the extent of change that this postwar modern masterpiece brought to the village area. In the lower right foreground is a four-bay garage building that was constructed to prove and demonstrate the very innovate concrete roof vault engineering that was developed for the new Dartmouth building. Hopkins Center was a prototype for Lincoln Center in New York City that was developed soon after. The garage building no longer exists. *Courtesy of Dartmouth College.*

Georgian Revival colonial garb, did little to excite postwar interest in this much-needed project.

At the urging of President Dickey, at the January 1956 Trustees meeting, approval was given for a new concept of the facility that would be a center for all of the arts—both performing and visual. A new building committee was formed, chaired by Nelson A. Rockefeller (1908–1979), class of 1930. Mr. Rockefeller's father, John D. Rockefeller Jr., was an admirer of Mr. Hopkins and donated $1 million toward the center as a personal tribute to Hopkins. The Rockefeller family had a long-established relationship with New York City–based noted modernist architect Wallace K. Harrison (1895–1981), and therefore, it was the younger Rockefeller who brought Harrison into the planning of the new project in the fall of 1955. Harrison had formed a partnership with fellow architect Max Abramovitz (1908–

2004) in 1941 known as Harrison & Abramovitz, and it was they, in working with Nelson Rockefeller and a small building committee, who brought new life to a stalled vision that was thirty years in the making. Concurrent with the ongoing planning for the new Hopkins Center was Harrison & Abramowitz's planning for the proposed new Lincoln Center that was to be built in New York City. Much of the new structural technology developed for the Dartmouth project was then used in the design of the new Metropolitan Opera House that was part of the larger Lincoln Center project.

A ground-clearing program began on October 24, 1858, and the following spring, Bissell Hall was razed. In total, fourteen buildings were cleared from the approximate four-acre downtown site. As part of redevelopment, South College Street, which had been laid out in June 1771 by Jonathan Freeman and Eleazar Wheelock and ran between East Wheelock and Lebanon Streets, was eliminated. The $8 million masterpiece of postwar modern architecture that followed—that boldly broke with almost two hundred years of architectural tradition—was dedicated on November 8, 1962. Earnest Martin Hopkins lived to see his vision fulfilled and died peacefully on August 13, 1964.

NORTH MAIN STREET

Much of what is now North Main Street—beyond that which borders the west side of the Green—is well within the campus area, yet it could be said that it is not as much in view as South Main Street or the two Wheelock Streets. Regardless, since it was first laid out by Jonathan Freeman and Eleazar Wheelock in June 1771, it, too, has been the subject of great change, especially in the twentieth century, and it is the site of some lost buildings of interest and their stories.

Former Dartmouth College faculty members Dr. Clifford Pease Clark and Dr. Frank Millett Morgan conceived of developing a boys-only independent boarding school next to the Dartmouth campus, so they founded the Clark Preparatory School in 1919. Dr. Morgan was the headmaster, and the school's primary purpose was "to prepare a boy adequately and thoroughly for college or business and to inculcate in him those basic principles and high ideals which tend toward the development of a manly character." The school prepared boys primarily for Dartmouth College, though its students did attend other colleges and universities.

The school occupied buildings and land situated on both sides of North Main Street, although its administrative quarters were at the northeast corner of North Main and Elm Streets, behind Baker Library. These buildings were razed or moved away in the early 1960s to make way for the construction of the new Kiewit Computation Center. On the west side of North Main Street, the school, in 1938, constructed Cutter Hall, a brick dormitory that is still standing, and owned several other buildings that remain part of the Dartmouth campus. The school's playing fields are now the site of the Choate Dorm Cluster.

The Clark School was a fine and successful institution; however, it was decided to merge it with the Cardigan Mountain School located in nearby Canaan, New Hampshire. The latter had been founded in 1945 as a boys pre-preparatory school by a group of prominent New England educators, businessmen and civic leaders, including Ernest Martin Hopkins, who was then retiring as president of Dartmouth College. Land for the school's campus in Canaan had been donated to Dartmouth College by the Haffenreffer family. The school opened in 1946 with an enrollment of twenty-four boys, and its growth was fueled by the merger of the Clark School with Cardigan Mountain School in 1953. The Clark School ceased

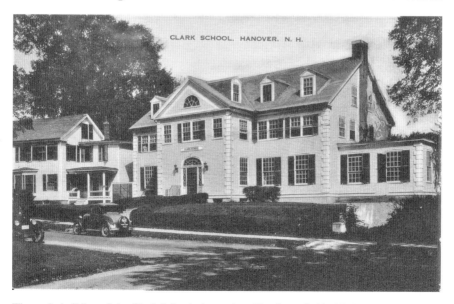

The main building of the Clark School, situated on Elm Street behind Baker Library. The building was built in 1925 and was moved away in 1963 to make room for the construction of the Kiewit Computation Center, which was completed in 1966. The Clark School left Hanover in 1953 and merged with the Cardigan Mountain School in Canaan, New Hampshire. *Author's collection.*

operations in June of that year, and all of the school's real estate holdings were acquired by Dartmouth College.

The removal of the Clark School to Canaan, New Hampshire, allowed the College to fill out its land holdings in this area of the campus and to plan for much-needed postwar facilities development. Although it was longer lived than Butterfield Hall (1896–1926), three major postwar buildings came to occupy the corner of North Main and Elm Streets that were also relatively short-lived and the loss of which was hardly noticed at the time. More unfortunate than their time on earth was their architecture, which was never well received by the Dartmouth community at large and earned two of them the derisive moniker "the Shower Towers."

Bradley and Gerry Halls were two multistory buildings joined at ground level by Filene Auditorium. Bradley Hall, home of the mathematics department, was named in honor of Albert Bradley, class of 1915, who, in later years, served as chairman of the board of General Motors Corporation and served on the College's Board of Trustees. Gerry Hall, the home of laboratories, classrooms and offices for the psychology department was named for Edwin Peabody Gerry, a noted medical figure in Boston. The two-hundred-seat Filene Auditorium was named for the Lincoln and Teresa Filene Foundation, its funder.

The architects commissioned with the design of the new three-building complex were E.H. and M.K. Hunter of Hanover, a husband-and-wife architectural team. Edger Hayes "Ted" Hunter Jr. (1914–1997) was the son of Edger Hayes Hunter (1878–1957), class of 1901, an engineer, superintendent of buildings at Dartmouth from 1904 to 1912 and a general contractor in the Hanover region. Ted received a BA degree from Dartmouth in 1938 and a master of architecture degree from Harvard in 1941. While at Harvard, Ted met Margaret "Peg" King (1919–1997), whom he later married. Margaret Hunter received a BA in botany from Wheaton College and was a member of the first class of female architects at the Harvard Graduate School of Design in 1942. While at Harvard, both Ted and Peg studied under architect Walter Gropius, the founder of the Bauhaus School in Germany following World War I. As students of Gropius at Harvard, the Hunters became leading proponents of the purer mid-century modern style locally when they returned to Hanover and established their practice in the Musgrove Building. In addition to maintaining a full architectural practice, they both taught architecture at Dartmouth until they left Hanover and relocated to Raleigh, North Carolina, in the summer of 1966.

There is no doubt that Bradly and Gerry Halls were designed in the pure international style, as perfected by architect Walter Gropius, and that when they were completed in early 1962, they presented a sharp contrast—more so than Hopkins Center—to the Georgian Revival style red-brick buildings that surrounded it. And there is no denying that architectural taste, especially with the College's active and often outspoken alumni, remained conservative. Soon after completion, the buildings were referred to as "shower-stall architecture," or "the shower towers," which was, indeed, unfortunate. They clearly deserved better than that.

Beside the Bradly-Gerry complex, another piece of postwar modern design was built, and it was likewise short-lived. However, unlike the derisiveness that was so often heaped on the Bradley-Gerry complex, the demise of this structure was due more to a fast-changing technology that made the entire building design, which was pragmatically specific, obsolete.

During the 1950s, Dartmouth was in the forefront of developing computer technology—the result of two professors of mathematics: John G. Kemeny and Thomas E. Kurtz. These two men and the college were pioneers in creating what became known as the Dartmouth College Time-Sharing System (DTSS), which led the way as a multiple-use computing system that was both reliable and versatile, and it had a capacity for highly complex, as well as very simple, operations.

In 1962, Professors Kemeny and Kurtz proposed building a college computation center, saying that "whether a student will ever use a computing machine or not, his life is likely to be affected by such machines, and hence, he should know something about their capabilities and limitations. In this sense, contact with electronic brains is as essential as learning to use the library." The following year, a committee on the "Implications of Modern Electronic Data Processing Equipment for the Dartmouth College Libraries" was formed. In 1964, the National Science Foundation granted $500,000 to Dartmouth for the development of a time-sharing system and the computer language BASIC. The General Electric 225 computer, plus its software, carried a price tag of $800,000, and by February, it was operational.

Skidmore, Owings and Merrill was established in Chicago in 1936, and by the 1960s, it was an international architectural firm, commissioned to design what was to be a free-standing single-story above-grade building next to the Bradley-Gerry complex, at the northeastern corner of North Main and Elm Streets. The building was a true modernist dictate that "form follows function," and it was reflective of the new technology that it was designed to house. The facility included six administrative offices, six graduate student

offices, a seminar room, conference room, reference library, student assistants work room, public teletype area, a lounge and a card equipment room. The basement housed the communications equipment and air-conditioning equipment and provided 5,700 square feet of area for future expansion. The entire building was designed with the greatest amount of flexibility in mind, with no interior supporting structure and only very minimal supporting structure at the four sides of the building's perimeter. Several buildings that had formerly been part of the Clark School were demolished or moved away to make way for what was named the Kiewit Computation Center. The new building cost $650,000 and was constructed by local general contractor Trumbull-Nelson Construction Company Inc.

The donor for the new state-of-the-art building was Peter Kiewit Jr. (1900–1979) of Omaha, Nebraska. Kiewit was the youngest son of Peter Kiewit, a bricklayer of Dutch descent, and Anna (Schleicher) Kiewit, an immigrant from Germany. The younger Peter attended Dartmouth after

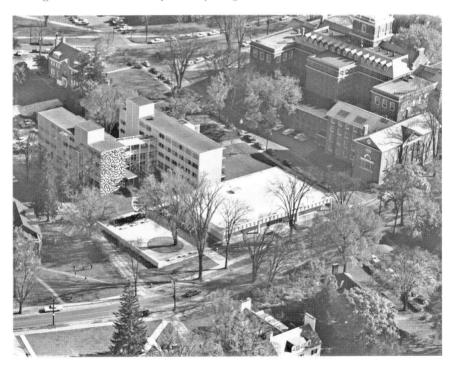

The Bradly-Gerry building complex, situated on Elm Street, and the Kiewit Computation Center with Bradley Court on North Main Street, shown here in the later 1960s. In 2000, the buildings were demolished, and Elm Street was discontinued to allow for the expansion of Baker Library. *Courtesy of Dartmouth College.*

graduating from Omaha Central High School in 1918, and he graduated in the class of 1922; however, after a year, he chose to return to Omaha and began working in his family's general construction business. Over time, Peter Kiewit Sons', later renamed Kiewit Corporation, became one of the largest international construction companies. On December 2, 1966, Peter Kiewit, with his wife, Evelyn, dedicated the new facility as part of a conference held on the Dartmouth campus. The subject: "The Future Impact of Computers." By 2000, thirty-four years later, the postwar modernist building had technologically become obsolete. Its designers never envisioned the coming of the powerful, high-speed personal laptop computer.

THE MARY HITCHCOCK MEMORIAL HOSPITAL

When the new thirty-six-bed Mary Hitchcock Memorial Hospital first opened on May 3, 1893, there was no guarantee that the new facility would be successful. For the public, the concept of hospitals was still new, especially in rural regions like the Upper Connecticut River Valley and north country. Shortly after the facility opened, a nursing school was added; however, in 1900, Hiram Hitchcock died, and the support of the hospital's most generous benefactor came to an end. Through the dedicated efforts of many within the Hanover and Dartmouth community and beyond, the hospital not only survived but continued to take hold and evolve. In 1913, the first expansion was made to the facility with the construction of a two-story wing, a gift of Dawn L. Hitchcock. It increased the hospital's capacity by two-thirds and included a maternity ward and other modern features. Billings-Lee House, a dormitory for nurses, was built in 1920, and six years, later Dick's house, the college infirmary, was added. The Hitchcock Clinic was organized in 1927 by the five doctors who were on the hospital's staff, and in 1938, a new clinic addition was constructed on the west side of the growing complex. By 1943, fifty years after the hospital had first opened, other building additions had been constructed, and renovations had been made to the rear of the original building. During these years, the inpatient bed count had risen to 196, and 4,568 patients had been treated in 1942.

In the years immediately following World War II, it was clear that with the recent advancements in medicine and related technologies, the hospital's physical plant was limited, and it was unable to handle the increasing demands put on it. Therefore, in the fall of 1947, an aggressive fundraising

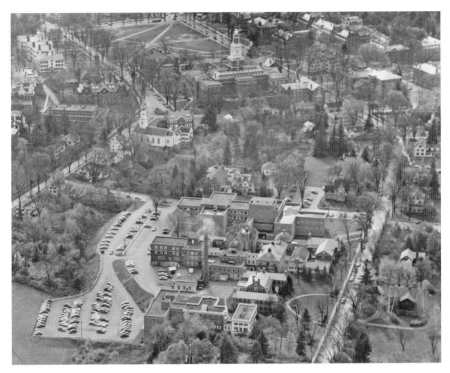

The Mary Hitchcock Memorial Hospital, looking to the southwest, circa the mid-1950s. Next to Maynard Street is the new Faulkner Building, which was completed in 1952. Behind it—and surrounded by newer construction—is the original building that was opened in 1893. In the foreground are the buildings of the Mary Hitchcock Memorial Hospital School of Nursing (1893–1980). *Courtesy of Dartmouth College.*

campaign was launched that resulted in a $3 million building program. Because the original 1893 building was set far back from Maynard Street, with a very large landscaped front lawn, entry porte-cochère and circular drive, a new, modern four-story addition was constructed in the front that connected to and fully masked the original but antiquated 1893 facility. The largest contributor was Marianne Faulkner of Woodstock, Vermont, who made a sizable gift in memory of her husband, Edward Daniels Faulkner. Mrs. Faulkner dedicated the new $2.2 million facility at an impressive ceremony on February 2, 1952. Hiram Hitchcock's memorial to has beloved wife, Mary Maynard Hitchcock, was transformed and positioned to play a leading role in the north country region. The new Faulkner Building brought the hospital's bed capacity to 263, and there was more change to come.

In 1970, four additional floors were added to Faulkner Building at a cost of $11 million, and the Norris Cotton Cancer Center, the Mental Health

183

Center and numerous other additions soon followed. By 1972, capacity was slightly more than 400 inpatient beds, and Mary Hitchcock Memorial Hospital had grown to be the largest hospital between Boston and Burlington, Vermont. By the mid-1980s, there was increasing pressure to add, modify and expand the facility, which was, in reality a hodgepodge of buildings dating back to 1893 situated on what had become a very congested site with serious infrastructure challenges. This all contributed to the decision to relocate the entire hospital to a new facility that could more easily look toward and embrace the future, free of the past. Therefore, ambitious plans were developed to construct a new facility, Dartmouth-Hitchcock Medical Center, which was to be located in Lebanon. As part of the planning process, Dartmouth College agreed to purchase the entire existing Maynard Street complex. In one very full day, Saturday October 5, 1991, more than two hundred patients were moved from the old hospital to the new $225 million complex. For the next four years, the old complex of buildings was carefully stripped of 96,402 pounds of copper, 131,687 pounds of wiring, 13,223 pounds of stainless steel, 19,006 pounds of aluminum and 639 tons of steel. The buildings were also made free of any asbestos materials that were part of much of the building's construction. Then Bianchi-Trison Corporation

This late-1960s architectural rendering shows the $11 million four-story addition that was completed in 1970. During the 1970s, more building area was added to the site; in the mid-1980s, it was decided to develop a completely new hospital in Lebanon. The Hanover complex was demolished during the fall of 1995, with a dramatic implosion of the Faulkner House Tower. *Courtesy of Dartmouth College.*

of Syracuse, New York, and their subcontractor, Controlled Demolition Inc., made the nine-story building ready to be imploded through a series of carefully controlled explosions. This author, then the planning, zoning and building code administrator for the Town of Hanover, issued a demolition permit for the old complex to be razed, including the additions designed by his architect father in the early 1970s. At 7:30 a.m. on Saturday, September 9, 1995, 500 pounds of dynamite, strategically placed in 750 holes that had been drilled into interior support columns, were detonated. In fifteen seconds, with precision, 16,500 cubic yards of concrete and masonry was reduced to rubble as a crowd of about five thousand watched. Cleanup, including recycling the pile of concrete and masonry material, some of which dated back to 1893, cost about $1.4 million.

BIBLIOGRAPHY

Annual Reports of the Town of Hanover, Hanover School District, and the Village Precinct of Hanover. New Hampshire.

Barrett, Frank J., Jr. *Images of America: Early Dartmouth College and Downtown Hanover*. Charleston, SC: Arcadia Publishing Company, 2008.

————. *Images of America: Hanover, New Hampshire*. Charleston, SC: Arcadia Publishing, 1997.

————. *Images of America: Hanover, New Hampshire*. Vol. 2. Charleston, SC: Arcadia Publishing, 1998.

Bartlett, Edwin J. *A Dartmouth Book of Remembrance*. Hanover, NH: Webster Press, 1922.

Chase, Frederick. *A History of Dartmouth College and the Town of Hanover New Hampshire (to 1815)*. Edited by John K. Lord. Second edition, Brattleboro: Vermont Printing Company, 1928.

Childs, Francis Lane, ed. *Hanover, New Hampshire: A Bicentennial Book, Essays in Celebration of the Town's 200ᵗʰ Anniversary*. Brattleboro: Vermont Printing Company, 1961.

Close, Virginia L., and Dick Hoefnagel. *Eleazar Wheelock and the Adventurous Founding of Dartmouth College*. Hanover, NH: Durand Press, 2002.

Dankert, Clyde E. *Hanover Street Names*. N.p.: self-published, 1981.

Graham, Robert B. *The Dartmouth Story: A Narrative History of the College Buildings, People, and Legends*. Hanover, NH: Dartmouth Bookstore Inc., 1990.

Hill, Ralph Nading, ed. *The College on the Hill: A Dartmouth Chronicle*. Hanover, NH: Dartmouth Publications, 1964.

Lathem, Edward Connery, ed. *Dewey's Reminiscences*. Hanover, NH: Hanover Historical Society, 1964.

Leavens, Robert French, and Arthur Hardy Lord. *Dr. Tucker's Dartmouth*. Hanover, NH: Dartmouth Publications, 1965.

Lord, John King. *A History of Dartmouth College 1815–1909*. Vol. 2 of *A History of Dartmouth College and the Town of Hanover, New Hampshire*, begun by Frederick Chase. Concord, NH: Rumford Press, 1913.

———. *A History of the Town of Hanover, NH*. Hanover, NH: Dartmouth Press, 1928.

Meacham, Scott Blackford. *Charles Alonzo Rich Builds the New Dartmouth, 1893–1914*. Charlottesville: School of Architecture University of Virginia, 1998.

The Records of the Town of Hanover New Hampshire 1761–1818. Concord, NH: Rumford Press, 1905.

Richardson, Leon Burr. *History of Dartmouth College*. Vols. 1 and 2. Brattleboro, VT: Stephen Daye Press, 1932.

Widmayer, Charles E. *Hopkins of Dartmouth: The Story of Ernest Martin Hopkins and His Presidency of Dartmouth College*. Hanover, NH: University Press of New England, 1977.

ABOUT THE AUTHOR

Frank J. "Jay" Barrett Jr. is a second-generation practicing architect who grew up in the Village at the College in Hanover, New Hampshire. From the time he was a young boy, he knew he wanted to be an architect like his father, from whom he developed and shared a deep love of buildings, history, art and landscape. As a young boy, he watched many of the buildings he has written about be constructed or "lost" as part of a changing village and college campus. Jay was trained in architecture and structural engineering at Wentworth Institute in Boston, Massachusetts, and since then—at first, working with his father—he left his own mark on Hanover and the region beyond. Increasingly, Jay's architectural practice included historic preservation work, and from 1990 to 2021, his home was the former Boston & Maine Railroad station located in Ely, Vermont that he restored and listed on the National Register of Historic Places.